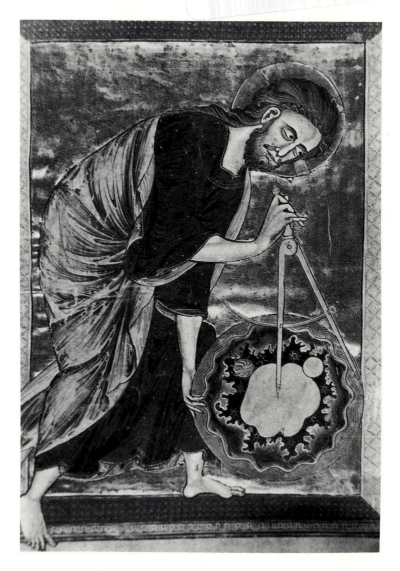

*Creator with Compasses. Bible Moralisée. 13th-century.
Vienna, Österreichische Nationalbibliothek MS. 2554, fol. 1.*

Word, Picture, and Spectacle

Papers by
Karl P. Wentersdorf, Roger Ellis,
·Clifford Davidson, and R.W. Hanning

Edited by Clifford Davidson

Early Drama, Art, and Music
Monograph Series, 5

MEDIEVAL INSTITUTE PUBLICATIONS
Western Michigan University
Kalamazoo, Michigan

1984

Printed in the United States of America

PREFACE

The present collection of essays represents an effort to provide publication for some miscellaneous contributions that treat problems in the areas of art and drama. Since in each case there is relevance to the study of drama and to the visual spectacle which we associate with the theatrical experience, it has been felt that all could be conveniently collected in a volume in the Early Drama, Art, and Music Monograph Series. Nevertheless, these papers will, it is hoped, be broadly of interest to students of iconography, literature, and art.

Karl P. Wentersdorf (Xavier University, Cincinnati) treats the *figurae scatologicae* and provides a careful examination of the use of scatological illustrations in the margins of Gothic manuscripts, and suggests that the reasoning behind the inclusion of such illustrations was much more serious than the mere amusement of readers. There are here implications of a most important sort for students of the early drama, both medieval and Renaissance. This scholar's comments on the scatological references in the medieval morality play--references which so disgusted Joseph Q. Adams that he refused to print the allegedly disgusting passages in his collection of early plays in 1924--will underline what many of us have long suspected: that is, that such references in, for example, *Mankind* are directly relevant to the themes established in the play.

Drawing on the whole from continental examples of art, Roger Ellis of the University of Cardiff attempts to provide a similarly close examination of another problem in early art: what is the function of the words which are inscribed in medieval art by the artists? His conclusions could be paralleled from English examples, and again indicate how study of the art throws light directly also on the study of medieval drama. In a sense the essay is a demonstration of the correctness of F. P. Pickering's concept of "reciprocal illumination."

R. W. Hanning (Columbia University), examining conceptions of creation both divine and human in the twelfth century, provides useful background to the depiction of the Creation in the century which produced the Anglo-Norman *Adam*. While the focus of his paper extends beyond the usual scope of EDAM research into the area of courtly literature, it should not be forgotten that such literature was capable of directly influencing the drama, as in the case of the *Adam* itself. Additionally, the twelfth-century milieu, including the reinforcement of the old idea of God as a Creator who works in ways analogous to the great masons of the Middle Ages (and hence like them holds a set of mason's compasses as the symbol of his act of creation), will be illuminating to students of drama and art from the later Middle Ages as well as to those whose principal work is in the

twelfth century.

My own study of space and time in early drama and art originated in an effort to write an essay on the aesthetics of early drama in the summer of 1978. Very quickly the essay outgrew the boundaries that I had set out for it, and to date several offshoots have been published elsewhere. Nevertheless, the present study, which tackles some difficult phenomenological questions related to the medieval understanding of space and time, remains the core of the lopsided and undisciplined manuscript that emerged from my early efforts. The present essay has, of course, undergone several transformations, and has benefited from the comments of a number of colleagues who are perhaps wiser and much better qualified to write on such a vexing subject than I am.

Clifford Davidson

CONTENTS

Illustrations

Fig. 10. Knight shooting arrow at hindquarters of nude man. Breviary.

Fig. 11. Centaur shooting at hindquarters of ape-man. Breviary.

Fig. 12. Man shooting crossbow at exposed hindquarters of man. Missal.

Fig. 13. Devil on stool, defecating. Psalter.

Fig. 14. Ape defecating into open jaws of diabolic monster. *Voeux du Paon.*

Fig. 15. Ape defecating in front of human face. Decretals of Gratian.

Fig. 16. Man bent over and defecating in front of nun. *Romance of Alexander.*

Fig. 17. King defecating. Arthurian Romance.

Fig. 18. Nude youth, defecating into stream. Book of Hours.

Fig. 19. Man defecating in front of another. Breviary.

Fig. 20. Cleric defecating, reprimanded by nude bishop. *Gorleston Psalter.*

Fig. 21. Bishop blessing exposed hindquarters of hybrid with human head. Book of Hours.

Fig. 22. Nude hybrid with human head presenting hindquarters, bishop with censer. Book of Hours.

Fig. 23. Hybrid bishop kissing hindquarters of ape with bow. *Voeux du Paon.*

Fig. 24. Templar kissing clerical monster's rump. *Voeux du Paon.*

Fig. 25. Hybrid beast kissing ape's hindquarters. *Voeux du Paon.*

Fig. 26. Man about to kiss rump of nude cleric with tail. *Gorleston Psalter.*

Fig. 27. Hybrid man with exposed buttocks, about to kiss exposed hindquarters of man. *Gorleston Psalter.*

Fig. 28. Simone Martini, *Annuciation* (detail).

Fig. 49. Mary Magdalene being taken up by angels. Woodcut, Albrecht Dürer.

Fig. 50. Last Judgment with Seven Deadly Sins and Corporal Acts of Mercy. Wall painting, Trotton, Sussex.

Fig. 51. "Giselbertus hoc fecit." Signature of artist. Tympanum, Cathedral of St. Lazarus, Autun.

Fig. 52. Logos Creator. Stained glass, Chartres Cathedral.

Fig. 53. Creation of Heaven and Earth. North Porch, Chartres Cathedral.

Fig. 54. St. John the Evangelist. English Gospel Book.

Fig. 55. IN initial at beginning of Book of Genesis. *St. Hubert Bible.*

Fig. 56. The Six Days of Creation. Manuscript illumination.

Text fig. a. Simone Martini, *Annunciation.* Drawing from original.

Text fig. b. Annunciation. Drawing from original in Piazza del Capitole, Florence.

THE SYMBOLIC SIGNIFICANCE OF *FIGURAE SCATOLOGICAE* IN GOTHIC MANUSCRIPTS

Karl P. Wentersdorf

The miniature pictures which embellish the margins of Gothic manuscripts dating from the late twelfth to the fourteenth centuries (see fig. 1) have long intrigued art historians because of the problem of interpreting their significance. The pictures represent not only characters or scenes from literary and religious works, but also persons from everyday life in a wide variety of professions, trades, and activities--knights and ladies, hunters and soldiers, tumblers and musicians, farm laborers ploughing, clerics preaching, women spinning, and children playing. Side by side with these realistic pictures appear the grotesque images of animals real and fabled, often engaged in specifically human pastimes or activities, as well as hybrid creatures that are part human and part animal or fabulous monster. It is the question of the *raison d'être* of these grotesque images that puzzles. Do they have any thematic connections with the texts in whose margins they appear? Are they mildly or mordantly satirical comments on the vagaries and vices of mankind? Are they straightforwardly symbolic representations of aspects of the world which surrounds, astonishes, and even threatens readers of the manuscripts? Or are they just naively amusing digressions from the serious business of study and contemplation, brief excursions into a meaningless world of eccentric fantasy?

Modern criticism has been strongly influenced by Émile Mâle's opinion that the grotesque images of Gothic art in general were not symbolic: most "bear the mark of a gay invention or good-humoured raillery," and "If ever works of art were innocent of ulterior meaning surely these are." Human and animal elements "are ingeniously blended" ("Capital letters shelter dragons with bishops' heads") but without didactic purpose; hence "All attempts at explanation must be foredoomed to failure."[1] The notion that the marginal images have no connection with the written content of the manuscripts is still with us, as when M. W. Evans describes the decoration of an initial in the manuscript of a work by St. Augustine: "The figure of a man attacking a florid monster had no relevance to the text, which is St. Augustine's treatise on Christian doctrine."[2] The denial is unconvincing, however, because the decoration referred to represents a winged dragon-like monster, and the dragon is a traditional symbol for the devil. The New Testament tells how the Archangel Michael and his angels battled in heaven with God's

1

adversary: "And that great dragon was cast down, the ancient
serpent, he who is called the Devil and Satan, who leads astray
the whole world" (Revelation 12.7-9). Numerous accounts of
fights waged against dragons--from early treatments of the hero-
ism of St. George to Spenser's story of the Redcrosse Knight
(*Faerie Qveene* I.xi)--allegorize the endless fight of the Church
against the errors of heresy inspired by Satan and in addition the
personal struggle of each member of the Church against temp-
tation. Either or both of these allegories may be intended in
the representations of Satan as a dragon in Gothic manuscripts.[3]
In his *De doctrina christiana*, Augustine is concerned with the
role of rhetoric in the training of teachers, so that they might
expound the Scriptures without error. Since human existence, in
the Christian view, demands a constant war on sin and error, the
relevance of the decorative dragon to the theme of Augustine's
treatise is unmistakable, and it would surely have been clear to
medieval readers of the manuscript. In other religious manu-
scripts, notably books of hours, the picture of a fiery dragon
near an unsuspecting man (fig. 2) or of a nude man with a spear
and shield confronting a dragon rampant (fig. 3) symbolizes the
spiritual dangers by which the individual Christian is threatened.
 It is noteworthy that a similar critical uncertainty exists
as to the significance of the grotesque Gothic sculptures, in-
cluding the gargoyles, that were antecedent to and highly in-
fluential upon the development of the marginal images in medie-
val manuscripts. Those sculptures were not always approved of
even in their own day. St. Bernard of Clairvaux went out of his
way to denounce them as monstrosities which, far from being an
aid to genuine religious devotion, were in his view a distraction
to the faithful--and especially to contemplatives--from proper
meditation and worship.[4] Such strictures may explain why some
modern historians and critics regard the Gothic sculptures, par-
ticularly the fabulous monsters and hybrids, as lacking in serious
religious significance. Francis Klingender, for example, observes
that "with the spirited animal musicians and monsters" carved in
stone on many religious buildings "we enter a world of gay rev-
erie, scarcely related to its sacred setting, which we shall meet
again presently in the margins of Gothic manuscripts."[5]
 Considerably less fancifully and with specific reference to
the grotesque images in manuscripts, Janson and Randall have
pointed out that the strange creatures and their activities con-
jure up a world characterized by a total reversal or inversion of
the natural order of things--the *monde renversé* effect. Janson
suggests that "the mainspring of the marginal grotesque" seems
to be "the pleasure in reversing the normal, rational order of the
world. . . ."[6] Thus a knight drops his sword and flees from a
snail, or a hare robed as a cleric reads at a lectern. Randall
asserts that the largest group of subjects "consists of parodies of
human foibles and folly," and that "the connotations of a *monde
renversé* . . . are readily apparent." She also observes that the

function of these images, constituting as they do the bulk of the iconographic repertory of marginal illustrations, was "less overtly didactic" than the purpose of analogous subjects in fabliaux and exempla; an "element of humor was seldom absent, in the rendering if not in the theme, and the aim was both to divert and to elevate."[7]

On this view, the source of the edification is to be found mainly in the element of satire: the illustrations parody human foibles and social weaknesses. Among the images drawn from the animal world, apes appear more frequently than any other creatures. For Janson, their activities parody or burlesque those of man: thus apes depicted as armed and fighting with each other burlesque the jousts and mortal combats of medieval knights; apes representing physicians, inspecting urinals or applying salves, parody the medical profession. There are also apes with religious attributes--wearing a bishop's mitre and accompanied by a cat with an asperge (fig. 4), carrying a holy-water vessel and an aspergillum while leading a funeral procession, wearing a mitre while using a crozier to operate a butter churn, investing an owl with the regalia of a bishop, or even celebrating Mass. According to Janson, images of this nature are parodies of the rituals of the Church.[8] These images, however, are more likely to have been intended as satires on unworthy individuals who performed these rituals, just as ape-knights and ape-physicians almost certainly constituted criticism of men who were not good members of their professions rather than criticism of the professions themselves.

What inclines the critical balance in favor of the latter view--that simian imagery satirizes fallible and sinful human beings rather than the institutions and professions--is the circumstance that some of the images show animals engaged in activities regarding which it is unlikely that the activities themselves are the target of the satire. Animals (and men) are depicted playing a variety of musical instruments. Surely there is no criticism here of music in itself, particularly since music had become an important part of the Christian liturgy. Strong criticism was directed, however, against music that was intended to awaken the sensuality of its hearers; thus, since the ape was a common symbol of gross sensuality, a picture showing that animal playing a musical instrument satirizes the musician whose art, as John of Salisbury grimly puts it, stirs lasciviousness and leads to the abyss of lust and corruption.[9] Again, when a nude man is shown embracing or hunting a hare (figs. 6-7), or when a hare is shown as a hunter carrying a bound man across its shoulder,[10] one can scarcely assume that the satire is directed against hunting as part of everyday life.[11] Such images pictorialize the moral theologian's lament that man all too often seeks opportunities for, and succumbs weakly to, the vice primarily symbolized by the hare--lechery.[12]

Whatever interpretation is placed on the parodic images as

a whole must be consonant with the nature of the subject mat-
ter contained in the manuscripts where they are found.[13] Many
of these manuscripts are of a religious nature, and some were
intended for official liturgical use by clerics, so that satire on
Church rituals *per se* would seem an unlikely intention. Satire
on individuals, on the other hand, would have been quite appro
priate, since the members of the secular and regular clergy who
used the manuscripts were no more immune than the rest of
humanity to the temptations and vices represented by the animal
imagery. Furthermore, most medieval Christians believed that
the demons of temptation sent by Satan came from a realm
where the practices (alleged to be paralleled on earth in the
activities of witches) were a total reversal of everything or-
dained for mankind by the Almighty.[14] Hence the *monde
renversé* effect in Gothic manuscript art was intended probably
as a symbolic representation of the inverted world of Satan's
hell and its reflection on earth. And pictorial reminders of the
diabolic dangers eternally hovering over the heads even of those
engaged in prayer and contemplation would have been as much in
place in religious manuscripts as were the gargoyles perched on
the edges of the roofs of religious and academic buildings.

This interpretation is supported by the implications of one
sub-category of grotesque images catalogued in the study of
marginal illustrations published by Lilian Randall but not dis-
cussed by her--the *figurae obscaenae*.[15] Her extensive and
invaluable study of the imagery is based on an examination of
327 manuscripts from various parts of Western Europe, the ma-
jority of them being religious in content; they range in date from
the late twelfth century to the second half of the fourteenth
century, and they originated primarily in the scriptoria and
ateliers of France, England, and the Low Countries. Randall
lists approximately 11,600 images of which 157 or fewer than $1\frac{1}{4}$
percent are categorized as *figurae obscaenae*.[16] Since the
selection seems to be fairly representative, there is no reason to
believe that the percentage of such *figurae* in medieval manu-
scripts as a whole would be very much different.

The *figurae obscaenae* listed and illustrated in the Randall
study fall into two not always separable categories: there is a
very small group of *figurae sexuales* (e.g., fig. 5) and a much
larger group of *figurae scatologicae*.[17] The latter images depict
creatures, human as well as animal and hybrid, partly or com-
pletely nude. In some of the images, one man or other creature
is attacking the posteriors of another with an arrow or with a
pole or spear; sometimes the motif is reversed and one creature
shows reverence for or kisses the other's hindquarters. In yet
other *figurae*, the nude or partially exposed creatures are bent
over and either defecating or breaking wind. Sometimes one
creature bares its buttocks in the presence of another in what
appears to be a crass gesture of defiance.[18] Critics have tended
either to ignore these grotesques or to dismiss them with a brief

comment on their vulgarity.[19]

The existence of these images, even though they constitute only a small fraction of the thousands of grotesques and *drôleries*, certainly requires some explanation. When art historians support the hypothesis that the marginal illustrations were intended to divert the readers of Gothic manuscripts, they are presumably not excluding the *figurae scatologicae*. It might be argued that some medieval readers were conceivably diverted and that the images which seem disgusting to some twentieth-century susceptibilities would have been regarded in the Middle Ages as little more than somewhat coarse. Even supposing this to be true, there remains the already mentioned question posed by the contexts in which the grotesque illustrations are found. The manuscripts containing the scatological items are sometimes religious and even liturgical in character. It may be granted that the people of any period, the Middle Ages not excepted, need their moments of relaxation and hilarity, but it is difficult to believe that the scatological figures were introduced *primarily* as comical and thus diverting elements in works like books of hours that were intended to encourage prayer and meditation among piously inclined laymen and clerics. It is particularly difficult to believe it of manuscripts that were created for the regular liturgical and other professional uses of the clergy--e.g., missals, breviaries, psalters, and volumes of decretals. The purpose of scatological imagery, at least in the early stages of the grotesque tradition, must have been as overtly didactic as the content of the manuscripts in which the illustrations were inserted. Naturally, when the novelty had worn off, the didactic impact was inevitably muted.

Considerable attention has been paid to the symbolic significance of other categories of grotesque images, especially animals and birds with a long history of allegorical usage; and recently it has been recognized that even when *figurae sexuales* are used by medieval artists, the intention is to exemplify moral concepts. Little if any consideration seems to have been given, however, to the specifically scatological images and their symbolic significance. It seems likely that they concretize commonplace Christian views about sin and the Devil in a long-standing religious tradition.

The extant evidence for that tradition is fragmentary, and understandably so. For most people of the post-medieval era, references to the excrementary processes are unpleasant, and except in ribald contexts (and sometimes there, too) such elements, whether literary or pictorial, have tended in the course of the centuries to undergo euphemistic change or to be suppressed altogether. During the Middle Ages, on the other hand, people were very outspoken: they called a spade a spade and did not hesitate to use the imagery of the dunghill. Indeed, much of the scatological imagery of the medieval period had its origins in the blunt language found at times in Scripture. Re-

ferences to dung as a literal cause of desecration or as a sym-
bolic representation of sin derive most probably from the numer-
ous biblical uses of the image, as in Lamentations 4.5: *qui
nutriebantur in croceis, amplexati sunt stercora* ("they who were
brought up [dressed] in purple have embraced dung").[20] This
motif is strikingly illustrated in a Gothic group scene where
gentlefolk are portrayed defecating and holding bowls of faeces
(fig. 8). Furthermore, the largest sub-category of scatological
images in the manuscripts (see note 18), that in which a man
(sometimes an ape or hybrid) exposes his posteriors while another
threatens attack with a bow and arrow (figs. 1, 9-12), was
prompted by the well-known words of Psalm 77/78.66 on the
manifestation of God's wrath: *et percussit inimicos suos in pos-
teriora, opprobrium sempiternum dedit illis* ("And he smote his
enemies in the hindquarters, and put them to eternal shame"). It
is evident that we are dealing here with ideas and practices
which were not only widely current in the Middle Ages but which
in point of fact antedated Christianity.

From the earliest times there had been a widespread be-
lief in the desecrating and debilitating effects of contact with
excrement. Desecration meant that a human being or cult ob-
ject was rendered unclean and therefore unfit, until purified, for
ordinary and above all ceremonial contacts, or that the preter-
natural powers of a deity, both as embodied in his cult objects
(such as statues and altars) and as manifested through his
priests, had been weakened or temporarily nullified. The act of
desecration was usually performed as a deliberate attack by or
on an enemy, though desecration might occur accidentally. Thus,
according to Jewish law, persons were defiled if, even without
being aware of it, they came into contact with "human unclean-
ness, whatever kind of uncleanness this may be" (Leviticus 5.3).
In one of his comedies, Aristophanes writes of a chorus instruc-
tor who forgets the dignity of his profession and "defecates on
[and therefore desecrates] Hecate's shrines."[21] In a satire by
Horace (I.viii), a statue of Priapus testifies to the truth of a
story he is telling with the asseveration: "If I am lying, let my
head be defiled by the droppings of crows and let Julius . . .
desecrate me with excrement."[22] An example of a comparable
descration in a Christian context is mentioned in the *Polychroni-
con* (IV.xxviii), where Higden tells how the Emperor Julian the
Apostate deliberately defiled a church in Antiochia by defecating
on the sacred vessels and cloths of the altar.[23] As for debilita-
tion, Roman folklore had it that stepping on dung in the dark
could destroy a man's virility (*Satyricon*, XIX).

Since excrement was believed to have the power of defiling
sacred objects and neutralizing preternatural forces, it is
not difficult to understand the development of the teachings by
Christian demonologists associating Satan and his demons with
excrement and vile odors (see fig. 13). The foul stenches of
hell were believed to be part of the punishment of those con-

fined for all eternity in the excruciating fires.[24] Furthermore,
on earth the power inherent in excrement could be directed
against Satan and his emissaries. These beliefs provide the
rationale for a bizarre method of exorcism described in a
passage in Martin Luther's table-talk, as recorded by his friends
and colleagues and published in 1566. The reformer told how, on
more than one occasion, the Devil had appeared to him but had
been driven off by scornful words and "tricks" (namely, crepita-
tion or evacuation):

> Doktor Luther sagte, wenn er des Teufels mit der heiligen
> Schrifft vnd mit ernstlichen worten, nicht hette können los
> werden, so hette er jn offt mit spitzigen worten vnd
> lecherlichen bossen vertrieben. Vnd wenn er jm sein Ge-
> wissen hette beschweren wollen, so hette er offt zu jm
> gesaget, Teufel ich hab auch in die Hosen geschissen,
> hastu es auch gerochen, vnd zu den andern meinen Sünden
> in dein Register geschrieben?[25]

> (Doctor Luther said that whenever he had been unable to
> get rid of the Devil with the aid of Sacred Scripture and
> serious words, he had often driven him away with sarcastic
> words and contemptuous tricks. And when the Devil had
> tried to burden his conscience, he had often said to him,
> "Devil, I have just defecated in my breeches. Did you
> smell it, and have you added it to those other sins of
> mine written down in your register?")

At the literal level of meaning, Luther evidently meant that his
"tricks" either neutralized the evil power of the Devil or else
expelled a demon residing temporarily in the reformer's bowels;
at the metaphorical level, the faecal evacuation connoted suc-
cessful resistance to sin through the expulsion of temptation.
This is evidently the significance of a manuscript illustration of
an ape, representing sinful man, defecating over a hybrid's head,
the horns on which identify the monster's devilish nature (fig.
14).
 Sometimes the depiction of defecation (figs. 15-20) or
exposure of the buttocks (figs. 21-22) symbolizes sin or the in-
tention of sinning--again a usage that is hardly surprising in view
of the fact that medieval preachers and moral theologians often
referred to excrement or to the evacuation of faeces as an
image for mortal sin.[26] In the *Inferno* (XVIII.106-34), Dante
tells how the sinners confined in the second bolgia of the eighth
circle, the flatterers, are punished by immersion in a malodorous
river of human excrement; among them he notices the whore
Thais, scratching herself with dung-encrusted fingernails. The
image originated, as was pointed out earlier, in Scriptural pas-
sages likening the abomination of sin to dung. In a long series
of religious works, from *The Ancren Riwle* (c.1250) to *The Pil-*

grimage of the Soul (c.1500), there are many denunciations of
sinners who "wer falle and ley defouled in the dong of synne";
and since it is human frailty that leads to mortal sin, the author
of The Vision of Philibert (c.1475) could apostrophize the
"wrecheyd fleche" of mankind with the outcry "O thou stynkynge
donge!"[27] In the morality play of Mankind (c.1465-70), the
protagonist Mankynde likewise laments his soul's association with
his flesh, "þat stynkyng dungehyll" (ll. 202-04).[28] A similar
attitude is revealed by Chaucer's Parson, who uses the image of
"ordure" several times to characterize "thilke stynkynge synne of
Lecherie" (Canterbury Tales X.839-905).[29] And the image
survived into the late Renaissance: in a comedy by Middleton and
Rowley, A Fair Quarrel (II.i.127), inchastity is referred to as
"sin's dunghill."[30]

This long-standing usage indicates the moral significance
of a Gothic manuscript's grotesque vignette showing a man bend-
ing over with his robe drawn above his waist, defecating while
presenting his buttocks to a nun who is holding up her hands in
dismay (fig. 16). Another vignette, found in a book of prayers,
is an equally explicit example of the dung-sin symbolism: on the
left, a young gentleman, with hands clasped as if in entreaty, is
defecating into a gold bowl; in the center, a servant (as go-
between) bears a large bowl toward a young lady on the right;
and she is standing, holding a bowl with one hand while reaching
out for the servant's bowl with the other (fig. 8). Both scenes
make forcefully satirical comments on lechery.[31]

The baring of the buttocks accompanied by the breaking
of wind constitutes a threat of defecation and thus seems to be
a milder form of excremental exorcism, as an act either of
desecration or of attack and hence defiance. Thus the tech-
niques used by demons in their battles with angelic virtues or
their assaults on humanity were believed to include the breaking
of wind. This idea is reflected in the morality play The Castle
of Perseverance (c.1405), where the opening stage direction re-
quires that the demon Belial shall "haue gunnepowdyr brennynge
In pypys in hys handys and in hys erys and in hys ars whanne he
gothe to batayl";[32] presumably Belial uses these fireworks in the
unsuccessful battle against Humility, Patience, and Charity in
Scene xviii (ll. 2186-2227). The same motif, with a clear im-
plication of defiance, is present in a non-marginal vignette in a
psalter: inside the initial for the text Cantate domino is a choir
led by Moses, singing the praises of the Lord; to the left of the
initial, a partially exposed demon is raising its tail and making a
raucous noise in a vain attempt to thwart the choir's harmonious
worship.[33]

Just as frequently, the gesture is used against rather than
by the powers of evil. Thus in a Hellenistic mime, a courtesan
named Charition, who has been captured by some Indians and is
about to be sacrificed to their goddess, is rescued by her
friends; one of the deliverers counteracts the evil forces of the

goddess and puts Charition's captors to flight by breaking wind repeatedly.[34] In the already cited Horatian satire, Priapus tells of observing some witches practicing their black arts and of driving the infamous creatures away with an explosive burst from his nates.[35] The same technique is used in Thomas Preston's tragedy *Cambises* (1569), with its many elements from the tradition of the medieval morality play. There the Vice Ambidexter tells of encounters he anticipates with three creatures--a snail, a butterfly, and a fly--each symbolizing mortal sin; in mentioning the butterfly, which in this context represents lechery and is said to be armed with a blue-speckled hen (the guinea hen, a cant term for a prostitute), Ambidexter boasts that he will defeat his opponent "with a fart."[36] There are reflections of the technique--this time unquestionably humorous--in Chaucer's *Canterbury Tales*: the Summoner, who complains that friars are similar to devils ("Freres and feendes been but lyte asonder"), tells how a dying man gets rid of a begging friar in this manner (III.2149-51); in the "Miller's Tale," Nicholas presents his buttocks and breaks wind in the face of Absolon in order both to humiliate and to drive off the unwelcome suitor (I.3799-808).[37] And in a German tale by Hans Sachs, "Der schmit im pachdrog" (1537), the lover of the smith's wife uses the same trick to put an unwanted wooer to flight.[38]

Non-literary evidence regarding this technique comes from a book on demons and sorcerers by Jean Wier, a noted Belgian physician and demonologist. Wier describes how Luther, according to the testimony of Melanchthon, had on one occasion been drawn into temptation by a devil and how, after an argument with the tempter, he had exorcized him by expelling wind: *Hoc dicto uictus daemon, indignabundus secumque murmurans abijt eliso crepitu non exiguo, cuius suffimen tetri odoris dies aliquot redolebat hypopcaustum*[39] ("After this had been said, the devil was driven away, filled with indignation and muttering to himself, by a loud expulsion of wind, the evil-smelling odors of which stank like a furnace for several days"). Another report, also originating with Luther, tells of a lady who, when bothered by a devil, adopted the same defensive tactic: *Sathanam crepitu ventris fugavit*[40] ("Satan was put to flight by a noisy burst of wind from the bowels"). The tradition regarding this practice suggests a possible explanation for an odd *figura* in which a naked man is holding the mouthpiece of a long trumpet to his posteriors.[41]

In some instances, the crude ritualistic gestures of exposing the buttocks and breaking or appearing to break wind, a motif found also on misericords,[42] is to be interpreted as a means of publicly manifesting defiance or contempt. The gesture, not unknown as a deliberate insult even in the twentieth century, was popular in Greek comedy in token of scorn for a despicable foe (see Aristophanes' *Peace*, l. 547; *Plutus*, l. 618; *Wasps*, l. 618).[43] The same mode of defiance accounts for the

manuscript *figurae* which show a man or hybrid bending over and
exposing his buttocks (figs. 21-22) or presenting his naked pos-
teriors to another man, who is threatening him with a drawn bow
and arrow or with some other weapon (figs. 9-12). Arrows and
spears are metaphors for God's punishment of sinners (Psalm
7.13-14; Job 6.4); and, as already noted, God is said by the
psalmist (77/78.66) to smite his enemies "in the hindquarters."[44]
Furthermore, weapons are also biblical symbols for the sinister
power by which tyrants and other evildoers force or seduce men
into the captivity of idolatry and other sins. Thus the Psalmist
cries out against those who are trying to entrap him, whose
"teeth are spears and arrows" (Psalm 56/57.5), and he appeals to
God for shelter against "evildoers, who . . . aim like arrows
their bitter words, shooting from ambush at the innocent man"
(Psalm 63/64.3-5). Hence the defiant men in the manuscript
illustrations represent either recalcitrant sinners scorning the
righteous, especially those of their critics who are using the
word of God as weapons, or else militant Christians expressing
scorn for their vicious demonic or human enemies.

It is this type of symbolism which explains the origin of
the coarse imprecations sometimes found in morality plays, as in
Mankind, where the devil Nowadays insults Mercy (because of the
latter's use of ink-horn language) with the lines

> "I haue etun a dyschfull of curdys,
> Ande I haue schetun yowr mowth full of turdys."
> Now opyn yowr sachell wyth Laten wordys.
> (ll. 131-33)[45]

It explains the coarse frivolity, again as in *Mankind*, when the
three devils Nowadays, Nought, and New Guise join in singing
what they sacrilegiously call a "Crystemes" song:

> Yt ys wretyn wyth a coll, yt ys wretyn with a cole,
> He þat schytyth wyth hys hoyll, he þat schytyth
> with hys hoyll,
> But he wyppe hys ars clen, but he wyppe hys ars clen,
> On hys breche yt xall be sen, on hys breche yt xall be
> sen. (ll. 335-42)[46]

There is comparable scatological invective in *The Castle of Per-
severance*, where the Evil Angel angrily piles scorn upon the
ineffectual activities of the Deadly Sins:

> þa þe Deuyl spede ȝou, al þe packe!
> For sorwe I morne on þe mowle,
> I carpe, I crye, I coure, I kacke,
> I frete, I fart, I fesyl fowle.
> (ll. 2405-08)[47]

Here such terms as *kacke*, 'defecate,' and *fesyl*, 'fizzle, break wind with a hiss,' are more than simply abusive: they are intended to evoke the horrors that were believed to be prepared for sinners by the devils in hell.

It might also be noted that the phenomenon of reversed values, held to characterize the demonic world, is exemplified by the often mentioned custom of revering Satan's buttocks, allegedly practiced by those in league with the Devil. Witches confessed during their trials that when the Devil appeared at their Sabbath they had to kiss his posteriors.[48] No less an authority on witchcraft than James VI of Scotland testified in 1597 to the continued existence of the practice in his country.[49] Evidence from France is provided by Guazzo, who cites a trial at Avignon in 1582 where--according to the verdict--witches and sorcerers had worshipped the Devil in the shape of a hideous black goat, had offered him lighted candles of pitch (again the *monde renversé* motif), and had shown him reverence with *osculum infame*.[50] Charges of this kind were not new: they had already been brought against the Waldensians at their heresy trials in the thirteenth century.[51] Again, when the Templars were charged with heresy and other crimes at the time of their suppression in the fourteenth century, it was alleged that each neophyte, upon admission to the Order, was required to offer the *osculum infame* in homage to his preceptor.[52] Even a leading prelate of the English Church--Walter Langton, Bishop of Coventry and Lichfield--was accused, according to a papal bull issued in 1303, of worshipping Satan in the same humiliating fashion.[53] Several manuscript *figurae* illustrate this widely credited servile practice. For instance, one picture shows a curious hybrid monster with a human head, wearing a bishop's mitre, orally saluting the buttocks of an ape carrying a bow (fig. 23); another depicts a Templar kneeling to give a similar kiss to a monster consisting of a tonsured male head perched on a rump with a pair of legs (fig. 24); a third shows a hybrid kissing the rump of an ape (fig. 25). There are yet other variations on this motif (see figs. 26-27).

The widespread belief in the existence of this alleged ceremony gives point to the not uncommon but undeniably curious medieval scurrility "Com kis myne ars," as in the Towneley mystery play of *Mactacio Abel* (l. 59). The insult recurs in the same play in the form "Yei, kys the dwills [devil's] ars behynde!" (l. 266) and "Com kys the dwill right in the ars!" (l. 287).[54] A slightly different version of the motif appears in *The Castle of Perseverance* when the Evil Angel mocks the Good Angel: "Goode syre, cum blowe myn hol behynde!" (l. 1276).[55] This ancient insult has also proved strangely long-lived, even surviving transfer to the New World.

In sum, the *figurae scatologicae* in Gothic manuscripts exemplify a well-established tradition of moralistic commentary and symbolism. The motif of defecation, long associated with

the concept of desecration, may serve as an image for sin: through sin, man defiles the sanctuary (soul) of his temple (body; cf. I Corinthians 6.19) just as faeces or other uncleanness defiles a church sanctuary. The voiding of excrement or breaking of wind in the presence of evil may also represent the rejection of sin because at one time defecation seems literally to have been a way to drive off a demon or avert evil influences. Thus the *figurae scatologicae* were not intended, at least in the early stages of their employment, to be vulgarly amusing, and they were hardly the product of "gay reverie" bent on doodling. And even where, in the later stages, they appear to be informed by a spirit of grim humor, they also contain an element of serious moralizing not always perceived from a twentieth-century perspective. As Robertson puts it when commenting on embarrassment sometimes experienced by modern critics with regard to the obscene elements in medieval art, those elements "were intended to be significant within the framework of Christian morality."[56] Their repulsiveness expressed for the medieval world the repulsiveness of thoughts and acts which were believed to constitute a serious defiance of divine law.

There is a great variety of motifs and symbolism in the category of the marginal illustrations labeled grotesque. If one takes into account the other categories--illustrations derived from religious sources like the Bible, from secular writings, and from daily life--there is an extraordinarily wide spectrum of pictorial imagery in Gothic manuscripts. This should hardly be astonishing in view of the variety of forms taken on by the strengths and weaknesses, the virtues and vices, of mankind; yet it has occasioned critical surprise. Randall has observed that "The frequent juxtaposition of unrelated themes in a totally incongruous context heightens the chaotic effect. . . . Sacred and profane elements appear side by side." She believes it to be possible that future critics will discover some rationale that is as yet unrecognized.[57] There may, however, be no need to search for such a rationale. The medieval era was one which clung to the belief that the progress of mankind--indeed, everything that happened--took place in accordance with a divinely ordained plan; at the same time, it was recognized that on the surface of things, order was constantly being disrupted, in the macrocosm as well as in the microcosm; and the macrocosmic disruptions took place at all levels of society and in all institutions. Those disruptions were such as to create the impression of impending chaos, moral as well as social. It is this appearance of chaos or near-chaos that is reflected in the strange world of the marginal illustrations in Gothic manuscripts.[58]

NOTES

[1] Émile Mâle, *The Gothic Image: Religious Art in France of the Thirteenth Century*, trans. from 3rd ed. by Dora Nussey (1913; rpt. New York: Harper, 1958), pp. 59-62. For reproductions of more than 700 marginal images from medieval manuscripts, see Lilian M. C. Randall, *Images in the Margins of Gothic Manuscripts* (Berkeley and Los Angeles: Univ. of California Press, 1966).

[2] M. W. Evans, *Medieval Drawings* (London: Paul Hamlyn, 1969), p. 27; the manuscript initial with the monster is reproduced by Evans, Pl. 42. For an exponent of the view that the imaginative marginal images are in some way thematically significant, see T. S. R. Boase, *English Art 1100-1216* (Oxford: Clarendon Press, 1953), p. 84: he is unable to accept the idea "that these intricate but whimsical designs are the mere doodling of the cloistered subconscious," and he regards them as symbols. For an enlightening example of the way in which grotesque marginal images may symbolically reflect specific happenings described in the text of the manuscript, see D. W. Robertson, Jr., *A Preface to Chaucer: Studies in Medieval Perspectives* (Princeton: Princeton Univ. Press, 1963), p. 223.

[3] For a detailed description of dragon-devil illustrations in one Gothic manuscript, a late twelfth-century Vulgate Bible, see Willard Farnham, *The Shakespearean Grotesque* (Oxford: Clarendon Press, 1971), pp. 20-23. One of these illustrations, reproduced as the frontispiece of Farnham's book, shows a man-headed dragon, crowned (to represent the Prince of Darkness?) and curled around a naked man (Everyman?) to form the initial 'V' for the word *Vir*, the opening word of the Old Testament book of Job. The illustration is most apt because the first chapter of Job includes a conversation between God and Satan in the course of which God agrees to allow the Devil to curl around Job (as it were) and to subject him to grave temptations (1.6-12). Further examples of pictorial dragon-devil imagery are reproduced in Robertson, *A Preface*, Pl. 39 (from the fourteenth-century Ormesby Psalter, a dragon to the left of the initial 'E') and Pl. 37 (from a fourteenth-century psalter, a human-headed dragon at bottom left), and in Randall, *Images*, Pl. XCIII, *figura* No. 451 (from the mid-thirteenth-century Rutland Psalter, a nude man astride a dragon, to signify the mastering of temptation).

[4] The denunciation of Gothic sculptures by St. Bernard and other medieval critics of *ars profana* is cited by Randall, *Images*, pp. 3-5.

[5] Francis Klingender, *Animals in Art and Thought to the End of the Middle Ages*, ed. Evelyn Antal and John

Harthan (Cambridge, Mass.: M.I.T. Press, 1971), pp. 315-16.

[6]H. W. Janson, *Apes and Ape-Lore in the Middle Ages and the Renaissance* (London: Warburg Institute, 1952), p. 163.

[7]Randall, *Images*, pp. 18-19.

[8]Janson, *Apes*, pp. 166-68. The *figurae* include, of course, many other animals as well as birds and insects with symbolic attributes.

[9]John of Salisbury, *Polycraticus*, in *Patrologia Latina*, 109 (Paris, 1855), cols. 402-03; English trans. in J. B. Pike, *Frivolities of Courtiers and Footprints of Philosophers* (Minneapolis: Univ. of Minnesota Press, 1971), pp. 31-33. For manuscript examples of such symbolism, see Randall, *Images*, Pl. XIII, *figurae* Nos. 54 (harp) and 56 (bagpipe).

[10]See Randall, *Images*, p. 107: a hare carrying a bound man over its shoulder (7 examples).

[11]The motif of the hare as hunter, carrying a nude man hanging by the feet from a pole across its shoulder, appears prominently near the bottom of the Hell panel in Hieronymus Bosch's symbolic triptych *The Garden of Terrestrial Delights* (c.1510-16).

[12]Beryl Rowland, *Blind Beasts* (Kent, Ohio: Kent State Univ. Press, 1971), pp. 87-102, has a detailed discussion of the symbolism of the hare in the Middle Ages.

[13]Among the 327 manuscripts which formed the basis for the Randall study, *Images*, pp. 12-13, the largest categories were as follows: psalters, 76; books of hours, 43; breviaries, 22; bibles, 19; romances, 18; missals, 6. Randall comments (p. 14): "The high proportion of private devotional books containing imaginative marginal embellishments . . . leaves no doubt as to the receptivity of the users toward diversion during the lengthy services, 'alorsque l'attention est fatiguée et que les paupières s'alourdissent'." Any reasoning based on the desirability of "diversion" can hardly apply, however, to such works as priests' breviaries, the missals used to say Mass, or official volumes of decretals.

[14]Among the alleged ceremonies and practices were the worship of Satan--sometimes in human and sometimes in animal form--with the notorious *osculum infame* (see below, notes 51 and 53), the use of the holy name in reverse (*dog*), the veneration of obscene objects, and the singing of lascivious songs. Authors such as Martin de Castanega (1529), cited by Richard Cavendish in *The Powers of Evil* (New York: Putnam's, 1975), p. 216, portrayed witchcraft "as an exact inversion of Catholicism"

[15]The number of *figurae obscaenae* catalogued by Randall, *Images*, pp. 192-94, totals (if cross-references are included) about 157.

[16]Randall, *Images*, pp. 27-40 (identification of the 327 manuscripts), 45-235 (index of image-subjects).

[17]The 23 *figurae* with a sexual emphasis derive as follows: from romances, 12; psalters, 5; hours, 4; sundry, 2. The 134 scatological *figurae* are distributed thus: psalters, 43; romances, 37; hours, 35; breviaries, 6; sundry (secular MSS.), 4; missals, 3; Decretals of Gratian, 3; sundry (religious MSS.), 3.

[18]Of the 134 *figurae scatologicae* catalogued by Randall, *Images*, pp. 192-94, more than 120 involve exposure of the posteriors. The most frequently occurring sub-categories are as follows: simple exposure, 29; defecation, 26; beak aimed at hindquarters, 23; arrow similarly aimed, 22; revering of posteriors, 9; pole aimed at hindquarters, 6; spear similarly aimed, 5; giving an enema, 4.

[19]Cf. Margaret Rickert, *Painting in Britain: The Middle Ages* (Baltimore: Penguin, 1954), pp. 148-49: in the Luttrell Psalter, the scale of some scenes "and also of the monstrous, often hideous and vulgar grotesques is disproportionately large in relation to the borders . . . [and] too often even a reasonably good initial and border is spoiled by a repulsive grotesque."

[20]See also IV Kings 9.37, Job 20.7, Psalm 82/83.10-11, Isaiah 36.12, Jeremiah 8.2, 9.22, 25.33, and Zephaniah 1.17. Of course, rhetorical habits change over the centuries, and imagery of the *stercus* and *sterquilinium* is much more common in the Old Testament than it is in the New.

[21]Aristophanes, *The Frogs*, ed. and trans. Benjamin B. Rogers, Loeb Classical Library (London: Heineman, 1927), II, 330-31.

[22]Q. *Horati Flacci Opera*, ed. Edward C. Wickham and H. W. Garrod, 2nd ed. (Oxford: Clarendon Press, 1912), *Sermonum* I.viii.37-39: "mentior at si, merdis caput inquiner albis/ corvorum, atque in me veniat mictum atque cacatum/ Iulius et fragilis Pediatia furque Voranus."

[23]*Polychronicon Ranulphi Higden*, trans. John Trevisa, ed. Joseph R. Lumby (London: Longman, 1874), V.171: "[he] gadred to giders þe holy vessel and towaylls of þe auter, and defouled hem wiþ the filþe of his ers."

[24]That the stench of defecation or crepitation could be used as an image for one of the punishments inflicted on the damned in hell is commented on by D. and H. Kraus in *The Hidden World of Misericords* (New York: Braziller, 1975), p. 107, in their description of a fifteenth-century French misericord: the grim wooden carving "presents a man with his nose up against the front of the [choir] stall seat, in pointed juxtaposition to the lower part of the sitter's body [*sc.* buttocks]. Photography gives us the proper meaning, however, when we study the man's face in the right-side-up position. Noting the look of terror in his eyes, one realizes

that this was meant to be no laughing matter but rather one
of the diabolic punishments, often seen in other church art,
that sinning man could look forward to in his eternity in
Hell."

[25] *Tischreden oder Colloquia Doctoris Martin Luthers*
(Eisleben, 1566), p. 290.

[26] For a Renaissance example of this image, see Andrea
Alciati, *Emblemata cvm Commentariis* (Padua, 1621), No.
LXXX, p. 353, where the motif *Aduersus naturam peccantes*
(sinners against nature) is illustrated by the picture of a
man defecating.

[27] Cited from the *Middle English Dictionary*, ed. Hans
Kurath and Sherman M. Kuhn (Ann Arbor: Univ. of Michi-
gan Press, 1959-), II, 1237.

[28] *The Macro Plays*, ed. Mark Eccles, EETS, s.s. 1
(1969), p. 160.

[29] *The Works of Geoffrey Chaucer*, ed. F. N. Robin-
son, 2nd ed. (Boston: Houghton Mifflin, 1957), pp. 255-58.

[30] *The Works of Thomas Middleton*, ed. A. H. Bullen
(London: John C. Nimmo, 1885), IV, 188. The dung-sin
symbolism survives even in contemporary literature: see
Juan Goytisolo's novel *Juan Sin Tierra* (1975), trans. Helen
R. Lane as *Juan the Landless* (New York: Viking Press,
1977), pp. 177-88.

[31] The same may be said of a *figura* in which a man
holding two pots is defecating into one and urinating into
the other (Randall, Pl. CX, No. 532) this image may have
been intended as a reminder of the biological fact summed up
in the grim aphorism attributed to St. Augustine: *inter
faeces et urinam nascimur* ("we are born between [the places
of] defecation and urination").

[32] *Macro Plays*, ed. Eccles, p. 1.

[33] For a reproduction of this *figura*, see Robertson, *A
Preface to Chaucer*, Pl. 37.

[34] Anonymus Oxyrhynchites, *Chariton*, in *Herondae
Mimiambi*, ed. Otto Crusius (Leipzig: Teubner, 1914), pp.
101-09.

[35] *Opera*, ed. Wickham and Garrod, *Serm.* I.viii.46-47:
"nam displosa sonat quantum vesica pepedi/ diffissa nate
ficus: at illae currere in urbem."

[36] *Chief Pre-Shakespearean Dramas*, ed. Joseph Q.
Adams (Boston: Houghton Mifflin, 1924), p. 643. For a
discussion of the *significatio* of the images used by Ambi-
dexter, see my paper "The Allegorical Role of the Vice in
Preston's *Cambises*," *Modern Language Studies*, 11 (1981),
54-69.

[37] *Works*, ed. Robinson, pp. 98, 54. Cf. Roy Peter
Clark's suggestion, in "Squeamishness and Exorcism in
Chaucer's *Miller's Tale*," *Thoth*, 14 (1973-74), 37-43, that
Absolon plays a "symbolic role as squeamish devil," and that

Nicholas breaks wind "to purge himself and Alisoun of their squeamish intruder." There are, of course, additional implications to Chaucer's use of the motif in the context of his tale. Thus in "Absolon, Taste, and Odor in *The Miller's Tale*," *Papers on Language and Literature*, 7 (1977), 72-75, Thomas J. Hatton observes that since in Chaucer's day the sin of adultery was often symbolized by foul odors, Nicholas' contemptuous act is a reminder that Absolon's desires are adulterous. And in "Art and Scatology in the *Miller's Tale*," *Chaucer Review*, 12 (1977), 90-102, Peter G. Beidler points out that after Absolon's senses of taste and touch have been offended by his imprinting of a kiss on what he realizes to be Alisoun's buttocks, the pattern is completed when his remaining senses--of smell, sound ("a thonderdent"), and sight ("he was almost yblent")--are violated by Nicholas' fart. Beidler also suggests that the violation of Absolon's senses prefigures the punishment of all five senses which the sensual sinner was taught to expect to suffer in hell; see the "Parson's Tale," X.207-10.

[38] *Sources and Analogues of Chaucer's Canterbury Tales*, ed. W. F. Bryan and Germaine Dempster (Chicago: Univ. of Chicago Press, 1941), pp. 120-22, line 44: "Der pfaff recht naus sein ars und den schmidknecht anplies." It is unlikely that Sachs was influenced by Chaucer's tale.

[39] Ioannes Wierus, *De Praestigiis Daemonvm, et Incantationibus ac Ueneficiis* (Basel, 1568), I.xvi (p. 93). The copy cited is in the Library of the University of Marburg, West Germany.

[40] Gustave Brunet, *Martin Luther: Les Propos de Table* (Paris: Garnier, 1844), p. 22.

[41] Randall, *Images*, Pl. CXIII, *figura* No. 543. Another *figura*, ibid., Pl. CXII, No. 542, shows two apes with a long trumpet; one is blowing into the instrument, the front of which is pressed against the hindquarters of the other. It seems literally to represent the forced introduction of wind into the body, and may imply criticism of windy rhetoric or unorthodox preaching. Cf. Jonathan Swift's diatribe against the preaching of the satirically named Aeolists in *A Tale of a Tub* (Sec. VIII): in honor of their founder's memory, the Aeolists store in each of their temples a barrel filled with wind, and "into this barrel, upon solemn days, the priest enters, where . . . a secret funnel is also conveyed from his posteriors to the bottom of the barrell. . . . Whereupon you behold him swell immediately to the shape and size of his vessel. In this posture . . . the sacred Aeolist delivers his oracular belches to his panting disciples."

[42] See Kraus, *Hidden World*, fig. 78, for the reproduction of a sixteenth-century French misericord ("Rear Exposure") in the Cathedral of St. Tugdual, Tréguier.

[43] In all three instances, Aristophanes uses the com-

pound *kataperdomai* (*perdomai*, 'to break wind'; *kata*,
'down'). Professor A. P. MacGregory (University of Illinois
at Chicago Circle), in a private communication, suggests
that the compound is loosely comparable to the expression 'to
shout down.'

44The Hebrew word *āhōr* can mean either 'hind-
quarters' or 'backwards,' and it is sometimes translated as
"into retreat" (or something similar). The Vulgate text,
however, has *in posteriora*, the King James version reads
"in the hinder parts," and the *Anchor Bible: Psalms II*,
trans. with notes by Mitchell Dahood (Garden City, N.Y.:
Doubleday, 1968), reads "on the rear." Dahood draws at-
tention, p. 247, to the Psalmist's fondness for *double en-
tendres* and argues that *āhōr* means 'rear' both anatomically,
alluding to the posterial boils with which the Lord afflicted
the Philistines (I Kings/I Samuel 5.9), and, in a military
sense, with reference to the rearguard of their army.

45*Macro Plays*, ed. Eccles, p. 158.

46Ibid., p. 165. In the original text, each of the
four lines is repeated.

47Ibid., p. 74.

48See Francesco Guazzo, *Compendium Maleficarum*
(1608), trans. E. A. Ashwin, ed. Montague Summers (Lon-
don: John Rodker, 1929; rpt. 1970), I.xii, citing on p. 35
Nicolas Remy's *Daemonolatreia* (1595) and on p. 47 Florimond
de Raymond's *L'Antéchrist* (1597).

49King James the First, *Daemonologie*, ed. G. B.
Harrison (New York: Barnes and Noble, 1922; rpt. 1966),
p. 37. Appended to this edition is a reprint of the anony-
mous *Newes from Scotland* (1591), according to which, p.
14, during the Scottish witchcraft trials of 1591, "*Agnis
Thompson* confessed that the Diuell being . . . in the habit
or likenes of a man, and seeing that they tarried ouer long,
he at their comming enioyned them all to a pennance, which
was, that they should kisse his Buttockes, in signe of
duetye to him."

50Guazzo, *Compendium*, II.xv (pp. 135-36).

51*Reliquiae Antiquae*, ed. Thomas Wright and James O.
Halliwell (London: John Russell Smith, 1845), I, 248: "in
aliquibus aliis partibus apparet eis daemon sub specie et
figura cati, quem sub cauda sigillatim osculantur."

52Gershon Legman, *The Guilt of the Templars* (New
York: Basic Books, 1966), p. 34 *et passim*.

53Thomas Rymer, *Foedera, Conventiones, Literae, et
. . . Acta Publica*, 3rd ed. (The Hague, 1739), I, Pt. iv,
p. 28: "W[alter] Conventrensis et Lichfeldensis Episcopus,
erat in Regno Angliae et alibi publice defamatus, quod Dia-
bolo homagium fecerat, et eum fuerat osculatus in tergo,
eique locutus multotiens."

54See *The Wakefield Pageants in the Towneley Cycle*,

ed. A. C. Cawley (1958; rpt. Manchester: Manchester Univ. Press, 1963), pp. 2, 7-8.

[55]*Macro Plays*, ed. Eccles, p. 40.

[56]Robertson, *Preface*, p. 21.

[57]Randall, *Images*, p. 19.

[58]The illustrations accompanying this article have been reproduced by kind permission of the Bibliothèque Municipale, Cambrai; the Bibliothèque Nationale, Paris; the Bibliothèque Royale Albert Ier, Brussels; the Bodleian Library, Oxford; the British Library, London; the Koninklijke Bibliotheek, The Hague; the Pierpont Morgan Library, New York; the Master and Fellows of Trinity College, Cambridge; and the Walters Art Gallery, Baltimore.

THE WORD IN RELIGIOUS ART
OF THE MIDDLE AGES AND THE RENAISSANCE

Roger Ellis

Next to the halo, the *word*, with its attendant symbols of book and pen, is arguably the commonest iconographic feature of religious art.[1] Not surprisingly, it has fared scarcely better than the halo at the hands of the art critic, whose need to stress the purely visual meanings of a work leads him most often to treat the word in art only as a decorative element.[2] More surprising, however, is its general neglect by students of iconography: the *word* focuses, most sharply of all, the tension in all systems of iconography between a work of art's intrinsic and extrinsic meanings. This paper, therefore, aims to consider the ways in which word interacts with image in the religious art of the Middle Ages and the Renaissance. It will also refer to parallels in medieval religious literature, especially the lyric and the vernacular cycle plays.[3]

The artist prints words on a religious painting for a variety of purposes, all presupposed if not equally realized. He intends (1) to symbolize the source of authority and inspiration, and (2) to facilitate interpretation by the creation of a label. These purposes bring us into the realm where words operate as sacred signs, whose power only the initiate can articulate but all must acknowledge. That is, the word is treated as a visual symbol, identical in formal terms with all the other visual symbols of which the artist has composed his work. At the same time, it is not operating on the same level as they are, for it is serving to explain and justify them. In principle, these two levels of meaning, the verbal and the visual, ought to complement and complete one another. In practice, they are inevitably in a state of tension with one another, as also is observable when the artist uses both realistic and symbolic details in his work (e.g., the Vézelay *Mystic Mill*) or brings together figures from widely separated times (e.g., van der Weyden's *Pietà*, in the National Gallery, London). The tension between verbal and visual meanings in the work thus reflects the tension, central to every religious position, between the world of sense-experience and that of understanding and belief. All these features also characterize the English cycle plays. Their version of the intrusive sacred sign, the source of both authority and inspiration, comes in the shape of untranslated liturgical texts, especially when they are to be sung (e.g., in the N-town *Noah*). They

21

provide for an intrusive interpreter as effectively as any label in
a painting could do (e.g., the Chester Expositor, or N-town Con-
templacio). They are as ready to mix realism and symbol as the
Vézelay *Mill*, most notably when they bring allegorical and his-
torical figures on stage at the same time (e.g., the N-town
Death of Herod, Purification of Mary). Their determination to
demonstrate the continuity, in their own time, of the original
drama of salvation leads them to practices the equal of anything
observable in the van der Weyden *Pietà*--i.e., what Kolve called
"medieval time and English place."[4]

But the *word* exists not only, not even primarily, as the
symbol of a superior principle. It exists to dramatize the in-
carnation of that principle in the processes of the world--
processes which the artist's chosen form prevents him from re-
presenting directly but upon which he is totally dependent. This
purpose makes the word a sign not of some abstract meaning,
but of its concrete realization in speech. The word, therefore,
inhabits another order of existence than the purely visual, and
the viewer who reads it brings to life the scene where it occurs
as almost nothing else could do. The attempt to symbolize a
total experience by this means parallels the use of successive
episodes of a narrative within the frame of the work so as ac-
tually to embody in it the processes of time on which any single
episode depends (e.g., the panel of the Betrayal in Duccio's
Maestà, in the Cathedral Museum, Siena). The purely visual
elements of the work are thus in a state of tension with the
verbal in that they require the spoken word in order to gain
their full measure of existence.

Literature also provides clear parallels with this use of the
word in a religious painting. The viewer who reads the words of
one will also read the words of the other, and to the same end--
prayer. Thus the religious lyric exists either as a prayer to be
uttered by the viewer--one of the best examples of this, "Jesu,
that hast me dere iboght," comes with an explicit directive to
the reader to this end[5]--or as narrative interspersed with, or
issuing in prayer.[6] The latter occurs in the cycle plays only in
the explicit benedictions of our representative, the chorus. But
the playwright has a still more exciting way of symbolizing a
total experience. Normally, he has to dramatize actions oc-
curring at the same time but in different places in an artificial
sequence according to the conventions of the subplot (that, too,
is how we have to "read" the Duccio panel of the *Betrayal*).
But, particularly when he chose to stage his plays by what Stan-
ley Kahrl has called the "place-and-scaffold" method,[7] he could
assign these separate actions to different parts of the acting
area and present them simultaneously so as literally to dramatize
a total and simultaneous experience. (Whether he ever did so
and to what extent are further questions, though Neville Denny
has argued strongly for the practice in Cornish drama.[8])

Of course, we have to deal not only with purposes but

also with presentation. The latter requires a further distinc-
tion--i.e., between overt and covert symbolism. The former
occurs when the artist prints his words directly on the surface
of the work; the latter when he uses a surface *in* the work to
carry them. The word as covert symbol inhabits an alternative
reality to that of the other signs in the painting and demands to
be read as the primary sign. By contrast, the word as covert
symbol is subordinated to the physical properties of the repre-
sented surface on which it appears, and it functions only as a
secondary sign: the primary sign--the source of significance--
remains the represented material universe. These different pre-
sentations of the word thus parallel the artist's different pur-
poses: the word points us both away from and towards the
heart of the visible universe. For all that, presentation sub-
serves purpose, for *purpose* is arguably the principal determinant
of the religious work. Of no works can it be said with less
justice than religious that purposes are nothing in art except as
realized.[9]

As good a work as any to give body to these generaliza-
tions is the *Annunciation* of Simone Martini, in the Uffizi (text
fig. a).[10] Simone has printed the angelic greeting--"Ave gratia
plena; dominus tecum"--directly onto the painting in the space
between the two protagonists so that the eye is drawn from the
lesser to the greater figure, left to right, as we read (fig. 28).
He has also printed words onto the golden band or stole which
passes about the angel's right shoulder and under his right arm
and whose ends reach to the floor on either side of him where
they twist and double on themselves. As well as being easier to
miss--and reproductions generally fail to show them--these words
are also more difficult to decipher. Simone's decision to print
them on a surface *in* the represented visible world of the
painting has led him to fragment them at those places where the
stole is concealed by the angel's right arm and his cloak. As a
result, we are confronted with three major and two minor pieces
of text. Our first instinct is to complete each fragment. Start-
ing with the largest at the bottom left of the stole, we get the
phrase "Spiritus sanctus superveniet in te et virtus alt," at which
point the text fragments. Our knowledge of the Gospel narrative
supplies the rest of the phrase: "altissimi obumbrabit tibi" (Luke
1.35). Like the *Ave*, the message is part of the angelic dis-
course at the Annunciation. Other fragments on the stole are to
be similarly interpreted. "Ne . . . meas I" becomes "Ne timea
Maria"; "ecce concipies in" requires the addition of "utero, et
paries filium" (Luke 1.30-31); the letters "eiu" and "en" perhaps
form part of the phrase "vocabis nomen eius Jesum" (v. 31).[11]
This naturalistic fiction permits the conclusion that we have a
whole text on the stole, such that if we spread it out flat and
read, left to right, from one end to the other, we should get a
whole and continuous message. This does not happen. The order
of the major fragments in the Gospel narrative is "ne timeas,"

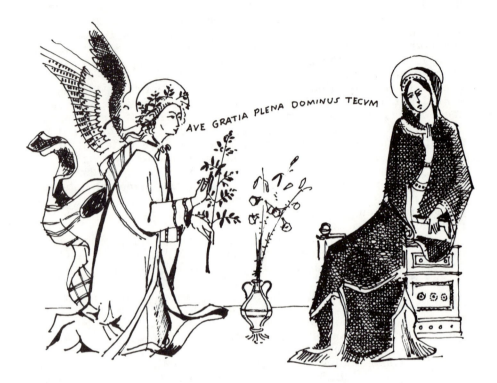

Text fig. a: Martini, Annunciation. Drawing from the original in the Galleria degli Uffizi, Florence. (See detail, fig. 28.)

"ecce concipies," and "spiritus sanctus." That is, Simone has not followed the logic of his fiction all the way, and we have to read the words not as a continuous message from left to right on the stole but from top to bottom, almost as separate lines of print on a page. We see, therefore, that the painting presents its words as overt symbols (the *Ave*) and as rather more covert symbols (*ne timeas*): to be sure, the latter's insistence on be-ing read, as it were, across the grain of the painting shows Si-mone even there unwilling altogether to abandon overt symbolism.

To see how typical this approach is of religious art, we might usefully contrast it with the frescoes of the life of St. James in the Eremitani Chapel, Padua, by Mantegna.[12] A backdrop of classical arches frames the different episodes of the saint's life. Two of them carry carved inscriptions, copied from classical remains. One reads: "L. Vitruvius Cerdo architectus"; the other is largely obscured by bystanders.[13] Like the words on Simone's stole, the words on these arches are presented as prop-

erties of the physical universe. But we readily perceive a vital
difference between the thoroughgoing naturalism of Mantegna's
words and the covert symbolism of Simone's. Mantegna's are
"written" words. As such, they refer us to a time before that
of the painting's subject--the time when they were carved in
stone. By contrast, Simone's words occur simultaneously with the
subject of the painting. The distinction is reinforced in this
instance by Mantegna's use of secular Latin (as contrasted to
Simone's use of ecclesiastical Latin) texts. Mantegna, then, uses
his words merely as one of the many signs in his work of the
pagan world which the faith of the martyr must oppose.
Simone's words come at the reader with the immediacy of speech
and need to be seen as the artist's attempt to bring his charac-
ters directly alive to the reader.

This important distinction between the spoken and the
written word will bear repeating. Consider, for example, the
different uses made of the *Magnificat* in the Visitation window
of Freiburg Cathedral and in Botticelli's *Madonna of the Magni-
ficat*, in the Uffizi (fig. 29).[14] In the Freiburg window the
words belong to the same time frame as the accompanying nar-
rative. By contrast, Botticelli has the Virgin, with the Christ
Child in her lap, writing down the words of the *Magnificat* as a
tangible way of storing them in her heart. We are to read these
words as the record of what was earlier spoken: when they
were spoken, they prophetically anticipated the realized event,
the Incarnation, which is the painting's formal subject. For the
artist of the Freiburg window, by contrast, the words themselves
constitute the realization of an event. Except, therefore, where
the artist presents his words as a written record in the process
of being written or read, we must read the words in religious
art as being spoken.

And even then, a written rather than a spoken word may
point us not toward naturalism but toward symbolisms of a most
obvious and thoroughgoing kind. Consider, for example, the il-
lumination of St. Matthew writing his Gospel in an eighth-century
manuscript, now Cod. 1224 in the Austrian National Library,
Vienna (fig. 31). Like Botticelli's Madonna, the Evangelist has
left his text, the opening words of his Gospel ("liber generationis
Iesu Cristi, filii David, filii Abraham"), unfinished; he has stopped
half-way down the right-hand page and has laid down his pen, as
if pausing for thought. We cannot interpret this text as sym-
bolic of the saint's speaking voice. At the same time, its status
as a written record is not that of Botticelli's words. Botticelli
has presented his text with due regard to scale and proportion.
The painter of the St. Matthew has not: he has given two whole
pages of text over to a single verse. Where, then, Botticelli
presents his words in the first instance as accessible to the scru-
tiny of characters in the painting and makes them available only
secondarily to the audience *of* the painting, it is that very audi-
ence at whom the artist of the St. Matthew is primarily direct-

ing his words. Any appearance of naturalism in the latter work
is therefore only a cover for the expression of a very thorough-
going symbolism. The words symbolize (or name) the saint for
us, as his keys do St. Peter or her alabaster pot the Magdalen.

Labeling, therefore, constitutes an important secondary
function of words in religious art. The simplest kind of label
names a character, a scene, or an action. Thus the twelfth-
century enamel of the curing of Naman the leper by Godefroid
de Hoy in the Victoria and Albert Museum, London, identifies the
bystanders, the place, and the subject of the work by way of the
words "famuli," "Jordanem," and "curatio Namam."[15] Slightly
more complex is one of the labels in Lorenzetti's painting of the
Presentation, in the Uffizi. Where, in his painting of the in-
cident, Giovanni del Biondo gives the prophetess Anna a simple
naming scroll with "Anna profetissa filia Phanuel," Lorenzetti
enters on her scroll that portion of the narrative in which she
figures (Luke 2.38).[16] Such labels are seldom otiose. A man
falling off his horse and identified by a label as Pharaoh--in the
glass of the north transept at Chartres, for example--elicits a
different response from a similar figure identified as St. Paul--
in, for example, Fouquet's illumination for the Hours of Etienne
Chevalier, now in the Condé Museum, Chantilly, where Christ's
words provide the label: "Saule, Saule, quid me persequeris?"
(Acts 9.4). The one warns how pride will have a fall, a theme
also represented pictorially at Chartres in the Psychomachia
sculptures of the south porch; the other draws our mind to
grateful recognition of the mercies of God.[17]

We see, therefore, as was earlier claimed, that the word
serves two main purposes in religious art: the interpretation
and, as well, the animation of the subject. We ought not,
though, to distinguish too sharply between these two purposes.
The text of the Ave exists primarily to provide a speaking part
for a character but also, on a lesser level, to serve as a label
for an event; the simplest label exists on some level as a word
uttered directly by the artist to the audience. The two func-
tions are unintelligible in isolation from one another and from
the larger purpose to which, as we saw, the cycle plays also
addressed themselves--that of creating a living moment for the
viewer to participate in and to interpret in the light of his
faith. As its overriding function, the religious work of art
therefore presupposes an address to and a response by the
viewer.[18] That address can be (1) indirect, when characters in
the painting are addressing one another, as in a play, in apparent
unconsciousness of the viewer's presence, or (2) direct, when the
author uses the label, in the manner of a chorus. Direct address
also occurs when a character turns out of the painting to face
the viewer, in the manner of a soliloquy or aside.[19] Direct
address to the viewer leads us away from simpler use of words
(expressions of expository and narrative functions) and into the
realms of debate and apologetics--a world where words once

spoken as part of a historical drama may now appeal directly to
us. We even find that we are given words with which to reply.

An excellent example of address to the audience occurs in
the copy of Ghirlandaio's fresco of the Last Supper in the re-
fectory of St. Mark's, Florence (fig. 30). There we find Christ
surrounded by his disciples and addressing them with words from
the Maundy discourse (the text runs along the wall at his back):
"Ego dispono vobis, sicut disposuit mihi pater meus regnum, ut
edatis et bibatis super mensam meam in regno meo" (cf. Luke
22.29-30).[20] These words belong in the first instance to the
assembled disciples in the painting, but the absence of any speci-
fic reference to them (such as would be provided, for instance,
by proper names) permits and requires every person who enters
the refectory to see the words as addressed to himself. (Such
also happens in the English cycle plays when words addressed in
the first instance to a stage audience can be appropriated with-
out difficulty to the actual audience of the play--e.g., the
speeches of Christ to the doctors in the N-town *Christ among
the Doctors*). Other words raise a doubt not about the audience
addressed but about the speaker. In Claus Sluter's *Well of
Moses*, in the Chartreuse of Champmol, Dijon, for instance, we
have a carving of Jeremiah with a scroll containing words from
Lamentations 1.12: "O vos omnes qui transitis per viam, videte
si est dolor sicut dolor meus." In the first instance, these words
are Jeremiah's. But from earliest times, they were appropriated
to the crucified Christ, whose sufferings they were held to pre-
figure--hence their use in the Good Friday liturgy. Now, Sluter's
carving was originally topped by a representation of the Cruci-
fixion. We must surely conclude, therefore, that as the eye
passes from Jeremiah to the crucified Christ we hear the speech
uttered twice: once, in time, by the prophet; once, out of
time--or in liturgical time--by Christ himself.[21]

The word directly addressed to the viewer is thus increas-
ingly detached from its immediate historical context and applied,
with the force and immediacy of a revelation, to the viewer's
own time. Consider, for example, the St. Mark of the early
ninth-century Aachen Palace School Gospel Book, now British
Library MS. Harley 2788 (fig. 32). Here we find the saint in the
process of writing a text into an open book and pausing to dip
his pen in the ink. The text is Mark 13.35-36: "Vigilate ergo
(nescitis enim quando dominus domus veniat: sero, an media
nocte, an galli cantu, an mane), ne, cum venerit repente, in-
veniat vos dormientes." This text is not functioning as a simple
label. (Above the saint's head we have the opening words of his
Gospel used for that purpose, on a scroll which his lion is dis-
playing.) Neither is it functioning as a simple speech. Rather,
it functions as an appeal to the viewer to prepare himself for
Christ's second coming. The sense of a direct appeal, off the
page and straight at the reader, is reinforced by the artist's
determination to get the whole text on, regardless of the cost to

any naturalism in the painting: having left himself insufficient space on the Evangelist's book for the last two words of his text, the artist carried straight on from the bottom line of the book into the painting and copied the missing words directly onto the surface.

The role of direct address to an audience, then, operates when one or more of the following conditions is met: a text addressed to an unspecified audience; a text that argues a case; a character who faces out of the painting toward the viewer. (The parallels with the cycle plays are too obvious to require comment.) So addressed, the audience is sometimes given words with which to answer. A fine example is at hand in the An-gelico *Annunciation* in St. Mark's, Florence. Angelico addresses us directly in his own person and urges us not to pass by without uttering afresh the greeting first spoken by the angel: "Virginis intacte cum veneris ante figuram pretereundo cave ne sileatur Ave" ("When you come before a representation of the immaculate Virgin, take care that in your departure *Ave* is not silent on your lips"). As if taking his own message to heart, he has painted a prayer above these words: "Salve mater pietatis et totius Trinitatis nobile triclinium" ("Hail, mother of mercy; noble couch of the whole Trinity"). On our behalf he has demonstrated the only possible response to his work, that of prayer.[22]

The presence of more than one speech in a work raises the question of how we are to connect them. We see from the Angelico and Martini *Annunciations* that speeches relate in the main--and in the manner of the cycle plays--in one of two ways: as expressions of a choric function, and as contributions to a debate.

We see choric speech most easily in paintings which divide a single speech among several speakers, usually angels. Thus Jaime Ferrer's painting of the Annunciation, in the Diocesan Muse-um, Vich, which gives Gabriel an abbreviated version of his greeting on a twisting scroll ("Ave Maria gracia plena dom[inus] te[cum]"), also provides us, above, with two sets of angels to left and right of the Father, each with a scroll in his hand. These scrolls together make up the opening phrases of the *Gloria* from the ordinary of the Mass.[23] This text is beautifully appropriate to the subject of the painting. Its opening words come from the angelic salutation on the first Christmas morning (Luke 2.10), and the whole passage reminds the reader of the mystical birth of Christ in the eucharistic celebration. The ac-tual division of the speech into parts, for which the drama can furnish exact parallels, symbolizes the way in which the devout speak in their liturgy with one voice.[24]

The second pattern occurs whenever the angel's speech to Mary at the Annunciation is followed by her answer. We have a charming example of this in the Psalter of Henry of Saxony (now British Library MS. Lansdowne 381; fig. 33). The angel and Mary each hold one end of a V-shaped scroll; the angel's words

("Ave Maria gratia plena") appear on that arm of the scroll nearest to him, and Mary's reply ("Ecce ancilla Domini") is on that part nearest to her.[25] (Use of the single scroll for both speeches suggests that what we hear as question and answer is, in another sense, an undivided word.) But question and answer need not connect so easily. Consider Bergognone's *Crucifixion*, in the Certosa, Pavia.[26] We pray to the Virgin for mercy in the words of a text embroidered on the hem of her robe: "Maria Virgo, Maria dei genitrix, salutem posce miseris. Amen" ("O Virgin Mary, Mary mother of God, seek salvation for us wretches, amen"). God/the author provides a riddling answer, embroidered on the hem of the Magdalen's robe, where it serves the secondary function of labeling the saint for us: "Maria optimam partem elegit que non aufere[tur] ab ea" (Luke 10.42). Now, the "best part" of Mary, as expressed in this painting, is her identification with the cross and with the sorrowing mother. The "best part" of the wretched Christian--that mercy which he so urgently asks for--is, therefore, hardly to be found elsewhere than in that same identification with suffering from which he is seeking release.

A final and very common instance of this pattern is that of prophecy realized. A ready example is at hand in Lorenzetti's painting of the Presentation, earlier noted. Two figures occur above the depiction of the scene. One, Moses, carries a scroll with words from Leviticus 5 describing the obligation of the poor man to make an offering of two doves; the other, Malachi, has a text (Malachi 3.1) describing how the Lord and the angel of the covenant will suddenly enter his temple. We see a clear connection between these texts and the action below. Joseph, the poor man, has brought his thank-offering in fulfillment of his obligation to the Mosaic law: Christ, the Lord, the greater offering, has entered his temple in fulfillment of the promise made to Malachi. Old and New Testaments have been brought into that same living relation of which the Bible itself makes so much.

Our study of words in religious art has thus taken us from those words spoken by characters in the painting to those spoken by the artist and his audience; from the simpler expressions of narrative function to more complex expressions of apologetic intent; and from the single speech to a number of speeches. We need finally to put the words back into their total artistic context--that is, to consider them as visual symbols. In this connection we need first to establish how they are painted--i.e., what scripts are used for them--and then to return to our distinction between overt and covert symbolism.

The first point needs little comment here since it has already received the expert attention of Dario Covi. Liturgical script seems to have been most widely favored. Its use brings the painting into immediate visual relation with its literary sources. Covi also shows how at the end of the Middle Ages,

when a greater range of scripts became available to him, the art-
ist could achieve particular effects by setting different scripts
against one another. Color could also be used symbolically. In
van der Weyden's *Last Judgment*, in Beaune, for example,
Christ's words to saved and damned are written, respectively, in
white and black.[27] Similarly, in the frescoes devoted to
episodes of the Passion in cells 36-37 of St. Mark's, Florence,
Angelico painted Christ's words concerning his executioners ("Pa-
ter dimicte illis quia nesciunt," cf. Luke 23.34) in black (cell
36); while in the neighboring cell (37) his words to the repentant
thief appear in white ("Hodie mecum eris in Paradiso," Luke
23.43).[28]

If we turn now to words painted directly onto the surface
of the work (words as overt symbols), we see that they are used
quite simply to define a physical space and to suggest patterns
of spatial relationship. The simplest use of such words is the
line. As in Simone's painting, this line may connect characters
so as to represent the speech that passes from one to the other.
Alternatively, the line can be used as part of a general pat-
terning, as in Fouquet's painting of St. Hilary in the Hours of
Etienne Chevalier.[29] Because no seat has been found for him at
the council convened by Pope Leo, St. Hilary has put himself on
the floor in the midst of the assembled bishops, uttering the
words "Domini est terra et plenitudo eius" (Psalm 24.1). There-
upon, the ground on which he is sitting rises up to put him on a
level with the rest of the council. This *exemplum* of humility is
given visual expression, first by putting the saint in the middle
of the assembly and then by placing the words immediately below
him, and similarly central.

A more complex pattern of spatial relationships results
from the use of words as a border enclosing a physical space and
thus separating that space from the rest of the painting and the
viewer. A simple use of the straight line as a border can be
seen in the painting of the Last Judgment attributed to the
Master of the Bedford Book of Hours, now in the Louvre. This
work uses Christ's words to saved and damned to divide the pic-
ture into left and right halves. But since they occur horizontal-
ly across the middle of the painting at some distance from their
speaker, they also constitute a further boundary, that between
heaven and earth.[30] A more interesting border can be found in
the reliquary of Charlemagne in Aachen cathedral.[31] One of the
many figures on this work is a three-dimensional representation
of Christ in a circular border which bears the words "cuncta
movens, cuncta regens, stabilis manendo" ("moving all things,
ruling all things, himself abiding unchangeable"). Wherever the
viewer begins to read, he receives the same message. No better
way could be found to dramatize the absence of beginning and
end--and of every limitation--in Christ.

The border has further importance for us. The artist may
present his words on it so as to make their reading easy or dif-

ficult. He can, for instance, present the border as two, or four, separate lines of text, one above another, in approximation to the lines of text on a page. Or he can make his border a continuous line and force us at some point to decipher upside-down writing. We have examples of both kinds in the center panels of a triptych from the workshop of Godefroid de Huy, in the Victoria and Albert Museum, London.[32] The central medallion of this panel, a scene of the Crucifixion, is set in a diamond-shaped border. The text on this border reads as two separate lines of print: the top line, composed of the upper arms of the diamond, gives us "In cruce Cristus obit: prothoplasti"; while the bottom line, composed of the lower arms, reads "debita solvit" ("Christ has died on the cross, and paid the debts of our first father").[33] Immediately below, a circular border frames a scene of the Harrowing of Hell. Its text cannot be read so easily, and the viewer has to turn himself, or the object, to read the whole message: "Premit hostem fortior; hic fortem captus spoliat" ("the stronger man defeats the foe; though captive, he despoils the strong"). [34]

Inevitably, words on a circular border create at some point a perspective opposed to the normal and imply that a religious perspective requires the overturning of that by which we usually live. This happens whenever the artist uses upside-down writing. In the Angelico fresco already noted, for example, Christ's words to the repentant thief are upside down; two paintings by the van Eyck brothers treat Mary's response to the angelic salutation similarly.[35] However we interpret such writing--and it brings us almost into the realm of code and sacred hieroglyph--its meaning is clear. The words are not ours by right, and we can appropriate them to ourselves only if we are willing to reproduce in our lives the distinctive stance of the saints who first spoke them.

Equally strange, important, and uncommon is the use of mirror-writing in paintings. An impressive example occurs in Orcagna's fresco of Hell in the Santa Croce Museum, Florence. In one corner of this picture a monstrous bird-figure is saying to terrified sinners, in mirror-writing, the words that greeted the damned in Dante's *Inferno* when first they reached hell: "Lasciate ogni speranza" (fig. 34).[36] This use of mirror-writing has the obvious function of showing hell as an inversion of heaven. Another example occurs on a wooden votive shrine in the Piazza del Capitolo, Florence, where a fifteenth-century *Annunciation*, restored in 1896 at the expense of the cathedral clergy, has the Virgin's response, inside-out (text fig. b). Like upside-down writing, which exposes the world of our ordinary perceptions to be the topsy-turvy state it really is, mirror-writing points us through the painting to a looking-glass world where our reality can be seen (in the words of Tweedledum) merely as someone else's dream.

Bellini's painting of the Annunciation in St. Alessandro,

Text fig. b: Annunciation. Drawing from original in Piazza del Capitole, Florence.

Brescia, is interesting for another reason.[37] As in Simone's painting, the angel's words join Mary and the angel. This time, though, we have to read from right to left to get the correct wording: "Ave gratia plena." Perhaps this variant of the normal order aims to show us the words as one by one they pass out from the angel's mouth and fall upon the Virgin's ear; the painter, that is, has attempted not merely to symbolize but actually to represent a process of speech.[38]

We turn now to words printed on surfaces in the paint-
ing--words, that is, presented as if painted on wood, carved in
stone, woven into cloth, written on paper--as instances of what I
have called covert symbolism. It is well to admit at the outset
that the distinction between overt and covert symbolism is more
apparent than real. When, for instance, the artist paints a scroll
in mid-air with no visible means of support or uses it as a bor-
der for his work, any words he puts upon it can hardly be dis-
tinguished from words written directly onto the surface of the
painting. Again, the actual surface being used to carry the
message may be treated with scant regard to its physical pro-
perties, as in the Vienna St. Matthew and the Aachen St. Mark.
The words are, then, very largely set free from the constraints
of their physical context and function as overt symbols.[39]
Lastly we have the halo used, amazingly, as a surface for car-
rying words. Sometimes the halo functions exactly like a bor-
der, and words written on it will have the status of overt sym-
bols. At other times the halo functions as a physical property
of the visible universe, and words then written on it function
as covert symbols.[40] In any case, the covert symbol makes no
major contribution to the visual meaning of the painting. By
virtue of its subordination to the represented surface on which it
appears it will contribute to the form of the painting only as a
decorative motif--i.e., as an instance of that impulse to natural-
istic expression which first led to the creation of the image.
Such words then gain significance only in proportion as they are
so lost in the work or so fragmented that their reading causes
difficulty. That difficulty may then be taken to stand as an
image for the difficult task (to which the believer is committed)
of "reading" the surface realities of life so as to find in them--
for he will find it nowhere else--their ultimate spiritual meaning;
a meaning of which ordinarily he can find only tantalizing frag-
ments.

How such words work we have already seen. The text
will be fragmented either because objects are placed between us
and it, or because of the instability of the object on which it is
printed (cloth folds and creases). In a similar way, the artist
may fragment his text, at beginning and end, if he presents it on
the facing pages of an open book. A novel expression of this
naturalistic impulse occurs when the artist prints words on the
halo and allows the head of the saint to come between us and
the whole message (for an example, see fig. 35).

But the artist has a still more exciting way of hiding his
text in the fabric of his work. He can weave the words into
decorative fringes for altar coverings or the clothing worn by his
characters. The viewer has then to determine which threads in
the fabric make up the message. Of all the painters of the
Renaissance, none seems to me to have engaged more passion-
ately in this quest for concealment of his texts than Bergognone.
We have already seen an example of his practice in the Pavia

Crucifixion. Another is his painting of the Madonna and Child
with two female Saints, in the National Gallery, London (fig. 35;
see the hem of the Virgin's mantle and the three haloes). A
much better example is his *Presentation*, from the Incoronata
Church, Lodi, which has texts on almost every surface capable
of receiving them, including the hems of Simeon's and Joseph's
cloaks, the stones of the temple, and the cloth on the altar.[41] In
his determination to blend words into a larger decorative pattern
Bergognone takes us as far in the direction of naturalism as
anyone could: it's as if, faced by the impossibility of using
words in a completely naturalistic painting and the impossibility
of doing without them in a religious commission, he has tried to
embalm them in the very considerable visual splendor of his
decoration.

It is perhaps appropriate that a study which began with the
arrestingly obvious *Ave gratia plena* of Simone Martini should end
with texts so cunningly concealed as those of Bergognone. The
temptation must be strong to use such evidence to distinguish
between medieval and Renaissance attitudes to religious com-
missions--to the disadvantage of the former, since it would seem
that the Renaissance artist had greater freedom in respect to his
presentation than his medieval counterpart enjoyed. Again, the
earlier-noted contrast between Simone's Latin texts and those of
Mantegna might tempt us to contrast medieval and Renaissance
attitudes to religion, and the production of religious art, to the
disfavor of the former. On such a reading, medieval religious
art would be fatally flawed in its readiness to use the narrative
methods of all primitive or folk art by its failure to separate
itself from its own primitive roots; by contrast, the religious art
of the Renaissance would grow out of a conviction that, far from
being a whole world, religion is merely a system of behavior like
any other, and is as accessible as any other to detached scrutiny
by the artist. These distinctions, however, are far from stating
the whole truth, as I hope the foregoing pages have shown. Not
only was an artist never wholly free in his presentation of
texts--at its most obvious, he was bound by the linear con-
straints of print--but he could never break free from the over-
riding purposes of his commission: to point viewers to the spiri-
tual principle which was both other than the world they inhabited
and, at the same time, its truest life.[42]

NOTES

[1]An indication of the importance of words in religious
art is provided by the use of letters as a decorative pattern
in late medieval art.

[2]For notable exceptions to this generalization, see A.

Goldin, "Words in Pictures," in *Narrative Art*, ed. T. B.
Heiss and J. Ashbery, *Art News Annual*, 36 (New York,
1970), 60-71; Millard Meiss, *Painting in Florence and Siena
after the Black Death*, revised ed. (New York, 1964), pp.
121-25; J. Sparrow, *Visible Words* (Cambridge, 1969), pp.
48-88; and D. A. Covi, "Lettering in Fifteenth Century
Florentine Painting," *Art Bulletin*, 45 (1963), 1-18.

[3]The parallels between art and drama have often been
noted. See, e.g., Émile Mâle, *L'Art religieux de la fin du
moyen âge en France* (Paris, 1908); M. D. Anderson,
Drama and Imagery in English Medieval Churches (Cam-
bridge, 1963); Rosemary Woolf, *The English Mystery Plays*
(London, 1972); and C. Davidson, *Drama and Art*, EDAM
Monograph Series, 1 (Kalamazoo, 1977), esp. Chapt. I.

[4]V. A. Kolve, *The Play Called Corpus Christi* (Stan-
ford: Stanford Univ. Press, 1966), pp. 101-23.

[5]*Medieval English Lyrics*, ed. R. T. Davies (London,
1963), pp. 120-25.

[6]E.g., "I sike when I singe," discussed in my "A
Literary Approach to the Middle English Mystics," in *The
Medieval Mystical Tradition in England*, ed. M. Glasscoe
(Exeter, 1980), p. 108 and n. 13.

[7]Stanley J. Kahrl, *Traditions of Medieval English
Drama* (London, 1974), pp. 30ff.

[8]Neville Denny, "Arena Staging and Dramatic Quality
in the Cornish Passion Play," *Medieval Drama*, ed. N. Den-
ny, Stratford-upon-Avon Studies, 16 (London, 1973), pp.
137ff.

[9]On this point, see further C. Davidson, "The Con-
cept of Purpose and Early Drama," *EDAM Newsletter*, 2, No. 2
(1980), 9-15; and the discussion on "intention" in W. K.
Wimsatt and M. C. Beardsley, "The Intentional Fallacy,"
conveniently reprinted in *Twentieth Century Literary Criti-
cism*, ed. D. Lodge (London, 1972), pp. 334-45.

[10]For a modern reproduction, see *Simone Martini*, ed.
G. Paccagnini (London, 1957), Pls. 39-40, p. 165.

[11]The cuffs of the angel's sleeves also carry his name:
"Gabriel."

[12]For a reproduction, see *Paintings by Mantegna*, ed.
G. Fiocco (London, 1963), Pls. 2, 4. The relevant frescoes
are discussed in Sparrow, *Visible Words*, pp. 61-62; Covi,
"Lettering in Florentine Painting," pp. 8-9; and in two
works by Millard Meiss: *Andrea Mantegna as Illuminator* (New
York, 1959), pp. 20-22, and "Towards a More Comprehen-
sive Renaissance Palaeography," *Art Bulletin*, 42 (1960),
104-06.

[13]The upper part of this latter inscription reads "T.
Pvllio T. L. Lino 1111111 V[iro] Av[g] Alb[ia]." Letters
lower down the arch read "Ꝺ Avg. Rom vman h." In the
present work, square brackets are used for words or letters

that the artist has, so to speak, deliberately concealed from the viewer, e.g., by placing an object in front of them. Abbreviations are expanded silently, and spellings modernized without comment.

[14]For the Freiburg window, see *Biblical Myths and Mysteries*, ed. G. Thurlow (London, 1974), p. 48. The Botticelli is discussed in Sparrow, pp. 55-56.

[15]For a reproduction, see I. B. Barsali, *European Enamels*, trans. R. Rudorff (London, 1969), Pl. 7.

[16]The paintings are conveniently reproduced in parallel in Meiss, *Painting in Florence and Siena*, Pls. 12-15. For a clearer reproduction of the Lorenzetti, see G. Martin, "Predellas in Siena," *Art News Annual*, 36 (1970), 127.

[17]For a reproduction of Pharaoh, see *The Stained Glass Windows of Chartres Cathedral*, ed. A. Dierick, Orbis Pictus, 2 (Berne, 1960), Pl. 16; and of Paul, *The Hours of Etienne Chevalier*, ed. C. Schaefer, trans. M. Sinclair (London, 1972), Pl. 32; for Pride, Adolf Katzenellenbogen, *Allegories of the Virtues and Vices in Mediaeval Art*, trans. A. J. P. Crick (London, 1939; rpt. New York, 1964).

[18]Literary parallels abound for this practice, some discussed in my "A Literary Approach to the Middle English Mystics," pp. 99-119.

[19]With this distinction between a character who faces out of the painting and one who faces inward, compare that made by G. Kaftal between "devotional images" and "scenes" in his introduction to *Iconography of the Saints in Tuscan Painting* (Florence, 1952), p. xviii, and that drawn by Meiss between the art produced in the third quarter of the fourteenth century and that in the first half of the century in Florence and Siena (*Painting in Florence and Siena*, Chapt. 1).

[20]See Sparrow, pp. 51-52. Sparrow does not refer to this work as a copy; the original, in Ognissanti, Florence, wants the text. See further R. van Marle, *The Development of the Italian Schools of Painting*, XIII (The Hague, 1931), 26 and fig. 11, for the suggestion that Benedetto da Maiano was the copyist.

[21]For a reproduction, see H. H. Hofstätter, *Art of the Late Middle Ages*, trans. R. E. Woolf (London, 1968), p. 135. For comment on the use of this verse in literary texts modeled on the Good Friday liturgy, see Rosemary Woolf, *The English Religious Lyric in the Middle Ages* (Oxford, 1968), pp. 36ff.

[22]For the full text of the hymn from which the prayer comes, see *Analecta Hymnica Medii Aevi*, ed. C. M. Dreves, LIV (Leipzig, 1915), 383-84.

[23]For a reproduction, see *Gothic Painting*, ed. E. Carlo, J. Gudiol, and G. Souchal, trans. M. Raeburn and W. Harris, Contact History of Art, 6 (London, 1965), Pl.

168.

[24]See Woolf, *English Mystery Plays*, p. 285, for a single example of usage in the cycle plays.

[25]For a more intricate use of a single scroll to carry a pair of speeches, in Mantegna's *Dialogue of Venice and Marcello*, see Meiss, *Andrea Mantegna as Illuminator*, fig. 3 and p. 10.

[26]For a reproduction, see *Bergognone*, ed. S. S. Ludovici, I Maestri del Colore, 128 (Milan, 1966), Pls. 10-11.

[27]For a reproduction, see *Rogier van der Weyden*, ed. M. Whinney, The Masters, 54 (London, 1966), Pls. 10-11. The feature is noted in Erwin Panofsky, *Early Netherlandish Painting* (London, 1953; rpt. 1971), I, 269.

[28]For a reproduction, see *L'Angelico a san Marco*, ed. L. Berti, Forma e Colore, 13 (Florence, 1965), Pls. 26-27. According to Mr. Lewis Allan, the ascription to Angelico is uncertain; a safer ascription is "School of Angelico" or even "School of Gozzoli."

[29]Reproduced in *Hours of Etienne Chevalier*, Pl. 38. For the legend of St. Hilary, see the companion page.

[30]For a reproduction, see *Gothic Painting*, ed. E. Carlo *et al.*, Pl. 29. The basic division between the saved and the damned in the painting is reinforced by means of a vertical line between them, made by a trumpet blown by an angel, from which issue words announcing the Last Judgment.

[31]For a reproduction, see I. B. Barsali, *Medieval Goldsmith's Work*, trans. M. Crosland (London, 1969), Pl. 51.

[32]For a reproduction, see Barsali, *European Enamels*, Pl. 8.

[33]If we read the lower borders clockwise, instead of from left to right, the text then ends "solvit debita." Where we begin to read is indicated by a +.

[34]Here too alternative word orders are possible, thus: "fortior hic fortem captus spoliat; premit hostem" ("the stronger man, though captive, despoils the strong; he defeats his foe").

[35]The one is the wing of the Ghent altarpiece; the other, the *Madonna in a Church*, in the Mellon Collection, National Gallery, Washington. For reproductions, see *Van Eyck*, ed. L. J. Bol, trans. A. J. Fransella (London, 1965), Pls. 28, 47. The feature is noted in Panofsky, *Early Netherlandish Painting*, I, 207.

[36]The fresco is discussed, but not the detail under analysis, in van Marle, *Development of the Italian Schools of Painting*, III (The Hague, 1924), 457-58, 663-64, and in Meiss, *Painting in Florence and Siena*, pp. 24-25.

[37]For a reproduction, see *International Gothic Art in*

Italy, ed. L. C. Vegas, trans. B. D. Phillips, revised D. T. Rice (London, 1968), Pl. 53.

[38]Speech was often symbolized in medieval writing by the ripples that spread out when a stone is thrown into water (e.g., Chaucer, *The House of Fame*, ll. 765ff).

[39]This happens when, for instance, the text presented is unaffected by any objects placed between it and the viewer, or, if cloth carries the text, by any creases and foldings in the cloth; also when texts are printed across, rather than down, the facing pages of an open book.

[40]Broadly, the halo can be presented as a circle framing the head from behind like a border and as an ellipse at an angle to the head. Use of the former, as the symbol of a spiritual principle, results in the same effects as are created by painting words directly on the surface of the painting. The flat disc regularly carries words, and they are usually easy to decipher (if sometimes incomplete; e.g., *Bergognone*, ed. Ludovici, Pl. 6, and cf. fig. 35 of the present article); the ellipse only occasionally, and they are not (e.g., ibid., Pl. 14).

[41]Ibid., Pl. 16.

[42]Grateful thanks are due to the following for permission to reproduce works owned by them: the National Gallery, and the British Library, London; the National Library, Vienna; the Gallery of the Uffizi, and the Museums of St. Mark's and Santa Croce, Florence. I owe special thanks to Mr. Lewis Allan of University College, Cardiff, for many helpful suggestions and for confirmation of doubtful readings; and to Mr. Peter Strevens for the line drawings in the text of my article.

SPACE AND TIME IN MEDIEVAL DRAMA:
MEDITATIONS ON ORIENTATION IN THE EARLY THEATER

Clifford Davidson

The medieval drama was, as Pamela Sheingorn usefully reminded us in a paper read at the Seventeenth International Congress on Medieval Studies, *one of the visual arts*, presenting visual displays for spectators who looked on or who otherwise participated in the event. Hence it will be necessary first to study the drama in terms of its spatial elements. But the plays also quite obviously broke with the static quality of such visual arts as painting and sculpture. For this reason we need additionally to see them as participating in time, a dimension that will require careful treatment if we are to avoid falling into modes of thought that describe our own age rather than the drama of the period we are setting out to analyze. Such analyses also seem to indicate some further directions for study that have serious implications for our understanding of the structure of medieval drama--e.g., the distinguishing of medieval as opposed to modern ideas of causation within drama--and naturally seem to me to lead to two areas where closer consideration is in order: (1) rising and falling and (2) apocalypse and closure.

The object of the present essay, which thus contains four sections that may seem to function almost as separate meditations on various aspects of early drama, is not to cover ground that has been too often previously covered, but rather to look at dimensions that have been too often neglected in previous scholarship directed toward the central issues raised by the playwrights and actors of the medieval stage. Herein I shall be building on the writings of such colleagues as C. Clifford Flanigan, who almost single-handedly introduced phenomenological study to early drama in such articles as "The Roman Rite and the Origins of the Liturgical Drama" (*University of Toronto Quarterly*, 43 [1974], 263-84) and "The Liturgical Context of the *Quem Queritis* Trope" (*Comparative Drama*, 8 [1974], 45-62), and Theresa Coletti, whose dissertation, "Spirituality and Devotional Images: The Staging of the Hegge Cycle" (University of Rochester, 1975), calls for attention to crucial aspects of early drama. In short, I wish to sketch the foundations for a phenomenology of early drama--a drama based in turn in both space and time. For purposes of this essay, therefore, I will attempt to emphasize *perceived experience* and *observable structures* within a methodology that has much in common with that of recent study of comparative religion (e.g., the well-known

work of Mircea Eliade).

I. SPACE

For medieval people, *space* was in a very real sense a
mystery. Frequently unmeasured in terms of such common units
as miles or (as today) kilometers, space as encountered by the
traveler often was the unquantified unknown.[1] On a smaller
scale, even short distances and diminutive dimensions were
experienced differently than today. The tendency was to see
the universe reflected in the areas in which one participated and
hence identified as one's own--areas that would normally be
quite small, usually geographically smaller than the nation or
even dukedom. Within this space, one's horizontal orientation
would be, as today, by the sun's course from East to West, and
by the North-South axis. But even this was subject to other
than positivist interpretations and to what we today loosely
understand as *mere symbolism*; hence we shall here need to
attempt to distinguish the function of the various relationships,
including those established through visual identification and
analogy, in order to arrive at a recognition of the phenomenol-
ogy of space as it informs early drama.[2]

East and *West* clearly have very significant meanings for
the Middle Ages and Renaissance, and are undoubtedly associ-
ated somehow with another binary set of symbols--the right and
left hands--which provide additional orientation in space. Al-
most everyone knows that at the Last Day of history according
to the Christian scheme of things, Christ will oversee the sep-
aration of the saved from the damned, who are identified in
binary fashion as sheep and goats; in iconography, the damned
are placed on the left, where they are herded off to the dark
and unpleasant reality of hell. So it is in the restored wall
painting of St. Thomas of Canterbury Church, Salisbury (fig.
36), where the damned on Christ's left include all manner of
folk, bringing together secular and clerical dignitaries along
with more humble people; these are being coerced by demons
into a hell mouth which gapes widely for them at the lower left.
Such is the scene also in the Judgment plays of the extant
Middle English cycles, which base their division of the race on
the account in Matthew 25.31-46 that locates the good souls on
the right and the bad on the left--the biblical source of this
iconography. Appropriately, in the N-town cycle, the Lord
makes a point of announcing to the saved:

With my *ryght hand* I blysse ʒow here:
my blyssynge burnyschith ʒow as bryght as berall;
As crystall clene it clensyth ʒow clere
All ffylth ffrom ʒow ffade. . . .
 (42.45-48; italics mine)

In illustrations in the visual arts, much is further made of the
fact that the good souls are given clothing, while the "cursid
caytiffis of Kaymes kynne" are sent off naked "In helle to
dwelle withouten ende."[3] There the unhappy ones will also be
denied the covering of clothing. The right hand is associated
with life and light and brightness, while the left hand is linked
with death and darkness and apparently dirtiness.

At the end of the *Republic*, Plato retold another and ear-
lier eschatological account which likewise utilized the symbolism
of *right* and *left*. He recounted the story of the warrior Er,
who had visited the other world and returned. After a long
journey, he had come

> to a mysterious region where there were two openings side
> by side in the earth, and above and over against them in
> the heaven two others, and . . . judges were sitting be-
> tween these, and . . . after every judgment they bade the
> righteous to journey *to the right and upward* through the
> heavens with tokens attached to them *in front* of the
> judgment passed upon them, and the unjust to take the
> road *to the left and downward*, they too wearing *behind*
> signs of all that had befallen them. . . .[4]

The passage here also established the meaning of vertical rela-
tionships just as in later Christian iconography, and these re-
lationships were associated with the symbolism of *right* and *left*.
Like hell, the place of punishment was in the earth and was
very dirty and dark (the Second Demon in the York *Fall of the
Angels* aptly explains upon his arrival in hell that "All oure
fode es but filth," and later Lucifer himself complains, "My
bryghtnes es blakkeste and blo nowe," ll. 106, 101); like
heaven, the place of reward in the *Republic* was in the heavens
and was the source of cleansing and light.[5]

The archetypal nature of right-left symbolism explains its
universality, for we will find that it is not merely limited to
official Christianity and Platonism. What is surprising is how
standard the meanings of *right* and *left* remain for widely dis-
persed cultures. Widespread in Africa and Asia is the practice
of utilizing only the right hand for eating or even for preparing
food, while the left is reserved for cleansing the self after
defecation and for touching the sexual parts. This binary divi-
sion can be very rigid, and clearly links the *right* with the *top
and front* of the body, and the *left* with the *bottom and rear*.
In plays which stress the body in the Middle Ages, we can find
a twofold division as well. Christ, whose body is wounded in
his Passion from his head to his feet, is crucified in the tradi-
tional *orans* position with his arms lifted in prayer and his
hands facing outward. Demons, on the other hand, are nor-
mally given costumes which identify them with lower bodily
functions; often they are depicted with double masks, with the

second placed over the genitals or upon the buttocks. An amusing but logical extension of this symbolism is stressed in the complaint of Lucifer in the N-Town *Fall of Lucifer* upon his transformation from "bryth" to "derke":

> Now to helle þe wey I take
> in endeles peyn þer to be pyght
> Ffor fere of fyre a fart I crake
> In helle donjoon · myn dene is dyth.
> (1.79-86)[6]

The scatological language in *Mankind* which proved so offensive to earlier editors is also, of course, very carefully chosen to associate certain characters with the subversive *left* who at the Last Day will be thrust *downward* into the mouth of hell.

Right-left symbolism retained its hold up to the seventeenth century. In gestures used in rhetoric--and, presumably, in the theater--the sign published by John Bulwer to illustrate *negabit* is a *left hand turned to the back*. In Ben Jonson's *Masque of Queenes*, the well-known witches' dance, which may well throw light on the witches' dance which served as an addition to *Macbeth*, calls for grotesque movements and gestures since "at theyr meetings, [they] do all thinges contrary to the custome of Men, dauncing, back to back, hip to hip, theyr handes joyn'd, and making theyr *circles* backward, to the left hand, with strange phantastique motions of theyr heads, and bodyes."[8] This description of a round dance performed backward suggests a counter-clockwise motion, itself suggestive of analysis possible through phenomenological study since, for example, the hands of clocks give primacy to the right-hand side of the face.

The dance in the *Masque of Queenes* is also a dance performed by women, and femininity has often been associated with *left* rather than *right*.[9] In the fourteenth-century *Holkham Bible Picture Book* (fol. 4), Eve, the woman, thus appears on the left, and it will be noted that both Adam and Eve eat the fruit with their *left* hands (fig. 37)--the same hands that hold the fig leaves over their genitals in the Expulsion scene below in the miniature. That they are both naturally right-handed is proven by the primacy of their right hands in the miniature on fol. 4[v], which shows them spinning and digging, their traditional occupations after the fall (fig. 40).

The symbolism of *right* and *left* is, as we would expect, carried forward from the primordial time of Adam and Eve to the time of their children, beginning, of course, with Cain and Abel. The Anglo-Norman *Adam* in its stage directions specifically instructs Figura to appear at the sacrifice of Cain and Abel with these two sons of Adam arrayed on his left and right respectively. A similar arrangement is seen in the *Holkham Bible Picture Book* (fol. 5) where additionally Cain's sacrifice mixes its

smudge with the smoke from hell mouth.

Quite naturally, therefore, *left*, like the *West*, became synonymous with despair just as the *right* and *East* became identified with hope. In depictions of the Crucifixion, the repentant thief is normally on Christ's right, and the unrepentant thief is on his left, for example. Medieval symbolism here extends into the Renaissance. In Marlowe's *Tragical History of Doctor Faustus*, where events are vertically oriented in relation to hell and heaven throughout, we may therefore speculate that in production before an audience acutely aware of the meaning of right and left the latter would receive some considerable emphasis. For Faustus, like Cain in the Towneley *Mactacio Abel*, the Anglo-Norman *Adam*, and the *Holkham Bible Picture Book*, hopelessly looks forward to darkness and pain in spite of the grandiose delusions which he exhibits. Of course in matters such as these, we can only attempt to draw sensible conclusions based on the best evidence from the visual arts, for as we know the relationship between the theater and the visual presentations of the artists remained close until the seventeenth century. In the famous woodcut from the title page of the 1624 quarto of *Faustus*, the devil appears in his own ugly shape before Faustus *at his left* (fig. 41).[10]

But the most rigidly oriented dramatic forms in either the Middle Ages or Renaissance are ritual and liturgical drama, for they are set within the church building where they normally share the meaning established by the building itself. In many regions the church building in the Middle Ages faced the East, with the choir or chancel at the east end of the building. Prayers were spoken by the priest *facing the East* even in churches to the eastward of Jerusalem, for the orientation of the Christian Church was toward the heavenly Jerusalem, not the earthly.[11] The biblical account had, after all, promised that the second advent of Christ would be *in the East* (see Matthew 24.27). Dunbar Ogden's conjecture is that at Canterbury in the late Anglo-Saxon period the Marys participating in the *Visitatio Sepulchri* might have entered the cathedral "from the north tower," which "would have allowed the women to wander some 100 feet through the worshippers and up to the steps of the main altar."[12] The procession is not only in the direction of the altar, but also toward the East--the direction which appropriately symbolizes Christ's Resurrection. As would have been appropriate in this ritual, the orientation of events would be correct since it would be consistent with the design of the universe. If Ogden's conjecture is accurate, the Marys would move from the West--the end of the church in which towers were built to house bells as a deterrent to demons who were, of course, themselves associated with the West. The women would thus also designate the direction toward which Christians were encouraged to travel in their earthly journey, for they were to move in the direction of perfection, illumina-

tion, and salvation. The nave of the church, as is well known, metonymically represented the world in which the people lived, while the choir or chancel represented heaven, for it was here that they would receive a foretaste of bliss when receiving or even seeing the heavenly bread of Communion. For the pre-twelfth-century Church, the Eucharist participated vividly in the Resurrection of Christ, an event which gave hope to the community and provided a center for their devotion. Later in the Middle Ages, churches would very commonly have their chancel arches painted with representations of the Last Judgment to illustrate the significance of the division between nave and chancel areas. Such is the location of the Doom painting at St. Thomas of Canterbury, Salisbury, which has been mentioned above. To face the East is to face in the direction of the second coming of Christ, an event that inspires fear and even possibly despair; but beyond the second coming is the heavenly feast toward which the members of the community look and from which they receive hope. In the Fleury *Visitatio*, the Marys appropriately conclude their roles with lines which proclaim the resurrection of the king of angels, the leading of the just out of darkness, and the opening of the way to heaven's kingdom. Here too the movement is toward the East where the Savior will appear in a manner foreshadowed by the way in which he appears at the end of the Fleury play. The person appearing "in the likeness [in similitudinem] of the Lord" comes to the women in the glorious white garments appropriate to Easter;[13] he is the Salvator Mundi of the visual arts.

In the widespread rites associated with the *Depositio* and *Elevatio* during Holy Week, the Sepulcher itself would be represented within the church as part of the paraphernalia of ceremony. In the later Middle Ages, the Sepulcher was commonly placed on or even built into the *north* side of the chancel or choir. Hence at Lincoln Cathedral the north side of the choir in the area of the high altar contains a tomb meant to represent Christ's burial place. The identification is utterly certain since the soldiers assigned to keep watch were carved into the stone tomb. The northern location is actually of utmost importance with regard to these Sepulchers. Like the West, the North also was ordinarily associated with the powers of darkness.[14] The usual reading of the Gospel lesson in the Mass by the deacon facing the North was regarded as a challenge to those powers.

When we turn to the famous diagram showing the staging for *The Castle of Perseverance* (fig. 38), the orientation of the staging of this didactic play is recognized on the whole to be consistent with the symbolism of direction that has been discussed above. This drama is very far removed from the rites and liturgical dramas, though, as we have seen, these were hardly outmoded forms in the early fifteenth century. *The Castle of Perseverance*, apparently written for performance "on þe [town] grene,"[15] nevertheless insists upon aligning the

stage with the world in a very specific way. Deus' scaffold is
in the East, Mundus' in the West, and Belial's in the North.
Belial's stage is appropriately also represented on the *under-
side* of the drawing in the manuscript. The only slightly puz-
zling feature is the presence of Flesh's scaffold at the top, on
the south side, but in a didactic play this location (turned
geographically toward the sun's warmth) would not be inappro-
priate on other grounds since the sins assigned to Flesh (Caro)
are those linked to bodily heat. Similarly, Covetous, on the
Northeast, occupies a position which designates a cold dispo-
sition. The accuracy of this reading of the symbolism is proven
by the structure of the play, which presents us with Mankind
(Humanum Genus) surrounded on three sides by the traditional
enemies of man who busily seek his destruction. Only when he
turns to the East, toward the stage of Deus, is he able to ob-
tain release from the agony of human existence--and during the
presentation of the play, before the conclusion, such release
seems by no means inevitable.

The central point in the *Castle of Perseverance* drawing
is, of course, the castle with a ditch around it in the center of
the playing area. The ditch is apparently part of the castle's
fortification system, and in no way should it be interpreted as
encircling the entire theater in the manner suggested in the
doubtful hypothesis of Richard Southern.[16] The castle setting in
the play is hardly a unique one, and Merle Fifield has called
attention to a group of miniatures in continental manuscripts
which seem to provide rather convincing examples of the alle-
gorical castle as it would have been used in a theatrical pro-
duction.[17] In the play, the castle is clearly the Castle of
Virtue--very closely related also to Mary Magdalene's castle in
the Digby play, which shows her being seduced to come forth
from it and to enter into the tavern, a location identified as the
devil's church.[18] As Confession explains in the *Castle of
Perseverance*, the castle in that play

> is a precyous place,
> Ful of vertu and of grace;
> Whoso leuyth þere hys lyuys space
> No synne schal hym schende.
> (ll. 1555-58)

If Natalie Crohn Schmitt is correct, the water of the moat
around this castle is to be associated with the Mother of God,[19]
for it is she who is invoked under the symbol of the "well of
grace" to "qwenche" the "fowle hete" of Lechery (ll. 2302-04).
This gives support to Schmitt's suggestion that the castle itself
should be identified allegorically with the Virgin, who is, after
all, symbolic of perfect human nature.

From the standpoint of orientation in space, the associa-
tion of the castle with the Virgin need not, of course, mean

total identification of her with the structure. The castle is a place where mankind is at the symbolic center of things and is aligned with the East-West axis that leads him away from the world, represented by the stage of Mundus in the West, and toward God in the East. But there is a vertical orientation here too, with the raised structure of the castle suggesting an upward alignment that can protect the frailty of human life from all the harm threatened by World, Flesh, and Devil. Through such an alignment, therefore, Mankind can be brought to participate in the grace and goodness conveyed into earthly life through the role of the Blessed Virgin in bearing the Christ Child who will be the Savior. For this didactic play, the return to the castle on the part of Mankind is really a return to a place closely associated with the Nativity in order to reduce the distance between man and God. Crucial to this action is the employment of what Mircea Eliade has called the "symbolism of the center."[20] It is here in the castle that Mankind can encounter the beneficence of heaven, but is also here that he encounters the assaults of the lower region which is the source of the Seven Deadly Sins and their threat to the moral life.

As what Eliade calls the "zone of the sacred," the center in the case of the castle is the place where reality can be encountered most certainly. In comparison, World, Flesh, and Belial offer only illusion, attractive but insubstantial. Such illusion involves the profanation of space--an act which repeats the Fall and intensifies its consequences. The role of Covetous here is particularly significant, since this sin involves the most militant *secularism*--i.e., insistence upon the value of a medium of world power separated from the system of real power implied by the center. Life is naturally sacred, and space is naturally sacred. But both may be profaned when vice is chosen over virtue. Such venturing forth from the center will leave Mankind alienated and subject to the forces of malice. The only place of safety is the castle.

For early drama, therefore, space is to be understood not in modern terms but in the manner in which it was perceived during the Middle Ages. The examples which have been cited above illustrate that space-as-measured quantity is a concept that will tend surely to distort and obscure the meaning of the early plays and their spatial orientation, which is based on ontological participation. These dramas may even receive their structure from the contemporary manner of orienting life in space, as in the case of the *Castle of Perseverance*. As will be demonstrated below, our modern notions of time will likewise need modification when we confront early drama critically.

II. TIME

Since drama is a temporal art, the question of time and drama may involve at least two related spheres of inquiry which

we may for convenience bracket together. The first, perhaps obliquely suggested by a line from a post-medieval play, *Henry IV*, Part I--Falstaff's question to Prince Hal: "what time of day is it, lad?"--is indicative of the swift movement of the Renaissance play and of the time-consciousness which has been identified as already typically *modern*. Here the rapid action of sixteenth- and seventeenth-century drama may be usefully contrasted to the seemingly almost static nature of the medieval liturgical drama. Both Shakespeare and, for example, the Fleury Master are interested in the process of "redeem[ing] the time," but their understandings of such a process are really remarkably different. The contrast between medieval and Renaissance/modern conceptions of time would thus seem to be of crucial significance.

The second sphere surely may be directed toward the sequential arrangement of events within the structure of the play. Elements of such arrangement may be mechanical or even arbitrary, as when one scene is placed before another for some reason having little or nothing to do with any principles of seriality. This might involve bringing different sets of characters on stage to separate segments of actions for reasons that are hardly the result of careful attention to the design of the play (e.g., for allowing time for costume changes, etc.) or even for reasons that are illogical.

One of the most serious difficulties that persons approaching medieval drama seem to encounter would appear to be in this region of expectations with regard to questions about seriality and sequential structure. Critical expectations for many are still tied to the common notion that events within the drama are subject to a strict seriality and even, when a crisis point in the play has passed, rigid causation. That which happens at a given moment is felt to be important (or *ought* to be important) for subsequent events, and of course it is true that we cannot very often reverse or alter the order of the episodes in any logical way. We cannot substitute a Pentecost play for an Annunciation play in the Creation to Doom cycles any more than we can exchange the position of the play-within-a-play in *Hamlet* with the closet scene in which Hamlet kills Polonius and confronts his mother. But even for Renaissance plays, the rigid imposition of a system of causation is surely a serious misapplication of Aristotle's analysis of Greek forms in the *Poetics*. Not even the Renaissance playwrights lived in the mechanistic world of Hobbes where everything could be analyzed in terms of causes and effects, of motion rooted in previous events that are capable only of limiting subsequent effects.

The contrast that can be observed between the medieval perception of time and the Renaissance view of temporality would seem to be indicative of a radical discontinuity, however, that very fortunately provides an illuminating contrast. In the medieval world, we are further from Hobbes than from Plotinus, and

with regard to *time* the earlier period is separated from the
later by some fundamental differences in the perception of its
qualities. Iconography thus is an important indicator of the
nature of this change that took place at the end of the medieval
period, for as Panofsky and others have shown, the images
which depict time in the following period illustrate a new and
increasingly hostile and even frightening figure.[21] Time in the
Renaissance is likely to be shown as the Destroyer, who is as-
sociated with death and the destruction of life. In an emblem
which appears in Giovanni Andrea Gilio's *Topica Poetica* (1580),
for example, winged Time appears beneath the sun (on the left)
and the moon (on the right)--symbols here of days and
months--and is waving a whip which signifies his cruelty (fig.
39).[22] On his head is an hourglass, adopted as part of the
iconography of time in the late fifteenth century,[23] and above it
is the face of a small clock with the hand set at eleven, the
hour at which Faustus' painful vigil begins in the last act of
Marlowe's play.

Other ways of presenting time in the Renaissance also
tended to reinforce its frightening aspect, as in the case of
Time the ultimate revealer of Truth (fig. 42)--an iconographic
type that brings its own threatening frown to bear upon both
pleasure and the wasting of one's temporality.[24] No one, of
course, could be so hostile toward idleness and *wasting time* as
the Puritans, who represented the union of economics and the-
ology in a social program that was deeply antagonistic to most
recreation and by extension to theatrical art, though recent
scholarship has revised our view of their unmitigated hatred of
the stage. Milton, who was to be sure an exceptional Puritan,
in his sonnet on Time deliberately ends with a sestet that em-
phasizes the close relationship between temporality and heaven's
will; "All is, if I have grace to use it so," he writes, "As ever
in my great task-Master's eye." The sense of the pressure of
time expressed here was the reason behind the strong antag-
onism of Protestants also generally against the vocation of the
contemplative life, but even in so Roman Catholic a country as
Italy both life and art had become marked by a much swifter
pace that we might associate with the active life. In that coun-
try, the early baroque style, particularly in music but also in
the visual arts, came to value *movement* above the more stylized
and stable relationships that had been present in the works
produced during the previous century. One only needs to com-
pare the restlessness of those works produced by Monteverdi
according to the rules of the *seconda prattica* with the mannered
polyphony of the listless Palestrina.[25]

In Shakespeare, the obsession with time finds expression
in the efficiency of the production itself--"two hours' traffic of
the stage"--and in the intense concern with temporal matters
related to those announced by Falstaff's opening line in *Henry
IV*, Part I. In *The Merchant of Venice*, for example, the near-

tragedy of the play is precipitated by the trick of time which
leaves Antonio without money at the moment when he must repay
the debt he owes to the hostile Shylock. Julius Caesar, on the
other hand, plays tragically into the hands of Time, who ap-
pears in the guise of Opportunity--often represented in icon-
ography as bald behind and with a forelock extended in the
wind, and as standing on a whirling wheel[26]--which at the given
moment locates him in a space where he is vulnerable to his
enemies. In spite of such omens as the "lioness whelp[ing] in
the street" and graves giving up the dead (II.ii.17-18) which
anticipate his murder (as if cause and effect were reversed),
Caesar allows himself to be flattered into going to the place
where he will die. Caesar's anachronistic query "What is't
a'clock?" at line 114 is not without significance; it illustrates the
playwright's intent to call attention to the *temporal* at this
point. For at least a little while, Opportunity befriends the con-
spirators--until she is seized by Mark Antony who along with
his cohorts is able to control the time.[27]

MEDIEVAL TIME. In contrast to the temporal qualities of
Renaissance plays, the medieval saints' plays, as far as we can
determine, existed in a kind of indeterminate time, while even
the linear time presented in the civic cycles with their Old
Testament pageants of the Creation, Fall, and other events early
in human history (e.g., the Flood, or the Sacrifice of Isaac)
was hardly concerned with strict chronology in any modern
sense. Instead, these plays are intended as representations of a
time beginning when the race had been newly brought into exis-
tence as a result of the Creation--i.e., primordial time. Utiliz-
ing the selection of events that had been previously established
in the visual arts,[28] the authors of the plays and the actors set
out in their productions to visualize the basis for post-lapsarian
man's shortcomings along with almost immediate *signs of hope*
extended to him in the structure of events. So indeed a play
dramatizing the Sacrifice of Isaac actually drew upon the implicit
typology which expressed that *hope* even though the staged
scenes might have failed to give particular emphasis either in
the play text or *visually* to typological significance.
 The civic Creation to Doom cycles thus were uninterested
in visualizing time as seriality--i.e., as an unbroken chain of
temporal moments in which the earlier are related in a causal
manner to the later--leading from the first instant perceived by
Adam to the events of the life of Christ and beyond. Certain
points in early history were *marked* by significant events which
point in the direction of the pattern of salvation as provided for
God's people through the Son. In a sense, the temporal pattern
of causation we today would expect here is as if reversed, with
later events establishing the form of the earlier events (though
these could, of course, be fully understood only after the later
event had taken place). The resulting typological design of

early history often, as we know, informed the topics selected by
the artists and their patrons. This was particularly the case in
the late medieval *Biblia Pauperum*, which was, as everyone
knows, vastly popular. One set of examples[29] from this source
may suffice. In the center Christ is carrying the cross, and
the scene is flanked on one side with Abraham followed by
Isaac, who is carrying the bundle of wood for his sacrifice.
The next page illustrates the Crucifixion, which is flanked by
Isaac with his hands in the gesture of prayer and about to be
sacrificed by his father, who has his sword raised. But the
angel, above, holds the father's arm, while below are the wood
intended for the sacrifice and the lamb that has miraculously
appeared. Through a knowledge of the events of the Passion,
the person looking at these illustrations will also come to a
knowledge of the foreshadowing of man's *hope* through the lan-
guage of typology.

In spite of the controversy and scepticism surrounding
the study of typology as it relates to drama particularly of the
late Middle Ages,[30] typological arrangement was part of the
stock-in-trade of the medieval playwright, who quite simply
understood the function of typology to be the revealing of veri-
fiable relationships between earlier events and their later fulfill-
ment. For what other reason is Isaac in the York pageant of
the Parchmentmakers and Bookbinders said to be "Thyrty ȝere
and more sumdele" (X.82) if not to draw explicitly upon the
parallel between the type and antitype?[31] Obviously, the same
habits of mind are at work here as in the illustrations in the
visual arts which show Isaac carrying the wood in the shape of
a cross.[32] Indeed, the Church felt strongly that these events
of the early history of the race had particular importance *be-
cause* they foreshadowed the events of Christ's life. This is the
understanding which derives from the liturgy, for which the
lamb that allowed the boy's life to be saved was in fact a secret
sign for the Savior of men. The sequence for Corpus Christi,
Lauda Sion, places great stress therefore on Old Testament
types of the Eucharist ("In figuris praesignatur,/ cum Isaac im-
molatur:/ Agnus Paschae deputatur. . ."). Although the type
(Isaac) has been fulfilled in antitype (Christ), the human will-
ingness of a son to die and of a father to sacrifice him, as in
the York play, was widely regarded as an important lesson by
which people could learn better the significance of the Passion.
The fact that the son Isaac is afraid does not destroy the par-
allel between type and antitype, for the Son of God will also
suffer agony during his Gethsemane experience immediately
before his arrest. Late medieval spirituality indeed placed
great emphasis on the very *human* manner in which Christ re-
acted at this time, for thus people could better feel the proper
empathy which was encouraged with reference to the *humanity*
of Jesus. As the Franciscan *Meditations on the Life of Christ*
formerly attributed to St. Bonaventura indicated, the Lord,

"although equal to his Father and co-eternal," in Gethsemane "appears to have forgotten that he is God and prays like a man."[33] Like Isaac's obedience, Christ's perfect obedience is in striking contrast to the disobedience which brought man's woe upon him in primordial time.

Further, the point needs to be reiterated that events in Old Testament history may be regarded as typological fore-shadowings of episodes in the life of Christ at the same time that these events are seen as paradigmatic schema by which we are to understand the rites of the Church. Thus the lamb of Abraham and Isaac is also a foreshadowing of the Mass, as the sequence *Lauda Sion*, cited above, shows. And hence the Exodus experience--the escape from Egyptian tyranny, the cross-ing of the Red Sea, and the wandering in the wilderness led by the pillar of fire and cloud which are the visible signs of the hidden God--provides the language and structure for under-standing the baptismal rite, which was introduced to the Church through the baptism of Christ himself. Egypt is figurally as-sociated with this world, from which Christ has delivered his people as Moses had brought the Israelites to safety. The Red Sea, as Father Daniélou notes, "is expressly identified with the baptismal pool whose water takes away sins."[34]

THE MARKING OF TIME. In no way does the medieval interest in typology establish the selection directly or even determine the order of the pageants in the civic Creation to Doom cycles. Any use of figural exegesis in approaching the plays requires a careful perspective through which it may be subsumed as part of a broader critical method. It has been pointed out that English art, particularly in the fourteenth century, tended to avoid any thoroughgoing reliance on typology in the presentation of biblical material; the plays likewise are not principally figural.[35]

But typology indirectly assists in establishing something of very great importance for our understanding of Old Testa-ment history in medieval drama. Typology indeed provides invaluable clues toward an explanation of the way in which the Middle Ages tended to view temporality and history. From the evidence of the plays and other documents, no attention was anywhere seriously given to the seriality of Jewish history dur-ing the span of the legendary "fowre thowsand wynter" during which "Adam lay I-bounden."[36] Instead, the artists, homilists, and playwrights all tended to see historical time such as that set forth in the Old Testament as *stamped* or *marked* through certain events or individuals. From the standpoint of chron-ology, people's sense of Old Testament (or, for that matter, more recent) history tended to be extremely vague. This is the inevitable conclusion of any careful analysis of the plays dealing with biblical history. In the saints' plays, segments of time in the post-biblical age receive dramatization, but again no interest

seems to have been shown in the presentation of temporality in the modern sense of a constant flow which is measurable and which continues at a steady pace even when we are not aware of it. To find viable parallels to the medieval understanding of time, therefore, we will need to look aside at conceptions of time in non-Western cultures.

A valuable study by Alexis Kagame of time and history in the thought of the Bantu language areas in Africa provides the following comment:

> In traditional Bantu culture . . . time is a colour-less, neutral entity as long as it is not marked or stamped by some specific event: an action per-formed by the pre-existent, by man or animal, a natural phenomenon (earthquake, appearance of a comet, eclipse of the sun, an accident caused by lightning, flood, drought, etc.). As soon as the action or the event impinges on time, the latter is marked, stamped, individualized, drawn out of its anonymity, and becomes the time of that event.[37]

So too the medieval understanding of events, at least on a non-philosophical and popular level, tended to see them in terms of special moments either in individual lives or on the level of public life. Though men were very much aware of the passage of the day or the seasons, they tended to be less aware of the current date *anno Domini*. They were indeed often not acutely attuned to any larger units of time than the yearly cycle or the seasons. Yet in medieval records the time is definitely *marked* by the ruling monarch's reign, and even the proceedings of a city council might refer likewise to events which are dated by the name of the mayor who was then in charge rather than by the number of the year which would identify it in modern prac-tice.

Within the space of a day, time for the Middle Ages did not present the sense of urgency, sometimes amounting to *chronomania*, which we observe today. While clocks were an invention of the medieval period, neither then nor in the Ren-aissance were they provided with the minute and second hands that segment time down to the smallest units of seriality. Clocks and other devices for keeping time were only regarded as use-ful in the larger sense of orienting oneself within the fluid time which flowed during the course of the day or night. An hour (*hora*) was not even a standard unit of measurement of time.[38] Jean Leclercq reminds us that men normally might function ac-cording to other rhythms than those provided by chronological time, as at Cluny "throughout the summer, regardless of the solar hour, afternoon began only when all the prayers allotted to the morning had been said and the meal finished."[39]

In one of the early references to the Corpus Christi play

at York, in 1394, the pageants are ordered to be played "in
locis antiquitus assignatis."[40] When time is regarded in such a
fluid way, designations of past time are necessarily vague. It
is expected that at York as elsewhere in the Middle Ages the
term *antiquity* would signify the past as recent as a generation
ago, though of course a much longer span of time might also be
meant. *Antiquity* thus signified "in grandfather's time or at
some earlier time." At York, the civic drama of Corpus
Christi day would have been established by the 1360's if *anti-
quity* as specified in the 1394 document indicates the existence
of the pageants for already at least one generation. Indeed, we
now know that dramatic activity of some kind was being re-
corded at York as early as 1376,[41] but again no firm dates
exist for the inception of the York plays. We also are not able
to determine the nature and extent of the plays in the four-
teenth century, for the extant records provide documentation
only for the dramas in a rather late state. In our modern
search for precision with regard to matters of dating and the
form of the plays at their inception, we are met by a frustrating
silence on the part of history.

In spite of the vagueness of the medieval historical
sense--a vagueness that stands in acute contrast to the Renais-
sance sense of time in its historical dimension--the Middle Ages
nevertheless did see history as in some manner linear. The me-
dieval vocabulary, unlike the African Bantu vocabulary, pos-
sessed signs signifying the *future*, which in spite of its appar-
ent imprecision was normally understood in terms of the comple-
tion of tasks, the end of a cycle of seasons which make up the
year, and, not least importantly, the end of history itself. In
past history, the role of the Savior was of course a basic tenet,
and through the events of his earthly life the historical process
was given its shape. But the early Christian literature had re-
jected the notion of cyclic time in favor of linear time, and
though the latter concept was not fully assimilable, there never-
theless was the general perception that the passage of years
was along a linear pattern. Of much more importance would
seem to be the way in which each individual year was divided
into segments analogous often to events in history and thus
marked according to the calendar. Through the calendar,
sacred time in the past becomes the occasion for a feast
day--i.e., sacred time in the present.

Through the content of the rites of the liturgy, there-
fore, the feast days of the calendar rendered time at those
points sacred and provided distinctions that imposed themselves
upon the fluidity of normal temporality. Each week was marked
by the sacredness of time as set apart on Sunday, the day
which celebrates the completion of the creation of the world.
This day was a day for attending the services of the Church,
for praise, for *re-creation* after six days of work. But there
were also, as we know, other festivals as well--feast days which

marked the divisions of the year according to the pattern of the
liturgical calendar. Beginning in Advent with a period of prep-
aration for the festival of Christmas and continuing through the
solemnity of Lent as well as the joy of Easter, the liturgical
year offered a pattern of renewal that was attached to the chang-
ing seasons. Shortly following the shortest day of the
year, the Church had arranged a feast which celebrated the
birth of the Savior of the world. Christmas was, of course, the
occasion for revelry and also for dramatic presentations of vari-
ous kinds from an early date. There were popular forms, often
quasi-dramatic, as well as monastic and liturgical. The popular
forms were normally recreative in nature, if we may judge from
the extant evidence. Among the examples we may include per-
haps even the dance songs, the *carols*, the games of the
season.

That the *feast* of Corpus Christi, established for the sea-
son of summer, should have come to be considered one of the
most appropriate dates in cities such as York or Coventry on
which to review sacred history is perhaps accidental. This
feast was proclaimed by Pope Urban IV in August 1264, and its
liturgy was adapted from the "ancient forms"--i.e., from the
office as it had been previously assembled in the diocese of
Liège.[42] The purpose of the feast was to honor the Euchar-
ist, which it was felt required this new festival since its role
during Holy Week was not sufficiently noted by worshippers.
By the middle of the fourteenth century, the festival was widely
marked in England, where the procession with the host quickly
became one of the most important liturgical events of the year.
The summer weather made the time normally satisfactory for
outdoor processions--and also for plays. That the feast honored
the Eucharist--and stressed its role from the figures of ancient
manna and the paschal lamb--hardly, however, dictated play
cycles on the whole subject of salvation history, and we know
now from recent work on dramatic records that a "Corpus
Christi play" did not inevitably mean the Creation to Doom
structure familiar to us from the extant cycles.

But the *feast* itself as such was an appropriate time for
religious drama; this day was *marked* in a special way and set
apart from the other days of the year. As a major feast newly
established in a propitious season, Corpus Christi quickly be-
came stamped as the day for extensive lay participation in de-
votional acts and devotional plays. The key factors in such
plays were the focus of lay piety following the Black Death of
1348-49, and the presence of the guilds which provided the
organization for civic theater. It was hence easy for a city
corporation such as York's to coordinate and oversee the efforts
of the organized guilds and thus to provide the appropriate
organization to buttress the civic theatrical effort. This was an
effort which was, to be sure, taken very seriously by the citi-
zens, as entries in the civic records indicate. Careful prepara-

tions for this feast day are recorded for many English cities. The streets were cleaned, the pageants in cities with plays or processions with *tableaux vivants* were made ready, hangings were hung from the upper stories along the procession or pageant route. The atmosphere was apparently supercharged with emotion, and in England as in France the festival unified the citizens of the city as only at two other religious festivals of the year--Christmas and Easter.[43] That the civic plays in particular should be part of such a festival suggests that they were able to partake of the heightened sense of time already offered through the occasion. The presentation of the episodes of the Creation to Doom cycles at York or Coventry is thus consistent with attention to those scenes in sacred history which had already been *marked* by the liturgy and by familiar representations in the visual arts. These scenes then would be brought to life in a livelier fashion than mere painting or sculpture, to which would be added the rightness of the emotional climate associated with the feast--an atmosphere that would have been far more significant than any perception of the theological basis of the feast's liturgy. Such an understanding of the concept of time and festival informing the plays will suggest, I believe, the limitations of objections to the shortness of the plays of the York cycle; what is today seen as disjunctive and aesthetically unsatisfactory was capable of being justified in the late Middle Ages by the explanation that these scenes were indeed bringing the important *moments* of sacred history before contemporary audiences. If the basic forms which the scenes took were necessarily established with attention to the arrangement of designs which show the sacred scenes according to traditional and recognizable patterns, so too the temporality of each scene had to be marked by participating *at least on the level of the imagination* in the sacred time which had marked the original event. When the plays were performed on other days than Corpus Christi--e.g., Whitsun week or St. Anne's day--a similar attitude toward time must, of course, have prevailed for the community involved, though it is easy to see why the popular Corpus Christi festival should perhaps have been the most propitious for drama in England during the late Middle Ages.

TEMPORAL SEQUENCES. Daniel P. Poteet II, who has studied *Passion Play I* from the N-town cycle in terms of the medieval philosophy of time, appears to corroborate the above analysis, and additionally he draws upon medieval thought to indicate how, since *time* was associated with *illusion* while *eternity* was associated with *truth*, temporal events were wrenched out of their "normal" position or perspective in the process of illustrating the episodes of sacred history.[44] Anachronism is also explained as conscious--the deliberate attempt to link together the past and the present through the introduction of bishops, pence, contemporary varieties of cloth, etc., into bib-

lical time. Both of these--temporal distortion for dramatic effect and the use of anachronism--result, says Poteet, in establishing "emphasis on the permanence of moral hierarchy and human condition and the denial of any special inherent significance of passing time."[45]

The recognition of the meaning of time--and of eternity--is implicit in plays dramatizing conversion such as the vernacular *Conversion of St. Paul* and *Mary Magdalene* in the Digby manuscript. In each play, a willful individual is made to submit himself or herself to a revelation of truth, which in each instance is eternal rather than temporal. Time is not explicitly mentioned, but is an important factor of theatrical interpretation nevertheless. In the case of St. Paul, the hero is a man (Saul) who more than anything else wants to impose the *law*. He is proud, busily seeking to overthrow the Christians in all parts of the world. As soon as he receives the letters from Caipha and Anna, he hastily sets forth, *wasting no time*, toward Damascus. He is anxious "To spede my jurney wythowt lettyng" (l. 84).[46] The journey is a *progress* (l. 134), which is undertaken with willful urgency. As Anna indicates to Caipha, he is indeed their "champyon in euery stownde" (l. 151). Saul, who is obsessively concerned with the ordering of actions in time in order to comply with the minutest aspects of Jewish law, is the person afflicted with *chronomania*, the fear of being idle even for an instant. But in the second scene of the play, following his progress to the second station where this portion of the drama will be played, Saul is struck down from his horse by the great light "wyth gret tempest," after which "Godhed spekyth in heuyn." The eternal has appeared to him, and the former urgency of his mission must now be forgotten. He has become "lame" and blind, and, he fears, his "men hath forsake me also" (ll. 198-201). As Deus tells Ananias, he will now find Saul "in humble vyse,/ As a meke lambe þat a wolf before was namyd" (ll. 217-18). Following his life crisis, Saul is now penitent, weeping for his abuses against the Eternal that has revealed himself to him, and he receives baptism, which renames him *Paul* and cures him of his physical and psychic wounds. When Saul leaves in procession for the third station or acting area, he has submitted himself to a new view of reality that lacks the old urgency and the old hostility against Christians, who comprise the new community of which he has become a member. He is changed by what he has seen and what he has experienced *from one who has been acting entirely within the sphere of the temporal, into a man who is in touch with that eternity which is beyond time*. God, as Thomas Aquinas had insisted, is "wholly outside the order of time, stationed as it were at the summit of eternity, which is wholly simultaneous"[47] In the Digby play, Saul's chronomania is seen to be inconsistent with the vision, which has revealed the unchanging truth to him in an instant of time. Perseverance, *the ability to wait in time for*

what will be revealed from beyond time, is indeed one of the
chief lessons of the converted man's sermon against the Seven
Deadly Sins in the final portion of the play (see ll. 521-23).

The Digby *Mary Magdalene*, in contrast to the previously
discussed play, presents a heroine who has surrendered herself
to time; instead of chronomania, she exhibits something ap-
proaching *chronophobia*, fear of time. Though she knows she
ought to continue to mourn her father in the castle which he
has left her and which functions in the play as a symbolic Cas-
tle of Virtue, she is easily seduced by Lechery, who promises
to serve her and to assist her in giving herself up to "sportys
whych best doth yow plese" (l. 459). "Ye be my hartys leche,"
she responds to Lechery (l. 461), and leaves the castle to go to
that traditional place of entertainment for the bored, the tav-
ern, which in medieval sources is described as a domain of the
devil. The taverner brings wine, which he promises will give
her relief "From stodyys and hevynes," and Mary agrees, iron-
ically calling him "ȝe grom of blysse" (ll. 488-89). The ap-
pearance of Curiosite to be Mary's lover delights her further,
and their dance together, while traditional in iconography,
further illustrates how she deliberately shuts herself off from
whatever would remind her of the eternal verities. Shortly we
see her sleeping in an arbor, a setting fairly commonly utilized
in medieval illumination and used here as a stage device, where
she is waiting for one of her customers, whom she calls "valen-
tynys" (l. 564), to appear. When the Good Angel accosts her
there, he immediately asks her, "Woman, woman, why art þou
so onstabyll?/ . . ./ Why art þou aȝens God so veryabyll?"
(ll. 588-90). That which is as "veryabyll" as time is to be put
aside in the interest of the eternal which is the source of all.
She will seek out Jesus, who is God come into time, in order to
cure the wounds caused by her submission to the temporal order
where she has been led astray by illusion.

Plays such as these mediate, of course, between the time
depicted in the drama--time which is marked by sacred events
of great significance for the entire audience--and contemporary
time. Written in the vernacular, they do not pretend to return
the spectator to the actual time of the original event, but rather
they provide instead an imaginative participation. But beyond
the imaginative experience, as in a religious picture showing a
saint, was an essence that shone through and made the play
more than a mere secular game. To look upon such plays, par-
ticularly if presented as devotional aids during the feast day of
a saint, was regarded as a useful way of breaking down the
barrier of time within the devotional experience elicited by the
sights staged by the actors. Understanding medieval drama in
terms of seriality hence involves a serious critical error, for the
plays indeed are founded on a different view of reality. It is
also important to recognize that this reality itself encompasses a
pre-Renaissance conception of temporality, which when judged

by the modern mind is perhaps most noticeably marked by its vagueness and imprecision.

 CAUSATION, TIME, AND DRAMATIC STRUCTURE. It is true that the medieval English Creation to Doom cycles in particular do deal with one very important cause--the Fall, which is the source of man's fallen nature and of the fractured course of history. But even here the effect is not something capable of being predicted entirely, for the medieval explanation involved something more than the immediate effect--Adam's unhappy consignment to limbo for 4000 years or more until, at the Harrowing of Hell, Christ would release him in the aftermath of his victory on the cross. The matter of cause and effect is paradoxical. As Augustine explained, the Fall of man was a happy one, for through it mankind would benefit more than it would lose.[48] The logic of *love*, which according to some early medieval philosophers was the most important principle in the universe, defied attempts at simplistic analysis directed at such matters as causation. It should come as no surprise when turning to the plays, therefore, to discover that many of them hinge upon episodes and scenes which *defy* the normal processes of causation as understood in post-Renaissance thought.

 The didactic plays--e.g., *Mankind*, *The Castle of Perseverance*, *Everyman*--illustrate the point very well, for they actually dramatize the ways in which normal causative patterns are shattered or canceled through the intervention of the divine. It is Being, which is the only source of unity in the universe, that provides the sacramental scheme so necessary, for example, to Everyman if he is to avoid the *effect* of damnation. And, as we see when he surveys his Goods and his Good Deeds, he would indeed be (if a current slang expression may be used) "in bad shape" at the moment of his death without the grace extended to him through the sacraments which compensate for his defects. The saint plays and Creation to Doom cycles, devotional in purpose, likewise fail to present causation in modern terms. Mary Magdalene in the Digby play is a spectacular example of medieval characterization. The heroine's fall encloses her for a time within the laws of World and Flesh--a small portion of the play only--but her conversion begins the extended scenes in which effects are constantly being detached from normal causes. Much of the material in the latter part of the play is from the *Golden Legend*, and we would use the term *miraculous* to describe it.

 In the *Secunda Pastorum*, a play in which we may at first suspect that the recreative principle has dominated from the first line through line 630 of the 754-line drama, the logic of the language and of events nevertheless defies normal analysis based on the study of causation or motivation. The play is about shepherds because it is a *shepherds' play* illustrating the events of Christmas; these are the shepherds to whom the

Christ Child was first revealed--an episode that was illustrated in art[49] and which generally was of considerable significance for Christian tradition and even for the conduct of everyday life. The shepherds provided not only an influential model of humility, but also, on account of Christ's important parable comparing his followers to sheep, they were a point of comparison by analogy for clergy and laymen. But these seem to be real English shepherds going about their tasks and complaining about the problems of their trade very much in an English context. They encounter a charlatan named Mak, a figure with a Scots name and pretending a southern accent--neither of which should endear him to the ordinary Yorkshireman. Mak, using magic to hoodwink the shepherds, steals a sheep and takes it to his wife, the shrewish Gill. Together they attempt to disguise their theft by placing it in a cradle and pretending that it is a newborn child--a parody, it turns out, of the Christ Child, who is the true Lamb of God destined to be sacrificed on the cross. The element of Christmas game is here, of course; there is good fun enough. But this is not simply a secular drama or a recreative exercise that excludes the sacred; indeed, secular events are, as this play indicates, placed within the context of the eternal breaking into time for man's salvation--a process that is also made contemporary through the continuing efforts of the shepherds of the Church.

The line which we would expect to find drawn between the secular and the sacred simply did not exist for the author of this play. Mak's efforts involve attempts at desacralization, but they only clear the way for the sacred event of the Nativity. By his attempt to *desecrate*, Mak paradoxically calls attention to the Incarnation and to the Eucharist, which, through the efforts of the latter-day shepherds who are the clergy, is celebrated as a remembrance of Christ's incarnation. Just as Adam's sin only results in man's salvation, so the desecration is the reverse of the theatrical effect which will follow--the birth of one who brings salvation to his people. Not even Mak's punishment is very harsh: he is tossed in a blanket--an act which, as one scholar has noted, was used to hasten "delivery in child birth."[50] The first portion of the play therefore may be seen as consistent with the tradition that the shepherds should prophesy--a tradition that characterizes dramatic portrayals of shepherds in medieval drama generally, as Thomas P. Campbell has shown.[51] Can we be surprised, therefore, when we learn that, in contrast to the York Shepherds' play, even the gifts of the shepherds have precise meaning, signifying the Passion ("a bob of cherys"), Christ as Savior ("byrd"), and Christ as King ("a ball")--gifts symbolically precisely parallel to the gifts of the Magi.[52] V. A. Kolve aptly comments: "the progression from episode to episode in this drama is often without consecutive impulse. It is not built upon a theory of direct causation. . . ."[53]

"Direct causation" can exist only in a world which has been successfully subjected to desacralization and in which a separate secular order has been established. For the author of the *Secunda Pastorum*, the world was not separated into the *profane* as opposed to the *sacred*. For this kind of drama, the parts by themselves indeed do add up to something less than the totality which they reflect; when that totality, which can be summed up only in Being, is removed or denied, the plays are destined to be the objects of less admiration than they deserve. By recognizing this, we discover the sources of prejudice which for so long insisted upon seeing the plays as tainted by superstition or as crude because of their supposedly naive treatment of reality. Modern rationalism, which as much as the forces of Protestantism signaled the dramatic changes of the sixteenth century, has always wanted to see smaller secular patterns as entities in themselves.

The secularization of drama in the sixteenth century did not, however, entirely remove the frame of the sacred into which earthly action was placed. Even recreative forms--specifically, comedy--could assert their subordination to the Providential order of things. In the realm of ideas, however, the humanists with their good sense and the scientists with their curious combination of scepticism and rationalism combined to help create a new climate for the future. Galileo was an important figure, of course, in the rise of the new scientific ideas, which applied quantitative measurement to physics and ultimately undermined metaphysical thought.[54] In England during the seventeenth century, his follower Thomas Hobbes likewise spread the "new philosophy of motion" which reduced both time and space to mathematical calculations. But it was the new attitude toward time that brought such ideas together in a way that temporal existence itself should later become viewed as seriality linked to causes--a world-view which most moderns will applaud as evidence of the "decline of magic." Causation therefore became, by the time of Dryden during the latter part of the seventeenth century, the concern which no dramatist could afford to ignore. Under the term *poetic justice* which said that effects in drama must be consistent with their causes, Nahum Tate revised *King Lear* in order to prevent the old king and his daughter from being more sinned against than sinning. *The punishment must fit the crime* had become not only a doctrine of fairness but also, more importantly, a law of seriality in drama.
In drama from the eighteenth to the early twentieth centuries, a principal function of causation was held to be an element of *motivation*, which would derive the driving force behind the play from within the realistic characters of the drama. From Maurice Morgann's essay on Falstaff through A. C. Bradley's *Shakespearean Tragedy*, motivation was implicitly or explicitly regarded as a mainspring of the dramatic action, with Tambur-

laine, Faustus, Richard II, Hamlet, Sejanus, and the other
heroes putting their stamp on all that happens. It was from the
character that the actor was supposed to begin in his re-crea-
tion of each scene, often to the neglect of meaning clearly im-
plied by the original text on the level of iconography or visual
effect. The theater made something very different of Elizabethan
and Jacobean drama, and it was in part the intractability of
medieval forms that made them remain through this period the
least favored plays in the English language.

The biases of the main stream of early twentieth-century
criticism are discussed in Chapter I of O. B. Hardison's *Chris-
tian Rite and Christian Drama in the Middle Ages* (1965). Ap-
plied to dramatic forms of the period before Shakespeare, these
biases were fiercely secular, antagonistic toward "superstition"
while at the same time accepting the convenient belief in evolu-
tion in the arts--a belief involving every bit as much critical
superstition as any medieval play might contain. Furthermore,
the implied attitude toward the earlier plays as "causes" of the
later, more highly developed drama led the critics to see the
latter also in precisely the terms they desired to adopt. Their
critical language was essentially the language of early twentieth-
century psychology, applied to the characters in *Hamlet*, *The
White Devil*, *Faustus*, *King Lear*, *Richard II*, *Macbeth*, etc., as
if these were real people. In the case of the last-named play,
critics wondered (on the basis of Lady Macbeth's lines at
I.v.16-30) if the protagonist and his wife had discussed the
murder before he had met the witches during his return toward
his castle. Hamlet's "madness" was taken seriously in the most
bizarre ways. Faustus, seen through the reinterpretation of
Goethe, became the romantic rebel, the crypto-modern person,
the aspiring and admirably ambitious precursor of all that is
progressive and good in modern life--including its secularism,
scientism, and scepticism. Little of this is taken seriously by
critics of the plays today, and it is hardly worthwhile mention-
ing except for the light that such earlier criticism throws on the
distortion brought about by such misreading of dramatic texts.
Locked into attitudes and ideas that were anachronistic in ap-
plication to these plays, those who emphasized motivation hardly
understood that their reasons really lay in a rejection of the
principles of causation implicit in them--principles that function
outside the intellectual milieu of the modern world. It was not
either a medieval or a Renaissance rule of rhetoric or drama-
turgy that *effects* could not happen on stage without being
rooted in complex *causes* within the psyche of the character,
from whom the action was supposed to flow. (What we know of
the practices of Renaissance playwrights in working up plays,
usually from pre-existing narratives, contradicts this view abso-
lutely.)

But the emphasis on motivation--an emphasis that finds its
ultimate culmination in the theatrical practice of "method act-

ing"--may, in fact, be paradoxically more in response to the
threat of temporal seriality as presented in modern science than
a result of attention to anything else. Mechanistic views of
causation as applied to human behavior are, when linked to
temporal seriality, the makings of a Frankenstein monster who
would be found threatening to all who become aware of his pres-
ence. There are, of course, those, like B. F. Skinner, who
can lively comfortably with this monster. But temporal seriality
that merely sees life in terms of chronological moments and
mechanistic causes, from which there is no release, is ultimately
pessimistic in the extreme, as Samuel Beckett has, I believe,
taught us. Motivation, therefore, may be seen as an attempt to
subsume recent ideas about causation in a more humanistic sys-
tem that is able to transcend serial temporality. But the tran-
scendence involved is only a surrogate transcendence, for it
simply breaks down temporal seriality by means of the applica-
tion of principles that are associated with it.

RITUAL STRUCTURES. The separation between ideas of
cause and effect is even wider in the forms identified with ritu-
al, which by definition are not cut off from the liturgy and
hence bear its interpretation of causation. The *Quem queritis*
scene, for example, involves imitation which deliberately sets
out to break down the normal sequential order of time, as we
have seen. The congregation thus is able to encounter or even
to see events which transpired long ago but which, through the
liturgical action of the Church and its power, continue to be
made present during the services of worshipping Christians.
The rite itself becomes *cause* while the *effect* is the represen-
tation of the sacred event, which to be sure does not exist
merely as a moment in time in the past. The executioners in
the Towneley *Coliphizacio* think their activity is like a game
(Hot Cockles) and localized in time which lacks significance
beyond the here and now;[55] as the participants in the earliest
Passion play, the play from Montecassino, must have known, the
sacred event is eternal and for all time.[56] But rite has made
the sacred event present for those in attendance to see and
experience. The logic of rite is the logic of power.
 To perform the rites correctly is to have power over the
universe. In India there is a saying which illustrates the
point: "If the priest did not offer up the sacrifice of fire every
morning, the sun would not rise."[57] Chronological time for
Indian thought "has no reality, that is to say efficiency, except
in the moments in which divine or sacred acts are con-
certed. . . . In this succession of acts linking moments it
would be vain to look for a given continuity: continuity is no
more than the fruit of the constructive activity which recom-
mences day after day."[58] While it is dangerous to make cross-
cultural comparisons on the basis of language, which may signify
rather different meanings within the different cultural contexts,

the Indian attitude toward the chain of causation as now under-
stood in the West is clear, and it also provides some definite
parallels with traditional Christian thought. Christian rites too
tend to deny the reality of chronological time, which they there-
fore seek to overcome in establishing representations of sacred
events of the past. Since these events are ones which have
marked the past, they also are ones that are able to bring the
meaning of the past event into the present. They also, of
course, are able to point accurately toward the future. By per-
forming the rites, men imitate the actions of the divine person
and hence communally make themselves more like him. In Chris-
tian rite, the central point is the Mass, in which the events of
Maundy Thursday are repeated in the sacred meal whereby the
congregation is able to partake of the actual body and blood of
Christ to their salvation, which is rooted in the future. But
the ritual extends further in the direction of those who were
the first followers of the divine one and also those saints who
came later. The calendar of the Church lists festivals and
saints' days which are relevant here. At Easter in particular,
the holy women, who provide on an archetypal level the pattern
to be followed by those who wish to follow Christ, come to the
tomb to certify that "the Lord has risen from the sepulchre,
who for us hung on the cross, alleluiah."[59] The St. Lambrecht
Visitatio Sepulchri thus also dramatizes this same scene with the
addition of communal singing, ending with the hymn *Surrexit
Dominus de sepulchro* in Latin and *Christ ist erstanden* in the
vernacular.[60] If the purpose of such ritual forms was to excite
devotion,[61] then they did so by achieving a remarkable imme-
diacy in which the congregation could join in praises at the side
of the grave beside the holy women who first discovered the
empty tomb. They were taught how to imitate the divine one
through examples of those who had previously imitated him with
all perfection possible.
 So too the liturgy focused also on the saints who lived
later, some of whom we know were legendary and even fabulous.
The most popular ones were likely subjects for Latin and ver-
nacular plays and for countless representations in the visual
arts. The famous Fleury Playbook contains, for example, a play
honoring the popular saint, Nicholas, and dramatizing the story
of his freeing of the son of Getron (*Ad representandum quomodo
sanctus Nich[o]laus Getron filium . . . liberavit*). The *repre-
sentation* ends with the entire choir singing of the love it feels
for the saint, who "may lead on high those who have been di-
vested of the burdensome flesh."[62] To invoke the saints is to
be lifted out of the temporal existence which binds one to illu-
sion and the vicissitudes of fortune. Even to venerate the sta-
tue of St. Nicholas is the way toward recovery of what is most
important to the parents of the child separated from them, for
to venerate the image is to give honor to the saint himself.
Following such veneration, the figure of Nicholas himself comes

to rescue the child for his parents. The rubrics or stage di-
rections call for someone to come "in similitudine Nicholai."[63]
The saint intercedes for the child with God, and his power is
established. That such power was considered real has been
demonstrated in recent scholarship.[64] The liturgical play, as
closely related to ritual form, is itself an invocation of divine
power. Such drama is radically separated from the later
Hobbesian concern with cause and effect within the secular order,
for here the secular order has no independent existence apart
from Being.

Even within the vernacular drama for which the divine
power functions less immediately, cause and effect are not the
basis for dramatic structure in any modern way. Instead, the
dramatic spectacle is designed to bring the audience within a
circle of action that transcends aesthetics in its function. By
bringing spectators into the scene, the vernacular play is ul-
timately part of the redemptive pattern which is characteristic
of the cult.

III. RISING, FALLING, LEVITATION, ECSTASY

In a drama which is essentially emblematic, the imagery of
falling as symbolic of human failure and alienation should logi-
cally be countered by movement upward as indicative of the
direction of salvation. But levitation on a literal, symbolic, or
even psychological level in medieval (and Renaissance) drama is
no automatic indicator of redemption from the chasm opened
through the pretensions or limitations of man. We need think
only of Macbeth, whose attempt to become the *highest* person in
the realm makes him the most wretched and despicable man in
Scotland. He may be compared to the familiar figure of Icarus,
whose upward flight was interpreted by mythographers to mean
a rebelliousness that determined his inevitable fall. The will to
rise indeed may be the most certain way to prevent the redemp-
tive pattern from functioning in one's life. On the other hand,
the only ultimate solution to man's post-lapsarian condition would
appear to be pointed by the Resurrection and Ascension, which
suggest the divine solution to the problem of the Fall. Such
upward movement, however, is paradoxically characterized by a
relaxation of the will and a surrender of the self to the tran-
scendent which allows the levitation to happen.

The pattern is implicit in a poem by the seventeenth-
century hermetic poet Henry Vaughan, who describes a vision-
ary experience in which the persona sees eternity "Like a great
Ring of pure and endless light" and also visualizes souls suc-
cessfully escaping from time. In contrast to the "fools" who
prefer the darkness of this world to eternity, these "did weep
and sing" as they "soar'd up into the *Ring*/ But most would use
no wing."[65] Vaughan's iconography, as his editor French Fogle
notes, has its source in the *Hermetica* which indicates that

souls, having escaped from the world and ascended to the eighth sphere, engage in song, "hymning the Father," in preparation for their entry into the deity "above the substance of the eighth sphere."[66] Here the will, as in the instance of Christ's surrender to his Father's wishes in the Passion story, requires to be detached from one's normally selfish and earthly attachments; only then can the ascent to the transcendent take place.

In contrast, to attempt *willfully* to rise upward thus is an act doomed from the beginning, as was Eve's hope in the N-Town *Fall of Man* to be equal with God

> So wys as godis in his gret mayn
> and ffelaw in kunnyng ffayn wold I be
> (2.195-96)

or Lucifer's vain belief in the York *Fall of the Angels* that his "powar es passande my peres" (I.56)--a belief that inspires him to attempt to move upward to the highest heaven as God's rival. In the N-Town, Chester, and Towneley plays as in the East Anglian *Holkham Bible Picture Book*, Lucifer actually attempts to sit in God's seat, which represents a rise in status that, he believes, gives him power over the heavens. The *Holkham Bible Picture Book* (fol. 2) shows Lucifer seated on a throne above the circle of the cosmos which encloses the Creator, who is pictured with his traditional compasses; on Lucifer's *left* are five evil angels who are willing to worship him, though as we would expect the six angels on his *right* turn away from him (fig. 43). In the Chester play, his follower Lightborne says:

> And here were nowe the Trenitie,
> we shoulde him passe by our fullgens.
> (I.200-01)

Aptly the Dominaciones, the order of angels who, along with the Principalities and Powers, are given authority with regard to the governing of the universe,[67] advise the rebels: "You have begone a parlous playe" (I.207). The division between selfish will and the eternal truth is hereby set forth in the term *play*, the significance of which has been usefully analyzed in this context by R. W. Hanning.[68] It is a "*daunce*," the Dominaciones indicate, which "wil torne to teene and traye" (Chester I.209; italics mine). These rebellious angels may indeed be presenting a theatrical spectacle--an entertainment characterized, as Hanning indicates, by *false* mimesis through which they hope to reorder the structure of things to suit themselves--but in the end their efforts are destined to be disastrous. The Towneley play shows Lucifer's final act of defiance as an attempted flight upward from God's seat. From the standpoint of stagecraft, this moment surely must have been spectacular, with Lucifer's

flight involving machinery for rising upward and then, unexpec-
tedly, plunging downward into the mouth of hell. The will to
rise is, of course, the determinator of an enforced fall.

RISING AND FALLING. To *rise* is indeed *radical experi-
ence* which breaks the actor free from his roots and lifts him up
over the mundane *space* in which he normally lives. It is, as
we have seen, capable of division into two classifications, de-
pending upon the element of volition. The one links a person
to the mystics and the highest kinds of religious experience,
while the other illustrates willful pride which inevitably goeth
before a fall. Yet in either case, dramatization of such experi-
ence will necessarily be exhilarating since it provides new per-
spectives and new insights for an audience. We today have
the advantage of drawing an analogy with flight as a passenger
in an airplane, which, if we look from the window of the air-
craft, enables us to perceive city streets and farm fields with a
sense of perspective that is radical because the point from which
we look down is unfixed, constantly changing with regard to
altitude and direction. The places normally associated with
events and to which we naturally orient ourselves when we are
on the ground are as if themselves floating, shifting. Flight is
in fact that kind of radical experience which severs normal spa-
tial and hierarchal relationships. Such severing of relationships
may signify either the rebellious shattering of social and reli-
gious bonds, or it may mean the more gentle absorption of the
actor into a higher state which abrogates the hierarchy itself.
For the medieval and Renaissance worlds, only the latter is
genuinely authentic, since the former must participate in the
false acting that denies the normal structure of things. The
rebel who believes that he has the ability to raise himself up-
ward as if in flight is a dreamer whose visions are false--and
also dangerous, for they may precipitate him downward as Luci-
fer was cast down because of his arrogance.

ASCENSION. As St. Bernard insists in his second sermon
on the Ascension, the duty of the individual--a duty affirmed
by St. Paul--is "to seek the things that are above, those to be
found where Christ is seated at the right hand of God. . . ."[69]
In contrast to the attempted self-elevation of Lucifer, the alter-
native option is open--i.e., surrender to the ultimate forces be-
yond the created universe which may raise one up, as in the
poem by Vaughan, to a circle of eternity, a realm characterized
by ecstasy. Bernard explains, "raise yourselves up by humili-
ty. . . . It is impossible for you to ascend unless you begin
by descending. That is an eternal law: 'He who exalts himself
will be humbled; he who humbles himself will be exalted' (Luke
14, 11)."[70] The model for this experience is without question
the resurrected Christ, whose Ascension likewise validated its
direction and underscored its importance.

Of very great significance, therefore, are the ritual re-
presentations of the Ascension which have been noted by Karl
Young,[71] who also describes the manner in which an image was
utilized in the rite to illustrate in a graphic and visual way the
manner of Christ's return to heaven: the effigy, which shows
the risen Christ holding a vexillum and standing in an aureole
of clouds, was raised by ropes until at last it disappeared
through the roof of the church. Ritual forms of this kind are
to be dated in the fifteenth and sixteenth centuries,[72] which
again will demonstrate the longevity of such forms. Their ap-
peal to transcendence, however, illustrates the point that man-
kind is not doomed to the limitations of a closed existence in the
world. Upward movement, while it inevitably makes a radical
break with the world of which man may be considered a part, is
nevertheless the only ultimate freedom open to him.

The possibility of Ascension comes, of course, through
the Resurrection in which Christ demonstrates his power to
overcome the downward pull of death. The grave is the sign of
mankind's imperfect temporal state; it is the normal conclusion
of bodily existence within the realm of becoming. Its terror,
with its final dissolution of the fabric of the body, came during
the late medieval period to be regarded as the symbol of man's
corruptibility and his need for repentance. Even faith cannot
stop the corruption of the body fabric in the tomb, for natural
processes of life insist upon returning "dust to dust." Hence
the Savior's resurrection on the third day is a sign of his abili-
ty to set aside the natural order by means of his *super*natural
power, which not only preserves the divine corpse but also
gives it life beyond the usual means established in nature.
Whereas the normal man's body in death is only the source of
life to worms, which are graphically enough depicted in the
visual arts,[73] Christ's resurrected body is itself the source of
life to those who share the hope of the religious community.

As a visual representation, the Resurrection was from the
first rivaled by the scene of the three holy women being met by
the angel at the empty tomb--a scene illustrated as early as
c.410 in a well-known ivory now in the British Museum.[74] Thus
in the *Benedictional of St. Ethelwold* (c.970) the holy women
(fig. 44) are chosen to illustrate Easter Sunday,[75] which is also
the occasion of the presentation of the *Visitatio Sepulchri* as
recorded in the *Regularis Concordia*. Both these manuscripts
are associated with the same location, Winchester, and both were
assembled following the reorganization of the Minster by King
Edgar in 964. The Easter Sepulcher used in the Winchester *Vi-
sitatio* was, of course, most likely of wood and temporary, uti-
lized for the *Depositio* and *Adoration of the Cross* rites as well
as for the dramatic ceremony on Easter.[76] In spite of the
tendency toward visualizing the verification of the Resurrection
through the event of the Marys approaching the tomb with its
heavenly messenger, the Resurrection itself remained, we need

to recognize, the crucial event of the Christian story within the
liturgy. As early as c.1220 at Beverley in Yorkshire, a play on
the subject of the Resurrection was reported to have been pre-
sented before a crowd of people in the churchyard. The actors
wore masks, and the spectators, motivated by delight, curiosi-
ty, and/or devotion, formed a ring as they watched.[77] Such a
drama as the Resurrection would have certified the power of the
Lord to raise men up also out of their living death and to bring
them in their imperfection to proper devotional attitudes.

 The Church Fathers had laid great stress on the relation-
ship between Easter, which commemorates the Resurrection, and
(1) the season of spring with its renewal of life, and also
(2) the Jewish Passover which has its roots in the Exodus ex-
perience.[78] In late medieval representations in the visual arts in
England, the risen Christ is often shown as a figure *standing*
triumphantly with vexillum or cross-staff in hand and stepping
forth with one foot on a sleeping Roman soldier. Such is the
case with a number of alabaster carvings, including an example
in the Hildburgh collection (fig. 45) and a well-known one at
Ripon.[79] In the Chester cycle, the stage directions indicate
that Christ should likewise place his foot upon the Roman sol-
diers as he steps forth (XVIII.153), while later Primus Miles
tells Pilate that "He sett his foote upon my backe/ that everye
lythe beganne to cracke" (XVIII.274-75). These Roman soldiers
may be thus seen as symbolic of the bondage which Christ has
overcome through the act of his Resurrection. Less directly
than in the writings of the Church Fathers, the Resurrection
scene as it was made visible in late medieval art and drama
nevertheless continued to find ways of illustrating the manner in
which the event included a release from death and also, there-
fore, a renewal of life.

 In the York play of the *Resurrection*, Christ rises from
the tomb without speaking; the spectacle provides almost the
entire effect of the scene, which therefore we can appreciate
only through what we know of it from the visual arts, particu-
larly examples from the same time and location, and from the
later comments of the soldiers. The only words during the
Resurrection itself are those of the angels' song, identified as
Resurgens (presumably the antiphon or alleluia verse *Christus
resurgens ex mortuis*) in a marginal note.[80] Unlike the other
extant vernacular cycles, York's Resurrection scene is purely
the presentation of a devotional image for the audience to see.
The model which demonstrates the pattern of radical and liminal
experience that overcomes death thus is given a presentation
designed for the audience to respond to with pure devotion.

 The Ascension, as noted above, extends the significance
of the Resurrection and makes explicit the implications of
Christ's victory over the powers of darkness and dissolution.
Liturgically, of course, the Feast of the Ascension brings to a
close the Easter season; on this day the paschal candle is ex-

tinguished, for it celebrates the return of Christ in his human
body to sit enthroned at the *right* hand of the Father. And
according to the early traditions of the Church, the ascension
of Christ was appropriately in the *East*.[81] The radical ex-
change of heaven for earth by Christ, *who retains his human
body*, thus links together *rising* with *East* and the *right hand*.
These latter validate the Ascension as authentic experience as
opposed to the attempt to rise by those whom we might call
radicals of the left hand, who are doomed to despair and to
being thrust down into darkness precisely opposed to the light
of heaven. Those who follow Christ, particularly in living the
significance of his Ascension, are thus *radicals of the right
hand*, whose behavior must be severed from the usual obsession
with the things of fallen existence. As the nineteenth-century
thinker Søren Kierkegaard insisted in modern times, a relative
relationship must be established to relative things at the same
time that an absolute relationship is required toward the abso-
lute.[82]

The staging of the Ascension play in the Creation to Doom
civic cycles is, of course, significant here, and Chester may be
used as an example which illustrates the point that the theatri-
cal effect was very important to the producers. The Chester
records for 1539-40 indeed note that the Taylors had agreed "to
bringe . . . forth" the play of the "assencyon" "full right"--
terminology which one critic rightly interprets to mean elaborate
staging designed for spectacular effect.[83] In whatever way it
was staged at Chester, the general effect of the scene is clear:
Christ goes to a particular spot, from which he ascends. The
ascent itself, perhaps by means of a device shaped like an
aureole and surrounded by clouds as in the image noted by
Young, is then arrested while Jesus sings "Ascendo ad Patrem
meum et Patrem vestrum, Deum meum et Deum vestrum. Allelu-
ya."[84] From the standpoint of English art, the iconography of
this scene is slightly unusual, for the most common representa-
tion of Christ shows his feet and the bottom of his gown disap-
pearing into the clouds (fig. 46).[85] The fourteenth-century
Holkham Bible Picture Book, however, illustrates precisely the
scene dramatized in the Chester play (fol. 38); here the full
figure of Christ rises above the raised ground on which he had
been standing--a figure set in the air against the background
of a cloud (fig. 47). In the Chester play also the angels re-
spond to the Christ with singing and surprise; there is no
reason why their music could not have included instrumental
accompaniment, as in the *Holkham Bible Picture Book* illumina-
tion. Angel musicians are, for example, included in local Ches-
ter art in the cathedral, where they play instruments on miseri-
cords and corbels in the choir stalls and in stone carvings on
the West front.[86] Music would naturally have reinforced the
audience's understanding of the significance of the Ascension,
since the meaning of the music would have underlined the ideas

of harmony and consonance implicit in the event. Music disso-
ciates the singers and players (as well as those who are intent
on the sounds) from less ordered distractions and gives a focus
to the mind. Indeed, in its ability to lift up the emotions music
is itself properly related to the upward movement of the Ascen-
sion, which is shown in the play in order to bring man closer to
the heaven behind the clouds through imitation of the radical
event.

The radical nature of the Ascension is also proved
through the response of the angels, who do not recognize
Christ because he returns to heaven in an earthly body. The
point is one that had been peculiarly interpreted by the Church
Fathers, who believed that the angels were not privy to the
secret of the Incarnation and hence were necessarily surprised
at the ascending figure of Christ, whose identity was hidden
behind his humanity.[87] In the Chester play, the third angel
asks:

> Whye ys thy cloathinge nowe so reedd,
> thy bodye bloodye and also head,
> thy clothes also, all that binne ledd,
> like to pressars of wyne?
> (XX.121-24)

The allegorical image of the wine press, though traditional,[88] is
surprising at this point, but to an audience that understands
the proper cultic associations it illustrates how Christ's mission
on earth has been the radical dissolution of the Old Law of
Judaism[89] in the Passion, which is the *source of the radical
freedom* expressed first in the Resurrection and then in the
Ascension.

At the end of Jesus' final speech which appropriately
mentions the "laste daye" (when he will return, again "quasi in
nube"), he completes his ascent, presumably disappearing into a
cloud as in the most common English iconography.[90] The placing
of the Son at the right hand of the Father is not represented in
the play, which stresses the ecstatic nature of the rising of
Christ to the heavens. Unquestionably there is a comparison to
be drawn here with ecstatic experiences of humans in other re-
ligious traditions, particularly with the radical ecstatic states of
the shaman who is said formerly to have traveled to the heavens
in the body though now he is able to do this only in the spirit.
As in the case of the Ascension, the ecstasy looks forward to
the end, to death.[91] But death, along with other causes for
human anxiety, is transcended in the experience.

In the Chester play, the apostles look forward to Pente-
cost, which they know will shortly bring them into the presence
of the Holy Spirit. As Mircea Eliade has said, "the symbolism
of ascension always refers to a breaking-out from a situation
that has become 'blocked' or 'petrified', a rupture of the plane

which makes it possible to pass from one mode of being to an-
other--in short, liberty 'of movement', freedom to change the
situation, to abolish a conditioning system."[92] This liberty and
this freedom are similar in some sense to the false dreams of the
radicals of the left, particularly as shown in Renaissance plays
(e.g., *Doctor Faustus*). In the late medieval plays, which in
the case of Chester are nearly contemporaneous with the great
period of Elizabethan drama,[93] another kind of radical experi-
ence is dramatized as a central experience around which devo-
tional drama may organize its visual and auditory structures.

ECSTASY. Structurally, of course, the plays of the
Assumption and Coronation of the Virgin are closely related to
the model set forth in the Ascension, though, from an icono-
graphic point of view, the Marian plays are distinctly different.
These plays, which present lively presentations extending the
static images of art, were considered highly controversial in the
Reformation period, and indeed the Towneley Manuscript shows
evidence that this material was thought to be so offensive that
the manuscript itself was mutilated in order to be rid of the
plays of the Assumption and Coronation.[94] The reason for the
controversy may be found not only in the nature of religious
images of saints, but also in their role, particularly with regard
to the Virgin, as mediating between the individual and eternity.
Protestants could find no warrant in the bible for Mary's ascent
and coronation as Queen of Heaven, and the devotional attitude
that she represented furthermore was anathema to their ration-
alism, which proclaimed this aspect of Christian tradition to be
mere superstition. But the events concluding Mary's life on
earth are of very great significance nevertheless, as we are
able to realize when they are examined from a phenomenological
standpoint. Unlike Jesus, Mary is entirely human, though to be
sure she is a particularly fortunate human since she is, as the
early Church Councils proclaimed, the Mother of God (*Theo-
tokos*). It is hence a sign of the greatest hope to man that a
human being and indeed a *woman should be raised as Christ
himself was raised in order to be crowned as he was crowned*
(fig. 48). That this second Eve--through whom the name *Eva*
has been converted by radical reversal of the letters to make up
the greeting of Gabriel, *Ave*, at the Annunciation[95]--has become
heaven's queen proves that humanity can be altered through
radical experience which may unite its members to Being itself.
As Mary in her devotion to the body of her Son after the
Crucifixion provides the paradigm of ideal human piety, espe-
cially as expressed in the Pietà or Our Lady of Pity, so also in
general terms she indicates the way that devotion is to take.
Ultimately devotion, which is at the heart of the Creation to
Doom cycles as it is of ritual forms and liturgical drama, should
be expected to lift the religious person up, to provide the ec-
stasy of divine visions whether in fact or in the imagination,

and perhaps even to achieve the goal of mystical experience,
which would take up the soul and unite it with Being in prepa-
ration for the final union of Christ and his Church at the Last
Day. The importance of the figure of Mary indeed was recog-
nized as a principal factor by the author (or authors) of the
N-Town cycle, which Stanley Kahrl and Kenneth Cameron be-
lieve might well have been produced at Lincoln where devotion
to Our Lady was particularly strong in the late Middle Ages.[96]
In any case, Lincoln is known to have had a liturgical play of
the Assumption as early as 1457-58--a play that, apparently,
also included Mary's Coronation, as the records from 1482-83 and
thereafter seem to indicate.[97] This play would appear to have
continued to be played in the cathedral at Lincoln up to 1540-
41, while St. Anne's Day pageants, presented on the feast of
the mother of the Blessed Virgin, were not abandoned until the
death of Henry VIII. However, devotion to the Virgin still
permitted an Annunciation play at the cathedral into the reign
of Queen Elizabeth, finally being suppressed following the per-
formance of 1561-62.[98]

These plays were of considerable cultic importance, and
obviously were abandoned with a reluctance that can only be
vaguely suggested by the records. Their importance lay, of
course, precisely in their ability to bring before the *sight* of
the people those scenes likely to be regarded as most significant
to their devotional lives. In the case of the Assumption and
Coronation, spectacular theatrics[99] were joined with an almost
practical interest in the Virgin's rise to heaven and her corona-
tion by the Trinity. Especially because Christ as King tended
to exhibit a stern aspect toward men, Mary's sympathy for all
mankind was not only popular but also provided a focus for the
religious and moral life of those who remain below in the realm
of becoming. Her ascent to heaven also therefore set the tone
for religious feeling among those who likewise aspired to the
level of Eternity.

The condition of the will in the act of ascending either in
the body or in the spirit toward eternity is perhaps best spelled
out in the Digby *Mary Magdalene*, where the saint and heroine
spends the final segment of her life living the existence of a
contemplative in the wilderness. She sets aside all earthly con-
cerns, including those which are related to food and clothing,
but she is not forgotten by heaven. Hardly could we anywhere
find a more perfectly radical ideal, and the theatrical effects
which the play demands go very far toward explicit presentation
of the phenomenological structure of such otherworldly contem-
plation. Having placed herself totally in God's will, she is sev-
eral times daily lifted up into the clouds--an action modeled on
the event that is decribed in the *Golden Legend* and in art (fig.
49)--and is fed heavenly food by angels. She appropriately is
grateful for being delivered from "hovngure and wexacyon" (l.
2033), and of course she illustrates precisely the kind of life

opposed to that lived by those designated as "fools" in
Vaughan's poem. She herself had, as we know, once lived
precisely such a life, shown earlier in the play. Her point of
crisis came, as we have seen, as she lay in an arbor waiting for
one or another of her lovers to appear. But the key to her new
behavior, especially at the end of her life which is given over
to ecstasy literally depicted, lies in that relaxing of the will
expressed in the following lines:

> I wyll evyr abyte me wyth humelyte,
> And put me in pacyens, my Lord for to love.
>
> . . .
>
> *Fiat voluntas tua* in heven and erth!
> Now am I full of joye and blysse.
> (ll. 1991-92, 2027-28)

Her earthly reward is the joy of hearing the songs of the an-
gels, of eating heavenly food (which, of course, is seen in the
shape of the communion wafer), of fulfillment in "gret felicete"
(l. 2036). For the audience watching this play in the early six-
teenth century (and perhaps as late as 1563, if John Coldewey
is correct in suggesting a production in this year at Chelms-
ford[100]), the "gle and game," if we may borrow thus the saint's
own words (l. 2037), are significantly indicative of a theatrical
experience possible through the presentation of such sights as
those in this play which point the way for all to follow. Es-
sentially, however, the experience remains a devotional one, but
it encourages the *radical break* with the sphere of becoming
that will tend toward release of souls toward the ring of eterni-
ty--a scene later visualized so vividly by the visionary poet
Henry Vaughan.

These comments should further suggest that in no sense
can a strictly formalistic approach to medieval drama provide
clues to its aesthetic basis in medieval Christianity. Particularly
in drama, the texts are not closed semantic structures that can
be read merely in terms of an internal pattern of signification.
Indeed, such a "literary" reading violates the meaning of the
dramatic text, which particularly in the instances elaborated
here sets forth patterns of signification that point toward the
phenomenological meaning that underlies the events portrayed on
stage. These events as set forth sequentially in each of the
plays discussed can benefit, as we have seen, from examination
in terms of diachronic analysis which sets them off historically
in terms of continuities and discontinuities. However, synchronic
approaches which relate the events to social and religious pat-
terns, and to the conditions which brought the staged examples
into existence though not in a directly causative way, will pro-
vide a necessary corrective to much previous criticism.

IV. PLAY AND APOCALYPSE

For the medieval actor or playwright, the *present moment* surprisingly may be said to have held little dramatic interest. Even in recreative entertainment in which mimes turned their mimicry against their hosts and others assembled to see them, the effect of the imitation could only involve past deeds and past events. That is, of course, a stance necessitated by the nature of time, which has been divided conventionally and philosophically into the categories of *past, present,* and *future*--but with the present an ever-changing presence that almost defies definition. Since from this point of view the *future* like the *past* may be linked together as the *not-present* as distinct from the *present*, it was the not-present that drama found to be the source of its fascination; alterity is hence essential to its effect. Distancing in time as well as space was indeed a normal practice in the theater before Shakespeare, as Bernard Beckerman has noted.[101] The object of the play-acting was thus to make the distant in time or space or both seem *as if* present on the stage; the viewers do not, of course, become actually contemporary with the events they see imitated on stage, but the impression of breaking down the barriers of time and space must be present if the play is to be brought alive. In ritual, however, the persons participating in the rite--the *things done*-- actually transcend time and space and stand in the presence of the events themselves in a spiritual sense. As ritual may look toward the past or future and even take its participants out of time itself, so ritual acts in the Christian liturgy may also, for example, gaze ahead beyond the future to eternity and the presence at the heavenly wedding feast at the conclusion of all history, which will end at the Day of Doom. So also may ritual or liturgical drama as well as vernacular religious plays leap ahead to that ultimate of future moments, the Second Coming of Christ, the second Advent. But the theatrical experience, as distinguished from ritual, cannot do more than suggest what the scene might be like, what the characters might say, etc. Nevertheless, the images thus presented in drama may, like religious pictures, prove to be of considerable devotional value; they may even be regarded as somehow participating in the mystery of the original or future event, though not in any absolute sense.

FUTURE. No one should find it at all astounding that, except for interest in events at the end of history, medieval drama finds no subject matter for dramatization in the future. In this drama it is especially as the past has been stamped or marked that its events become of interest to the theater, even when these events are secular ones that make up the structure of, for example, a secular interlude. The future on the whole is simply a neutral expanse of time that has not as yet been marked in any way, and hence, like, say, a stretch of water

stretching as far as one can see but having little interest for
one, it is almost entirely outside one's area of concern. Only
the coast on the other side of the water seems worthy of atten-
tion--i.e., beyond future time is the heavenly kingdom, which
certainly was not absent from people's minds.

Since the past had already happened, since it was there-
fore enclosed within the limits of what had taken place, the
necessary abridgment of the freedom of the artist had thus also
taken place so that he might create the plays which served
medieval audiences in various ways. For the playwright, like
the actor, needed to have his choices laid out for him; unlike
the modern artist or playwright whose existence is in the midst
of chaos in critical and stylistic matters as well as in content,
he could hardly have existed in an atmosphere of such anarchy.
It was not simply that the past was more comfortable, but that
it provided what the playwrights and actors needed in their col-
laborations which delighted and taught and inspired to devotion
their audiences.

Past events are not reversible normally, though the play-
wright's skill or perversity might choose to rearrange the tem-
poral details. In the Renaissance, Shakespeare made Prince Hal
equal in age to Hotspur, though historically the latter was an
older man than the prince's father. Yet the medieval play-
wright's rearrangements, which are rarely the result of un-
bridled imagination (e.g., the York Nativity play, which is in-
formed by the new form of the Nativity introduced by St. Brid-
get of Sweden), nevertheless do need to involve the establish-
ment of some internal consistency, a quality that was recognized
as analogous or even coterminous with *game* and *play* with their
conventions and rules. In bringing scenes to life, theatrical
logic needs to be applied rather than the logic of rational dis-
course. When, for example, the logic of the homilist impinges
too much on the drama, as in *Gorboduc* and, I believe, in some
of the speeches of Mercy in *Mankind*, the result is less satis-
factory dramatically than we might like. Events that have taken
place, either in the recent past or distant (e.g., in "antiquity"
as defined popularly in the usage of the Middle Ages), inevitab-
ly require the reshaping necessary to make presentation upon
stage viable. In the case of the medieval Creation to Doom
cycles, such reshaping was limited and indeed could not be
otherwise, since the plays set out to present in lively form
precisely those scenes which were already well known from the
visual arts. Recreative or didactic forms might take more re-
shaping or even original shaping when existing structures failed
to provide the necessary designs needed by the playwrights,
whom we must always imagine working closely with actors and
stage designers to produce drama that was immediately destined
for production.

The future quite obviously provided no such source ma-
terials for drama, and hence in that period so far removed from

our current twentieth-century anxiety about the future and our
fascination for "futurology," the stage found little to interest it
in time which had not yet come into the present. The exception
to this rule is, of course, the matter of the end time, which
laymen and churchmen alike saw in terms of myth rather than,
as is so often the case today, man's self-destruction.

ANTI-CHRIST. For the great English Creation to Doom
cycles the feared Last Day seems to be almost obligatory within
the structure of the cycle itself, though we know that such a
conclusion was in fact not required in civic drama that focused
less broadly on sacred history. Of the extant cycles, only
Chester has dramatic material between biblical times and the
appearance of Christ as judge in the East, and this, like the
Judgment play, is closely linked to the event of the end of the
world. Chester's unique plays are the Clotheworkers' *Anti-
christ's Prophets* (Play XXII) and the Diars' *Antichrist* (Play
XXIII). The first of these is, as Rosemary Woolf suggests,
surely "modelled upon a prophets' play."[102] In rather pedes-
trian fashion, prophets appear to speak of the coming of Anti-
Christ, and at the end of the play the Expositor simply explains
the Fifteen Signs of Doomsday. These Signs appear widely in
the visual arts, though perhaps most impressively in painted
glass in All Saints, North Street, York, and in the *Holkham
Bible Picture Book*, fols. 40V-42. Of particular interest is the
last scene represented on fol. 41V of the *Holkham Bible Picture
Book* and also in the York glass: all the living die in prepara-
tion for the resurrection of all at the Second Coming.
The Chester Expositor, following Peter Comestor's *Historia Scho-
lastica*,[103] places this event on the "thirteene daye" when "shall
dye all men/ and ryse anone agayne right then"--i.e., on the
fifteenth day (XXII.325-26). (The death of all the living also
plays, as we shall note, a part in the Towneley *Judicium*.)
Much more lively is the Chester *Antichrist*, which selects
scenes from the massive Anti-Christ literature of the Middle
Ages[104] to show a mounting struggle between a pretender to
divinity who is *simia Christi*, "ape of Christ," and the true
Christian people. A mock resurrection, fake miracles in which
persons are raised from death, conversions of earthly leaders--
these are all part of the spectacle which illustrates the period
that will come "in the last days." Needless to say, there was
intense interest in this kind of prophetically determined future
history--an interest that would also be aroused following the
Reformation among Protestants. As Norman Cohn says of the
medieval period, "generation after generation lived in constant
expectation of the all-destroying demon whose reign was indeed
to be lawless chaos, an age given over to robbery and rapine,
torture and massacre, but was also to be the prelude to the
longed-for consummation, the Second Coming and the Kingdom
of the Saints."[105] Like the earlier *Ludus de Antichristo* from

the twelfth century, the work of the Chester playwright draws
from such promising material; from his sources he designs a
play that exploits the legend's possibilities for theatrical dis-
play.

Chester's Antechrist in his presence insists on his sov-
ereignty in the world and proclaims himself to be the Messiah;
like Lucifer in the first play of the cycle who insists upon sit-
ting in God's "steade" in order "to exsaulte myselfe in this same
see" (I.186-87), Antechrist makes a point of seating himself in a
chair of authority. Here he accepts the sacrifices of the kings
of the earth and mocks the true sovereignty in heaven and
earth of Christ, who has been crowned (offstage) following his
Ascension in Play XX. Antechrist's power is, however, based on
fraud--i.e., on the demonic deception that has made it possible
for him to appear to raise the dead. Antechrist's bragging will
be recognized as reminiscent of Herod, who is the great symbol
of vindictiveness (in painted glass at Fairford he is appropri-
ately shown holding a sword with a child on it as on a spit);
the actor playing the role of Antechrist will hence surely have
had ample opportunity for indecorous behavior and gesture
which undercut his actions and words. But it is the appearance
of Enoch and Elijah that transforms the play into an effective
confrontation between an agent of the devil and agents of the
true God. The seriousness of the audience's interest in such a
scene could hardly have dampened its enjoyment at seeing Ante-
christ put in his place, though, of course, certain Lollards and
the majority of Protestants may have broadly objected to the
entire idea of *playing* with such religious ideas.[106] The *play*
element which seemed almost lacking in the previous pageant
here appears heightened as the two forces at work in the world--
forces, divided in a binary manner, which go back to the
primordial alignments that had been shown in the earliest plays
of the Creation to Doom cycle--engage in what seems more than
anything else like a mock battle. Of course, evil has no chance
for survival in the face of good since it is all pretense and
deception without substance; the men whom Antechrist has
brought back to life cannot, for example, eat food that has been
blessed by Elijah. (The fact that the food is "breadd" further
suggests a connection with the Eucharist, and this does provide
perhaps a connection with the emphasis of the liturgy of the
feast of Corpus Christi, the occasion for the performance of the
Chester plays before the change to Whitsuntide.[107]) And
Antechrist, the "ape of Christ," cannot in the end prevent his
own destiny from being consummated: he too must be seized
upon by demons, who revel in the knowledge that he will soon
feel "pennance and payne" (XXIII.680). If the latter days will
see the rise of such a tyrant, at the least he will fail to with-
stand the assaults of the agents of divinity, who still continue
to control time and space.

DOOMSDAY. While the Anti-Christ theme is hardly one that is required in order to complete the theatrical display of the late medieval Creation to Doom civic cycles, the Last Judgment would obviously seem, of course, to be more clearly essential, though it is missing from the Cornish cycle. Significantly, Doomsday represents a point in history when every person will return and play his part in the drama that will be staged in the court of the divine Judge. This way of looking at the final events of history is not frivolous. At York the Last Judgment play was considered so significant that its staging was assigned to the most important and affluent guild, the Mercers. Of course the guild members themselves would not in this case have performed in this pageant, and we have record of payments to others, presumably more capable as players than the Mercers who virtually controlled the city council and who must have insisted upon the playing of their play in a properly impressive manner. Judging from the evidence of payments for the pageant, this guild was very concerned surely to see that the final spectacle of the cycle was appropriately spectacular. Payments in 1461 are recorded for extensive repairs to the pageant, for the services of four minstrels, and for the "klarke for playeng."[108] Very likely the clerk was the director of the play who paid the other players out of his fee of eighteen shillings (not then a small sum), since the presence of these other actors is also verified by the records as well as by the demands of the play text for personnel. The meticulous accounts illustrate surely the value of the Doomsday play to the guild, which regarded its role in the presentation of the theatrical spectacle as a form of charitable duty.

To think about the end of the world is a prime duty of the religious person, and it is no accident that such thoughts are stressed in sermons and other texts associated with the *beginning* of the Church year--i.e., with the season of Advent, which parallels the historical period from Adam up to the birth of Christ. The warning contained in John Mirk's sermon for the first Sunday in Advent is quite explicit:

> Wherfor he þat wyll scape þe dome þat he wyll come to at þe second comyng, he most lay downe all maner of pride and heynes of hert, and know hymselfe þat he ys not but a wryche and slyme of erth, and soo hold mekenes yn his hert. He most trauayl his body yn good werkes, and gete his lyfe wyth swynke, and put away all ydylnes and slewth. For he þat wyll not trauayle here wyth men, as Seynt Barnard sayth, he schall trauayle ay wyth þe fendes of hell.[109]

Advent is thus a time to recall Adam's fall and the effect of the event upon the race with its subsequent need for salvation, and quite simply such looking back to that primordial event also invites--even demands--looking ahead into the future to the

other end of time's linear passage. The *Speculum Sacerdotale* advises:

> Knowe that the aduent of oure Lord is in þre maners.
> The first is in his flesche; the secound in hertes of his
> trewe peple, the whiche aduent is iche day by the Holy
> Gost; and the thridde aduent is when he schall come at
> the day of dome in his maieste.[110]

Just as the people before the birth of Christ waited for his coming, so now in Advent the members of his Church should anticipate the final Advent when time and space should be abolished and when all the souls who have been accepted into bliss will enter into the ecstasy of Being.

The position of the Apocalypse in the devotional lives of the people is suggested by the placement of scenes showing this future episode in the visual arts. The Last Judgment was indeed one of the most common subjects of medieval art, and appears in its most complex form in John Thornton's East Window in York Minster and in manuscript illuminations such as those in the Douce Apocalypse, which preserve the form of apocalyptic events from the book of Revelation attributed to St. John. This is, however, unusual in more popular art, for most of the Last Judgment scenes in England are derived from the account in Matthew 25, which also is the source for the extant Last Judgment plays with their emphasis on the Corporal Acts of Mercy as a principle of division between the good and the bad souls. Such is the case in the wall painting unusually placed on the west wall of the parish church at Trotton, Sussex, where the Good Soul at the Judgment (curiously placed on Christ's left, since the normal orientation is reversed in this example) is encircled by emblems illustrating the Corporal Acts (fig. 50).[111] The emblems are, of course, illustrative of Christ's words which, in the paraphrase of Mirk's *Festial*, assert: "For when 3e dyddyn þus for my loue, 3e dydden hyt to me and as moche þonke I kan you for þat 3e dydden to þe lest of myn, as 3e hadden don hit to myn owne selfe; wherfor goo 3e now ynto þat ioye þat euer schall last."[112] At Trotton, as at St. Thomas of Canterbury, Salisbury (fig. 36), the image of the Savior appears sitting on a rainbow and judging the sons of Adam. At Salisbury, as we have seen, that wall painting is "correctly" oriented with the good souls on Christ's right and the evil ones on his left, and it is placed in the more conventional East end of the nave over the chancel arch. The placing of such a wall painting may therefore indicate the direction of Christian hope, which in order to be fulfilled must pass under the Judge in order to be present at the heavenly feast that here is prefigured in the Eucharist celebrated at the altar on a daily basis. Quite appropriately, the epistle lesson for Corpus Christi, the feast day which was the occasion of drama in many

English cities, links the past event of the "death of the Lord" to the time when he shall "come" again, and the linkage is through the communion of the body and blood received at the altar. So also does the sequence for the same feast day look forward past the Eucharistic banquet to the heavenly banquet in eternity.

The Last Judgment plays in the civic cycles thus prove that late medieval Christianity did not merely look back at the events of past biblical history; indeed, there is after all a future orientation about the religiosity of this period. The historical events themselves tended to be placed within the framework of eschatological hope which demanded provision for a proper entrance into the desired state at the Last Day. The Mass itself is at once a memory of past events in time and a foreshadowing of events which are summed up in this hope. But in order to have hope, despair must also be potentially present; the possibility of the joys of the heavenly banquet is balanced against that of the sorrows of hell. In the continental Latin and Provençal music-drama *Sponsus*, the wise virgins imply their opposites within the binary system. So also in the Last Judgment, the followers of Abel gain their significance through comparison with the followers of Cain. In a sense, therefore, the vernacular plays of Doomsday set out to do something encouraged by the contemplative tradition: they attempt to visualize what it would be like for the individual to be present at this final act of history. Thus the spectacle may be regarded as a meditative aid not so far removed from the iconography of such a painting as Georges de la Tour's well-known *La Madeleine au Miroir*. In this painting, Mary Magdalene, her left hand placed on a skull--a reminder of mortality, as we must be aware--and using the light of a candle to look into a mirror, prepares her face to meet the face of her Redeemer at the Last Day.[113] Mary Magdalene is not only the ideal contemplative, but also the model whom all men attempting to engage in meditation should learn to follow; she is indeed the exemplar of the contemplative life which stresses devotional acts just as her sister in medieval tradition (which saw Mary Magdalene as the same Mary who was the sister of Martha) embodies the essence of the active life. In seeing the play of the Last Judgment, therefore, a person may do precisely what the Magdalen had done in her retreat from the observing of appearances in order that she might give attention to the realities of earthly existence and to its mortality as tested against the Last Judgment. To be present at the play hence gives a person an imaginative view of what that event would resemble when it occurs, and it allows the viewers to visualize themselves among the souls of the evil as well as the good rising from the tombs. In the visual arts, even the highest dignitaries of the Church clearly were possibly to find themselves on the left hand of God at this fateful day, and hence no ordinary person could be so presumptuous as to

assume that his future life would of necessity be secure.

The Towneley *Judicium*, unlike its source which is the York Mercers' play, tips the interest in the direction of Cain's kin and the devils who will torture them forever. This play thus becomes, like the quotation from Mirk's *Festial* above, cautionary as well as devotional, and hence it seems in part to exemplify the sneer in the *Tretise of miraclis pleyinge*: "Pley we a pley of Anticrist and of the Day of Dome that sum man may be convertid therby."[114] The separation of good and evil souls through the instrumentality of St. Michael will be followed by the evil ones being seized upon by *primus demon* or Satan, *secundus demon*, Tutivillus, and perhaps some others dressed in the hairy garments normally assigned to devils in English art of the late medieval period. At lines 112-16 of the Towneley play, Satan comes to the realization that the Last Day of history has come, and looks forward to the conflict, which in fact will be aggression turned against the souls of the wicked, for the war with the powers of God has already been lost. The demons set out to appear at the Judgment carrying their books and rolls containing evidence of wicked deeds for use in their legal claims in which they will assert their right to the followers of Cain. After the decision of the Judge, they will be able to carry away their own to the prison house of hell where they will live forever "in pyk and tar" (XXX.597).

The irrationality of the demons' world is particularly evident in Tutivillus, who is normally assigned the task of collecting words skipped or mumbled in the services of the Church and in devotions. This demon writes down those words on a roll (he is identified in line 212 of the Towneley play as a "courte rollar") and then presumably places them in a bag. Tutivillus is appropriately described by the author of *Jacob's Well* in a section that treats Sloth, one of the Seven Deadly Sins:

> Jacobus de vitriaco tellyth þat an holy man stood in cherch in a qwere, and sey₃ a feend beryng a gret sacchell full of thyng. þe feend, as þe man askyd þe feend what he bare, þe feend seyde: "I bere in my sacche sylablys and woordys, ouerskyppyd and synkopyd, and verse and psalmys þe whiche þese clerkys han stolyn in þe qweere, and haue fayled in here seruyse."[115]

In the Towneley play, he tells his name:

> Mi name is tutiuillus,
> my horne is blawen;
> ffragmina verborum/ tutiu[i]llus colligit horum,
> Belzabub algorum/ belial belium doliorum.
> (XXX.249-52)

The first line has been adapted from Tutivillus' usual motto
(*Fragmina psalmorum colligit horum*[116]) and reflects the ex-
panded duties of the Towneley Tutivillus, who seems to have
charge of idle and wicked words generally. But since these
words collected by Tutivillus are wrenched from their original
context in the interest of demonic vindictiveness, they illustrate
how all rationality is put aside. An actor playing this demon
furthermore shows the manner in which normal patterns of be-
havior will need to be set aside for this role; he is like one
playing in a game and taking on a character that requires con-
sistency entirely apart from the player's normal behavior. The
player thus becomes like a puppet, losing his normal freedom of
movement and action in the game which restricts behavior to
that which is in this case appropriately inappropriate. We may
be reminded that perhaps the earliest proscenium arch back-
ground for playing is that illustrated in medieval miniatures in
the margin of a Bodleian Library manuscript of the *Romance of
Alexander* (c.1340) which shows a puppet theater.[117] The
self-limiting action which the demons impose on themselves thus
reduces their role in the game to a closed system which, with
its arbitrary and irrational rules for behavior, cuts them off
from the sources of life represented by those figures associated
with heaven. The closed system functions like the proscenium
arch, which separates action from whatever else might naturally
be connected with it.

The idea of playing such creatures as demons was found
particularly upsetting by the enemies of play acting, for in some
sense the players were believed to be participants in the evil
which they only represented. But representation is neverthe-
less bringing something back into the present through perform-
ance, even though this may be bringing the event before one's
eyes again but imaginatively. The grotesques which are demons,
very common figures in the visual arts, nevertheless come alive
in a more real sense when *played*. Comic elements and deliberate
absurdity, however, help to forge a division between evil fig-
ures and the normal conditions of life. If the audience can
laugh at the character of Tutivillus, as it surely did, laughter
can assist in estabishing the necessary separation between the
figure of evil and the audience. The laughter also made the
role tolerable to the person playing it, though in no sense
should we suggest that the demons as presented in the Towneley
Judicium were broadly or essentially slapstick. Devils and hell
also very definitely had their serious side which went beyond
the play element such as was introduced in the medieval vernac-
ular plays.

The apocalyptic events themselves are, of course, to be
taken very seriously. The Towneley play may signal to us that
"domysday is comme" (XXX.115) through the speech of devils,
who are aware of its imminence through the tradition of the
Fifteen Signs of Doomsday, but those happenings are not there-

fore laughable simply because they have been announced by
demons. Making reference to the death of all the living (on the
thirteenth day, according to the *Historica Scholastica*), the sec-
ond demon indicates that recently "saules cam so thyk" that
"Oure porter at hell yate" has been required to be "vp erly and
downe late" in the carrying out of his duties with reference to
the evil souls in need of accommodation in hell (XXX.371-76).
Satan indicates his suspicion that the time was "nere the prik"
on account of this sign (XXX.368-70). All have died, and at
this point in the play, as Satan notes, all souls have gone forth
from hell to attend at the court of the Last Judgment.

Beyond the Judgment and the binary separation of souls,
who are either welcomed into heaven or coerced into hell, the
medieval theater could not extend its art. *Representation* fails
in any attempt to carry further the expression of heavenly bliss
or even of eternal tortures. In the visual arts, the heavenly
city is not uncommonly represented, as is the region of hell.
Both are best known by their entrances, with St. Peter acting
as the porter at one and welcoming the clothed souls of the
righteous, and with demons standing guard at the other with its
gaping entrance shaped like the mouth of a great and ravenous
beast. Hell represents the *technology* of torture, with the blast
furnace utilized by the artists to show its intense heat in the
service of torture from the time of its introduction among medi-
eval metal workers.[118] Heaven ordinarily appears like a medi-
eval city with walls and idealized buildings not so different from
those we know to have existed in England. But the heavenly
wedding feast, the ecstasy of bliss--these are events beyond
the ability of the theater to represent for a very simple reason.
The theater is temporal, setting forth spectacle in sequential
patterns that provide imitation of events in the realm of becom-
ing; Being is beyond its normal realm. Eternal punishment, of
course, appears frequently enough in the visual arts, though
even here the depiction is likely to be the torture of souls prior
to the Last Judgment, as also in Dante's *Divine Comedy*. The
depictions therefore visualize hell from the perspective of this
side of the end of time. The theater thus is likewise time-
bound, even in its vision of the closure of the historical pat-
tern.

It is, of course, to the gates of heaven that the Last
Judgment plays look at their conclusion. The souls of the wick-
ed may still be in the process of being herded off to their ter-
rible fate, but the audience's attention is really focused finally
on those who have received salvation. The Chester plays con-
clude with speeches by the four Evangelists, while Towneley and
York are completed with music, suggesting the manner in which
earthly beings are brought finally into perfect tune with the
eternal order. Deus in the York Mercers' play concludes, as we
might expect, with the gesture of his blessing:

And þei þat mendid þame whils þei moght
Schall belde and bide in my blissing.
(XLVII.379-80)

And in the end the angels cross from place to place singing a melody. In the Towneley manuscript, the closing music is appropriately the *Te Deum*--the song of praise which had also been sung by the angels around God's throne in the first play of the York Creation to Doom cycle.[119]

NOTES

[1]See the provocative remarks of Jean Leclercq in his article "Experience and Interpretation of Time in the Early Middle Ages," *Studies in Medieval Culture*, 5 (1975), 9, who reports the study of Robert Fawtier, "Comment, au début du XIVe siecle, un roi de France pouvait-il se représenter son royaume?" *Académie des inscriptions et belle-lettres, Compte-rendu des séances de l'année 1959* (Paris, 1960), pp. 117-23.

[2]See John Velz, "From Jerusalem to Damascus: Bilocal Dramaturgy in Medieval and Shakespearian Conversion Plays," *Comparative Drama*, 15 (1981-82), 311-26, for a study of one aspect of the handling of space in early drama.

[3]*The York Plays*, ed. Richard Beadle (London: Edward Arnold, 1982), Play XLVII.317, 370.

[4]*Republic* 614c-614d (italics mine); *Collected Dialogues of Plato*, ed. Edith Hamilton and Huntington Cairns, Bollingen ser., 71 (Princeton: Princeton Univ. Press, 1961), p. 839.

[5]See Robert Hertz, "The Pre-eminence of the Right Hand: A Study in Religious Polarity," in *Right and Left: Essays on Dual Symbolic Classification*, ed. Rodney Needham (Chicago: Univ. of Chicago Press, 1973), pp. 3-31. The association of *right* with *up* is neatly set forth in Swedish, which uses the word *högra* (i.e., *higher*) for the right hand. For another study which provides interesting insights with regard to spatial orientation, see George Lakoff and Mark Johnson, *Metaphors We Live By* (Chicago: Univ. of Chicago Press, 1980).

[6]*Ludus Coventriae*, ed. K. S. Block, EETS, e.s. 120 (1922).

[7]Bulwer's plate illustrating this gesture is conveniently reprinted in B. L. Joseph, *Elizabethan Acting*, 2nd ed. (Oxford: Oxford Univ. Press, 1964), fig. 5.

[8]*Ben Jonson*, ed. C. H. Herford, Percy and Evelyn Simpson (Oxford, 1925-52), VII, 301. Jonson normally utilized *dancing* as an emblem of order, as John C. Meagher notes (*Method and Meaning in Jonson's Masques* [Notre Dame: Univ. of Notre Dame Press, 1966], pp. 82-91). As such, it functioned emblematically, particularly in the masques for which dancing was central to their structure. An illustration showing a per-

verse round dance is the seventeenth-century woodcut noted by
John P. Cutts, "Seventeenth-Century Illustrations of Three
Masques by Jonson," *Comparative Drama*, 6 (1972), 130, fig. 2.
This kind of dance also functioned emblematically for Jonson,
who surely saw it as a hieroglyph of *disorder*. The result was
not entirely novelty of spectacle, however, since he insists that
he relied upon "the authority of antient, and late *Writers*" for
the specification of properties associated with the witches danc-
ing to the "hollow and infernall musique" provided for the occa-
sion (*Ben Jonson*, VII, 283). See also Meagher, p. 52.

[9]For similar reasons, perhaps, masculinity is associated
with the sun and femininity with the moon. See the interesting
alchemical illustrations from the *Rosarium philosophorum* (Frank-
fort, 1550) which are reproduced by C. G. Jung in *Collected
Works*, XVI (Princeton: Princeton Univ. Press, 1954), figs.
1-10; Sol and Luna here not only represent elements in chemical
union, but also the male and female principles themselves. It is
therefore interesting to see the emblems of sun and moon on the
right and left respectively of the crucified Christ in an illus-
tration such as the one in British Library MS. Arundel 60, fol.
12[v] (Francis Wormald, *English Drawings of the Tenth and Elev-
enth Centuries* [London: Faber and Faber, 1952], Pl. 33). The
history of this iconography is briefly sketched by Gertrud
Schiller, *Iconography of Christian Art* (Greenwich, Conn.: New
York Graphic Soc., 1972), II, 109.

[10]Unquestionably this is the side to which, for various
reasons, the devil or his bad angel makes approach. The illus-
trations that accompany the Middle English poem "Of the Seven
Ages" in British Library MS. Add. 37,049, fols. 28[v]-29, show
that in every case the artist has carefully placed the protagon-
ist's (good) "Angel" on his right and the "Fende" (or bad
angel) on his left. See Alan H. Nelson, "'Of the seuen ages':
An Unknown Analogue of *The Castle of Perseverance*," in *Stud-
ies in Medieval Drama in Honor of William L. Smoldon*, ed. Clif-
ford Davidson (*Comparative Drama*, 8, No. 1 [1974], 127-28). In
The Castle of Perseverance, Humanum Genus comments that
"T[w]o aungels bene asynyd to me" and that "þe ton techyth
me to goode" who may be seen "On my ryth syde" (ll. 301-03).
Though he does not say so, the other angel, who attempts "To
drawe me to þo dewylys wode/ þat in helle ben thycke" (ll.
308-09), would obviously be associated with his other side--i.e.,
his left.

[11]Louis Bouyer, *Rite and Man*, trans. M. Joseph Costelloe
(Notre Dame: Univ. of Notre Dame Press, 1963), p. 170.

[12]Dunbar Ogden, "The Use of Architectural Space in
Medieval Music Drama," *Studies in Medieval Drama in Honor of
William L. Smoldon*, p. 65.

[13]See the scene represented in the production by the
Society for Old Music, as illustrated in the frontispiece in *ibid.*

[14]Josef A. Jungmann, *The Mass of the Roman Rite*, trans.

F. A. Brunner (New York, 1951), I, 413; Bouyer, p. 176.

[15]Line 134; I quote from the edition by Mark Eccles, *Macro Plays*, EETS, 262 (1969). Cf. Natalie Crohn Schmitt, "Was There a Medieval Theatre in the Round," in *Medieval English Drama*, ed. Jerome Taylor and Alan H. Nelson (Chicago: Univ. of Chicago Press, 1972); see also S. Miyajima, *The Theatre of Man* (Clevedon: Clevedon Printing, 1977), pp. 39–41. For a somewhat different interpretation of the stage diagram, see Catherine Belsey, "The Stage Plan of *The Castle of Perseverance*," *Theatre Notebook*, 28 (1974), 124–32, who makes reference to the *mappa mundi*.

[16]Richard Southern, *The Medieval Theatre in the Round* (London: Faber and Faber, 1957), pp. 17–142; see Schmitt, "Was There a Theatre in the Round?" in *Medieval English Drama*, pp. 292–315. Southern's suggestions, in spite of almost total lack of evidence, nevertheless attracted a large following. See also the discussion in Miyajima, pp. 33–46.

[17]Merle Fifield, "The Arena Theatres in Vienna Codices 2535 and 2536," *Comparative Drama*, 2 (1968–69), 259–82, Pls. 1–7.

[18]See *Jacob's Well*, ed. Arthur Brandeis, EETS, o.s. 115 (1900), pp. 147–48, for the identification of the tavern as the devil's "chapel"; here "his dyscyples stodyen and syngyn, bothe day and nyght." See also G. R. Owst, *Literature and Pulpit in Medieval England*, 2nd ed. (Oxford: Blackwell, 1961), pp. 438–41.

[19]Schmitt, "Was There a Medieval Theatre in the Round?" in *Medieval English Drama*, p. 306.

[20]Mircea Eliade, *Cosmos and History: The Myth of the Eternal Return*, trans. Willard R. Trask (1954; rpt. New York: Harper and Row, 1959), pp. 12–17.

[21]Erwin Panofsky, *Studies in Iconology* (1939; rpt. New York: Harper and Row, 1962), pp. 69–93; Ricardo J. Quinones, *The Renaissance Discovery of Time* (Cambridge: Harvard Univ. Press, 1972), pp. 3–27.

[22]See also Samuel C. Chew, *The Pilgrimage of Life* (New Haven: Yale Univ. Press, 1962), pp. 12–17.

[23]Panofsky, *Studies in Iconology*, p. 82.

[24]Chew, *Pilgrimage of Life*, pp. 19–22; F. Saxl, "Veritas Filia Temporis," in *Philosophy and History: Essays Presented to Ernst Cassirer* (Oxford, 1936), pp. 197–222; D. J. Gordon, "*Veritas Filia Temporis*: Hadrianus Junius and Geoffrey Whitney," *The Renaissance Imagination*, ed. Stephen Orgel (Berkeley and Los Angeles: Univ. of California Press, 1975), pp. 221–32; Russell Fraser, *The War Against Poetry* (Princeton: Princeton Univ. Press, 1970), pp. 52–76.

[25]For an analysis of Palestrina's *mannerism*, see especially Audrey Davidson, *Substance and Manner* (St. Paul: Hiawatha Press, 1977), pp. 63–71. The older idea of the early baroque in music has been subjected to a rather thorough revision; see

the important comments by Arnold Salop, *Studies on the History of Musical Style* (Detroit: Wayne State Univ. Press, 1971), pp. 213-14, and also Audrey Ekdahl Davidson and Clifford Davidson, "The Function of Rhetoric, Marlowe's *Tamburlaine*, and 'Reciprocal Illumination'," *Ball State University Forum*, 22, No. 1 (Winter 1981), 20-29.

[26]Chew, *Pilgrimage of Life*, pp. 26-30.

[27]For a discussion of time and *Hamlet*, see Clifford Davidson, "The Triumph of Time," *Dalhousie Review*, 50 (1970), 170-81.

[28]Patrick J. Collins, "Narrative Bible Cycles in Medieval Art and Drama," in *The Drama of the Middle Ages*, ed. Clifford Davidson, C. J. Gianakaris, and John H. Stroupe (New York: AMS Press, 1982), pp. 118-39.

[29]H. Th. Musper, *Die Urausgaben der holländischen Apokalpse und Biblia Pauperum* (Munich: Prestel-Verlag, 1961), p. 24.

[30]See Arnold Williams, "Typology and the Cycle Plays: Some Criteria," *Speculum*, 43 (1968), 677-84. Williams is reacting to approaches of the kind recommended by John Dennis Hurrell, "The Figural Approach to Medieval Drama," *College English*, 26 (1965), 598-604. See, however, the balanced approach of Patrick J. Collins, "Typology, Criticism, and Medieval Drama: Some Observations on Method," *Comparative Drama*, 10 (1976-77), 298-313.

[31]On the age of Isaac, see Minnie E. Wells, "The Age of Isaac at the Time of the Sacrifice," *Modern Language Notes*, 54 (1939), 579-82. Richard J. Collier points out the parallels between Isaac and Christ at the time of his Passion in *Poetry and Drama in the York Corpus Christi Play* (Hamden, Conn.: Archon, 1978), p. 209. See also Rosemary Woolf, "The Effect of Typology on the English Mediaeval Plays of Abraham and Isaac," *Speculum*, 32 (1957), 805-25.

[32]See the misericord at Worcester Cathedral (M. D. Anderson, *The Imagery of British Churches* [London: John Murray, 1955], Pl. 5a). This typology is consistent with the recommendations presented in the treatise *Pictor in Carmina*; see M. R. James, "*Pictor in Carmina*," *Archaeologia*, 94 (1951), 161. Rosemary Woolf additionally notes examples, including painted glass in the corona at Canterbury, in which the wood is arranged on the altar in the shape of a cross ("The Effect of Typology," p. 807). See Madeline Harrison Caviness, *The Early Stained Glass of Canterbury Cathedral* (Princeton: Princeton Univ. Press, 1977), fig. 148.

[33]*Meditations on the Life of Christ*, trans. and ed. Isa Ragusa and Rosalie B. Green (Princeton: Princeton Univ. Press, 1961), p. 321.

[34]Jean Daniélou, *The Bible and the Liturgy* (Notre Dame: Univ. of Notre Dame Press, 1956), p. 95.

[35]W. A. Pantin, *The English Church in the Fourteenth*

Century (Cambridge: Cambridge Univ. Press, 1955), p. 241;
Collins, "Typology, Criticism, and Medieval Drama," pp. 302-05.

[36]*Religious Lyrics of the XVth Century*, ed. Carleton
Brown (Oxford: Clarendon Press, 1939), p. 120 (No. 83).

[37]Alexis Kagame, "The Empirical Apperception of Time and
the Conception of History in Bantu Thought," in *Cultures and
Time*, introd. Paul Ricoeur (Paris: Unesco Press, 1976), p. 99.

[38]Leclercq, "Experience and Interpretation of Time," p.
14. See also the general discussion in Reginald L. Poole, *Medi-
eval Reckonings of Time* (London: SPCK, 1921).

[39]Migne, *PL*, CXLIX, 668, as cited by Leclercq, "Experi-
ence and Interpretation of Time," p. 12.

[40]*York*, ed. Alexandra F. Johnston and Margaret [Dor-
rell] Rogerson, Records of Early English Drama, 1-2 (Toronto:
Univ. of Toronto Press, 1979), I, 8.

[41]Ibid., p. 3. Our knowledge of the York plays has in
many ways been greatly strengthened by the dramatic records
edited by Johnston and Rogerson. For example, the important
indenture from 1433 gives considerable information about the
Doomsday pageant, and also the records give documentation for
the relationship between the pageants and the religious proces-
sion.

[42]*Les registres d'Urban IV*, II, 423-25; the contents of
the bull establishing the Feast of Corpus Christi (*Transiturus
de hoc mundo*) are summarized in Horace K. Mann, *The Lives of
the Popes in the Middle Ages*, XV (London: Kegan Paul,
Trench, Trubner, 1929), 201. See also the recent book by Peter
W. Travis, *Dramatic Design in the Chester Cycle* (Chicago:
Univ. of Chicago Press, 1982), Chapt. I.

[43]A. N. Galpern, "The Legacy of the Late Medieval Re-
ligion in Sixteenth Century Champagne," in *The Pursuit of Holi-
ness*, ed. Charles Trinkhaus and Heiko A. Oberman (Leiden: E.
J. Brill, 1974), pp. 169-72.

[44]Daniel P. Poteet, II, "Time, Eternity, and Dramatic Form
in *Ludus Coventriae* 'Passion Play I'," in *The Drama of the Mid-
dle Ages*, pp. 232-48.

[45]Ibid., p. 240.

[46]References are to *The Late Medieval Religious Plays of
Bodleian MSS Digby 133 and e Museo 160*, ed. Donald C. Baker,
John L. Murphy, and Louis B. Hall, Jr., EETS, 283 (1982).

[47]Thomas Aquinas, *Peri Hermenias*, Lesson 14, as quoted
by Poteet, p. 284. Paul's progress exemplies the various stages
of "ritual" isolated by students of ritual processes aligned with
the social sciences; see Victor W. Turner, *The Ritual Process*
(Chicago: Aldine, 1969), pp. 166ff, for the categories "*separa-
tion, margin,* and *reaggregation*" and "*preliminal, liminal,* and
postliminal."

[48]For an explanation of the divine design implicit in the
Creation and Fall, see *City of God*, XIV, 27.

[49]Schiller, *Christian Iconography*, I, 84-88.

[50]Claude Chidamian, "Mak and the Tossing in a Blanket," *Speculum*, 22 (1947), 186-90.

[51]Thomas P. Campbell, "Why Do the Shepherds Prophesy?" in *The Drama of the Middle Ages*, pp. 169-82.

[52]Lawrence J. Ross, "Symbol and Structure in the *Secunda Pastorum*," *Comparative Drama*, 1 (1967), 122-43; rpt. in *Medieval English Drama*, ed. Taylor and Nelson, pp. 177-211.

[53]V. A. Kolve, *The Play Called Corpus Christi* (Stanford: Stanford Univ. Press, 1966), p. 119.

[54]See Owen Barfield, *Saving the Appearances* (New York: Harcourt, Brace, Jovanovich, n.d.), pp. 80-81. In the discussion which follows, another important dimension may be noted, and this involves aspects of medieval psychology and theater pointed out by Natalie Crohn Schmitt in her important article, "The Idea of a Person in Medieval Morality Plays," in *The Drama of the Middle Ages*, pp. 304-15.

[55]See Owst, *Literature and Pulpit*, pp. 510-11; Kolve, pp. 185-86. Hot cockles is pictured in a fourteenth-century manuscript illuminated by Jehan de Grise of Bruges (Bodley MS. 264, fols. 52, 97, 132V); see Lilian M. C. Randall, *Images in the Margins of Gothic Manuscripts* (Berkeley and Los Angeles: Univ. of California Press, 1966), p. 111. See also Joseph Strutt, *The Sports and Pastimes of the People of England*, revised and enlarged by J. Charles Cox (1903; rpt. Detroit: Singing Tree Press, 1968), pp. 308-09.

[56]Sandro Sticca, *The Latin Passion Play* (Albany: State Univ. of New York Press, 1970), pp. 66-78 (Latin text); Robert Edwards, *The Montecassino Passion* (Berkeley and Los Angeles: Univ. of California Press, 1977), pp. 10-21 (English translation).

[57]Raimundo Panikkar, "Time and History in the Tradition of India: Kala and Karma," in *Cultures and Time*, p. 64.

[58]L. Silburn, *Instant et Cause* (Paris, 1955), p. 43, as quoted by Panikkar, p. 64.

[59]*Winchester Troper*; translation from David Bevington, ed., *Medieval Drama* (Boston: Houghton Mifflin, 1975), p. 29.

[60]Karl Young, *The Drama of the Medieval Church* (Oxford: Clarendon Press, 1933), I, 632.

[61]See Rosemary Woolf, *The English Mystery Plays* (Berkeley and Los Angeles: Univ. of California Press, 1972), pp. 80ff.

[62]Bevington's translation (*Medieval Drama*, p. 177).

[63]Ibid., p. 176.

[64]On the power of the religious image, see, for example, Richard C. Trexler, "Florentine Religious Experience: The Sacred Image," *Studies in the Renaissance*, 19 (1972), 7-41.

[65]"The World," in *The Complete Poetry of Henry Vaughan*, ed. French Fogle (Garden City, N.Y.: Doubleday, 1964), pp. 46-49.

[66]Fogle's note in ibid., p. 232; cf. *Hermetica*, I, 26a.

[67]Gordon McNeil Rushforth, *Medieval Christian Imagery* (Oxford: Clarendon Press, 1936), p. 214.

[68]R. W. Hanning, "'You Have Begun a Parlous Pleye': The Nature and Limits of Dramatic Mimesis as a Theme in Four Middle English 'Fall of Lucifer' Cycle Plays," in *The Drama of the Middle Ages*, pp. 140–68.

[69]Jean Leclercq, *Bernard of Clairvaux and the Cistercian Spirit*, trans. Claire Lavoie (Kalamazoo: Cistercian Publications, 1976), p. 145.

[70]Ibid., p. 148. In Turner's terminology, the process described is to be identified as a *"ritual of status reversal"* (*Ritual Process*, pp. 167ff).

[71]*Drama of the Medieval Church*, II, 483.

[72]Ibid., II, 484.

[73]T. S. R. Boase, *Death in the Middle Ages* (London: Thames and Hudson, 1972), *passim*; see also Marjorie M. Malvern, "An Earnest 'Monyscyon' and 'þinge Delectabyll' Realized Verbally and Visually in 'A Disputacion betwyx þe Body and Wormes,' a Middle English Poem Inspired by Tomb Art and Northern Spirituality," *Viator*, 13 (1982), 415–43.

[74]Ernst Kitzinger, *Early Medieval Art in the British Museum*, 2nd ed. (London, 1955), Pl. 7.

[75]Fol. 51V. See Francis Wormald, *The Benedictional of St. Ethelwold* (London: Faber and Faber, 1959), p. 11.

[76]See Young, *Drama of the Medieval Church*, I, 118–22. For a study of the Easter Sepulcher, see Neil C. Brooks, *The Sepulchre of Christ in Art and Liturgy*, Univ. of Illinois Studies in Language and Literature, 7, No. 2 (Urbana, 1921), but more systematic work on English examples is currently being done by Pamela Sheingorn for Early Drama, Art, and Music.

[77]E. K. Chambers, *The Mediaeval Stage* (Oxford, 1903), II, 339; Richard Axton, *European Drama of the Early Middle Ages* (London: Hutchinson, 1974), pp. 162–63.

[78]See Daniélou, *The Bible and the Liturgy*, pp. 287–92.

[79]Arthur Gardner, *English Medieval Sculpture*, revised ed. (1951; rpt. New York: Hacker, 1973), fig. 605; see also W. L. Hildburgh, "Iconographical Peculiarities in English Medieval Alabaster Carvings," *Folk-Lore*, 44 (1933), 39–40, fig. 1; Gertrud Schiller, *Ikonographie der christlichen Kunst* (Gütersloh, 1971), III, Pl. 216; Tancred Borenius and E. W. Tristram, *English Medieval Painting* (Paris: Pegasus Press, 1927), Pl. 71 (Norwich retable).

[80]JoAnna Dutka, *Music in the English Mystery Plays*, Early Drama, Art, and Music, Reference Ser., 2 (Kalamazoo: Medieval Institute Publications, 1980), pp. 23–24. See also Pamela Sheingorn, "The Moment of Resurrection in the Corpus Christi Plays," *Medievalia et Humanistica*, n.s. 11 (1982), 111–29, and Meg Twycross, "Playing 'The Resurrection'," *Medieval Studies for J. A. W. Bennett*, ed. P. L. Heyworth (Oxford: Clarendon Press, 1981), pp. 289–90.

[81]See Daniélou, *The Bible and the Liturgy*, pp. 313-14.

[82]Søren Kierkegaard, *Concluding Unscientific Postscript*, trans. David F. Swenson and Walter Lowrie (Princeton: Princeton Univ. Press, 1941), *passim*.

[83]Harry N. Langdon, "Staging of the Ascension in the Chester Cycle," *Theatre Notebook*, 26, No. 2 (1971-72), 58; *Chester*, ed. Lawrence M. Clopper, Records of Early English Drama, 3 (Toronto: Univ. of Toronto Press, 1979), p. 37.

[84]*The Chester Mystery Cycle*, ed. R. M. Lumiansky and David Mills, EETS, s.s. 3 (1974), p. 373. The Ascension image from Kleinwangen, Switzerland, is also illustrated in Orville K. Larson, "Ascension Images in Art and Theatre," *Gazette des Beaux-Arts*, 54 (1959), 162; this entire article is important, though the author tends too easily to accept Émile Mâle's thesis that the art was influenced significantly by the drama. See also Dutka, *Music in the English Mystery Plays*, p. 20.

[85]Meyer Schapiro, "The Image of the Disappearing Christ: The Ascension in English Art Around the Year 1000," in *Late Antique, Early Christian, and Mediaeval Art: Selected Papers* (New York: George Braziller, 1979), pp. 266-86.

[86]Sally-Beth MacLean, *Chester Art*, Early Drama, Art, and Music, Reference Ser., 3 (Kalamazoo: Medieval Institute Publications, 1982), pp. 19-21, 86-89, Pl. I.

[87]Daniélou, *The Bible and the Liturgy*, pp. 304-07.

[88]See Schiller, *Iconography of Christian Art*, II, 228-29, fig. 808; Christ as the one who treads the winepress is suggested by St. Gregory the Great, but became a motif in art later, apparently in the fourteenth century.

[89]On this point, see Lynn Squires, "Law and Disorder in *Ludus Coventriae*," in *The Drama of the Middle Ages*, pp. 272-85.

[90]See Schapiro, "The Image of the Disappearing Christ," *passim*.

[91]Mircea Eliade, *Myths, Dreams, and Mysteries*, trans. Philip Mairet (New York: Harper and Row, 1960), pp. 95-97.

[92]Ibid., p. 118.

[93]Lawrence M. Clopper, "The History and Development of the Chester Cycle," *Modern Philology*, 75 (1978), 219.

[94]See Martin Stevens, "The Missing Parts of the Towneley Cycle," *Speculum*, 45 (1970), 258-59, 264.

[95]See *Ludus Coventriae*, 11.219: "this name Eva is turnyd Ave."

[96]Stanley J. Kahrl and Kenneth Cameron, "Staging the N-Town Cycle," *Theatre Notebook*, 21 (1967), 129; but see the more likely argument of Gail McMurray Gibson for an East Anglian Provenance in her "Bury St. Edmunds, Lydgate, and the *N-Town Cycle*," *Speculum*, 56 (1981), 56-90.

[97]*Records of Plays and Players in Lincolnshire, 1300-1585*, ed. Stanley J. Kahrl, Malone Soc. Collections, 8 (Oxford, 1974), pp. xvi-xvii.

[98]Ibid., pp. 61-64, 67.

[99]A play which illustrates such spectacular theatrics is the still extant play of Elche, Spain; this play has been described by Margaret Sleeman in a forthcoming paper entitled "The Staging of the Misterio de Elche and Other Spanish Assumption Plays." The Play of Elche has been filmed under the auspices of the Folger Shakespeare Library.

[100]John C. Coldewey, "The Digby Plays and the Chelmsford Records," *Research Opportunities in Renaissance Drama*, 18 (1975), 81-121.

[101]Bernard Beckerman, *Shakespeare at the Globe, 1599-1609* (New York: Macmillan, 1962), p. 147.

[102]Woolf, *English Mystery Plays*, p. 292. See also Travis, *Dramatic Design in the Chester Cycle*, pp. 223-41.

[103]Cited in William W. Heist, *The Fifteen Signs before Doomsday* (East Lansing: Michigan State Univ. Press, 1952), p. 26.

[104]Richard K. Emmerson, *Antichrist in the Middle Ages* (Seattle: Univ. of Washington Press, 1981), surveys the medieval context of this motif.

[105]Norman Cohn, *The Pursuit of the Millennium*, revised ed. (New York: Oxford Univ. Press, 1970), p. 35.

[106]*A Middle English Treatise on the Playing of Miracles*, ed. Clifford Davidson (Washington: Univ. Press of America, 1981), pp. 43-44.

[107]Clopper, "History and Development of the Chester Cycle," pp. 220-21; *Chester*, ed. Clopper, pp. liii-liv; see also Travis, *Dramatic Design in the Chester Cycle*, pp. 1-29, for a discussion of the importance of Corpus Christi for the city of Chester and its plays.

[108]Johnston and Rogerson, *York*, I, 92.

[109]John Mirk, *Festial*, ed. Theodor Erbe, EETS, e.s. 96 (1905), p. 2.

[110]*Speculum Sacerdotale*, ed. Edward H. Weatherly, EETS, o.s. 200 (1936), p. 4.

[111]See also Clifford Davidson, "The End of the World in Medieval Art and Drama," *Michigan Academician*, 5 (1972), 261-62.

[112]Mirk, *Festial*, p. 4.

[113]See the commentary in Louis L. Martz, *The Poetry of Meditation*, revised ed. (New Haven: Yale Univ. Press, 1962), p. 1.

[114]*A Middle English Treatise*, ed. Davidson, p. 43.

[115]*Jacob's Well*, ed. Brandeis, pp. 114-15; see also Jacques de Vitry, *The Exempla*, ed. Thomas F. Crane (London: Folk-Lore Soc., 1890), p. 100 (trans., p. 233); cf. ibid., p. 6, trans. p. 141: "A certain holy man, while in [the] choir, saw the devil loaded down with a full sack. He adjured the devil to tell him what he was carrying, and the devil replied that the sack was full of syllables and words and verses of the psalms

abbreviated or omitted by the clergy during the service. 'These
I diligently preserve for their accusation'." See also the im-
portant study by Margaret Jennings, *Tutivillus: The Literary
Career of the Recording Demon*, Studies in Philology, 74, No. 5
(1977).

[116]Thomas Wright, *Latin Stories*, Percy Soc., 8 (1842), as
quoted in Owst, *Literature and Pulpit*, p. 513n.

[117]Randall, *Images in the Margins of Gothic Manuscripts*,
figs. 585-86; the illustrations appear on fols. 54V and 76 in the
manuscript, which is Bodley MS. 264. See the commentary in
George R. Kernodle, *From Art to Theatre* (Chicago: Univ. of
Chicago Press, 1944), pp. 193-94.

[118]Cf. W. O. Hassall, *The Holkham Bible Picture Book*
(London: Dropmore Press, 1954), p. 139.

[119]Research for this paper was supported in its early
stages by a Faculty Research Fellowship from Western Michigan
University. Work toward its completion was also aided by re-
leased time from teaching awarded by the Department of English
of Western Michigan University. A portion of the paper was
also presented informally to the Shakespeare and Iconography
Workshop at the University of Szeged, Hungary, while I was a
visiting scholar there in December 1982.

Permissions to use illustrations which accompany this
paper have been granted by the National Monuments Record, the
Folger Shakespeare Library, the Victoria and Albert Museum,
the Redundant Churches Fund, the British Library, Canon J.
A. Armstrong, and David E. O'Connor.

"UT ENIM FABER . . . SIC CREATOR": DIVINE CREATION AS CONTEXT FOR HUMAN CREATIVITY IN THE TWELFTH CENTURY

R. W. Hanning

The phenomenon of human creativity comes under varied, sometimes intense scrutiny in several of the French vernacular poetic narratives written in the second half of the twelfth century. These works, of varying length and generic type-- *romans d'aventures, romans d'antiquité, contes, lais*--abound in characters (male and female) who, often as the result of education in the seven liberal arts as well as necromancy, possess extraordinary powers of illusion whereby they make marvelous scenes and objects appear and disappear, or temporarily and outlandishly transform quotidian places and things. Other characters construct, with special knowledge and skills, artifacts that defy the laws of nature and all attempts to explain them, while still others use gifts of wit and insight to manipulate characters and situations, to create or remove obstacles to the success of the story's protagonists--in short, to knot and unknot the narrative. All such figures are clearly artist surrogates, and their handiwork epitomizes the literary constructs in which they appear. The fact that their activities sometimes seem of questionable morality to us, and that accusations of impiety, blasphemy, or diabolical powers are sometimes--and not always inaccurately--lodged against them within the works themselves, suggests that the authors of these texts possess considerable self-consciousness about not only the power but also the potential dangers involved in combining education and imagination to produce autonomous fictions.

I have recently examined twelfth-century artistic self-consciousness within the context of the evolution of medieval vernacular poetry, using as my focus what I call poetic emblems--artifacts that call attention to the peculiar, defining characteristics of the texts that contain them--and contrasting the fascination with human creativity revealed in high medieval emblems with the different concerns of their early and late medieval analogues.[1] In this essay I propose to approach the same subject from a new perspective, following the lead of scholars who, in recent years, have begun to explore the links between courtly poetry of love and adventure and the lively, innovative intellectual milieu of the twelfth-century schools (especially urban cathedral schools) where the clerical authors of these narratives undoubtedly received their training in the tri-

vium and quadrivium.[2] The object of my attention will be the
twelfth century's heightened interest in divine Creation and the
Creator it reveals--an interest manifested in philosophy, biblical
study, and the visual arts. The age inherited, both separately
and in combination, two traditions of creation accounts: the
Judaeo-Christian and the Platonic. Its efforts to rationalize,
synthesize, and interpret this legacy generated arguments and
attitudes that underlie its scholarly treatments and manuscript
images of creation, the shape of its Christian monuments, and,
I believe, the articulation of continuities and tensions between
the creative activities of God and the artist in its most inventive
fictions. (Though I do not here explore the effects in drama,
surely the implications of what I describe for students of the
spectacle of medieval theater should not be underestimated.)

I

The twelfth century's cosmogonic inheritance included both
authoritative texts and influential commentaries on them. First
and foremost, of course, was the account (more precisely, ac-
counts) of Creation in the first two chapters of Genesis. The
initial chapter tells how God created the world in the course of
six days; in addition to the basic act of making or creating (*ex
nihilo*, as Christian teaching interprets it), the hexameral text
enumerates a range of more precise divine activities, most of
which result from verbal commands, e.g., dividing and gather-
ing together waters, making living things grow and multiply.
God sees, names, approves of, and blesses various parts of his
Creation. Several verses contain obscurities that were to occa-
sion much comment and exegesis: in Genesis 1.1 God creates
heaven and earth, yet in 1.2 the *Spiritus Dei* (not further de-
fined in the text) moves over the waters of a primal, as yet un-
ordered cosmos; light is created, and separated from darkness,
God calling the former day and the latter night, on the first
day (1.4-5), yet the sun and moon, which are said to preside
over day and night, respectively, are not created until three
days later. The nature or duration of the "days" of creation is
never specified, nor a reason given for describing each in turn
with the same unusual locution: "factum est vespere et mane,
dies unus (secundus, tertius, etc.)" (1.5, etc.). On the sixth
day, God, speaking in the plural, proposes, without explaining
his terms, to make man "ad imaginem et similitudinem nostram"
("to our image and likeness," 1.26), and proceeds (in the singu-
lar) to do so, but only "ad imaginem Dei," male and female
together (1.27); while in the next chapter God makes man alone
"de limo terrae" ("out of the slime of the earth," 2.7), with
woman subsequently formed from a rib taken out of man's body
(2.21-22).[3]
When the early Christian communities attempted to under-
stand the process and product of divine Creation in the light of

their beliefs about Jesus as Messiah, Christ, and son of God, they based their exegesis not only on the Genesis account(s), but on several other brief references, some quite graphic, to the Creator and his works in other books of Hebrew scripture, including Wisdom 11.21: "sed omnia in mensura et numero et pondere disposuisti" ("but thou hast ordered all things in measure, and number, and weight"); Ecclesiasticus 18.1: "qui vivit in aeternum creavit omnia simul" ("He that liveth forever created all things together"); Exodus 20.11: "sex enim diebus fecit Dominus caelum et terram et mare et omnia quae in eis sunt, et requievit in die septimo" ("For in six days the Lord made heaven and earth, and the sea, and all things that are in them, and rested on the seventh day"); and Proverbs 8.22-31, the voice of personified *Sapientia Domini* describing how she was with God when he created the world, since "Dominus possedit me in initio viarum suarum antequam quidquam faceret a principio" ("The Lord possessed me in the beginning of his ways, before he made any thing from the beginning," 8.22).

The most magnificent fruit of early Christian meditation on the Genesis Creation story, the prologue (1.1-18) of the Gospel according to John, incorporates the idea of the Wisdom of God as the firstborn of the Creator, living eternally with him, and the agent of Creation. The Johannine formulation takes its point of departure from the speaking Creator of Genesis, and presents the creative force as the communicative power or Word (Gk., *Logos*, Lat., *Verbum*) of God, which is God, is with God, and is the medium through which all is created (John 1.1-3). The Logos contains life which is the light of men, a light shining in darkness which cannot understand or contain it ("tenebrae eam [i.e., the light of the Logos] non comprehenderunt" [1.5]). This last statement constitutes an exegesis of the separation of light (day) from darkness (night) in Genesis 1.3-5; the Johannine reading suggests an antagonism between (superior) light and (inferior) darkness absent from the Hebrew text, and furthermore seems, confusingly, to equate God's Word, his equal and the agent of Creation, with one of the works of that Creation. Finally, and most importantly of all, the Johannine prologue unequivocally identifies the creating Logos with Jesus, the Word become flesh and only Son of the Father (1.14), thereby insisting on a link (not fully defined) between the eternal Creator and his temporal Creation focused on a particular creature and a particular moment in time.

The prologue concludes with the statement that no one has seen God, but that his only Son, from within the Father's bosom, reveals him. These words, as we shall see, gave to succeeding Christian centuries, at least until the late Middle Ages, the definitive solution to the awesome problem of how to depict God, the Creator: by representing him as the Son, the Logos-Creator, in his incarnate form of Jesus Christ, thereby reversing the direction of the Johannine Word-Become-Flesh, and

interpreting the verbal declaration intended by John 1.18 ("uni-
genitus Filius [Deum] enarravit") as a visual representation of
the Father.

The biblical accounts of, and references to, Creation,
however contradictory or irreconcilable they may seem to us,
were all forms of the Word of God, and therefore true, to
Christian exegetes, who consequently undertook rather to re-
concile than to choose among them. Their labors were further
complicated by the existence and authority (though not, for
Christians, canonic status) of an entirely different account of
Creation, the Cosmogony contained in Plato's dialogue, *Timaeus*.
The *Timaeus* embodies a characteristically complicated, Platonic
blend of analysis and myth, philosophy and symbolic narrative.
Socrates has described an ideal society (much like the one in
Plato's *Republic*, one gathers) before the dialogue begins; now
he wishes to hear it depicted, as it were, in action. His friend
Critias agrees to animate the Socratic model by clothing it in an
ancient tale of Athenian heroism (the famous legend of Atlantis).
But first Timaeus, another friend, will, as a prologue, describe
the origin of the cosmos and proceed as far as the making of
humanity, at which point Critias' "history" will begin.[4] Clearly,
the intent of this whole, complex metaphorical structure is to
claim universal validity for the Platonic conception of justice
developed in the *Republic* by demonstrating its equal currency
in the spheres of ethics, history, and cosmology. As F. M.
Cornford said many years ago, the *Timaeus* contains "a cos-
mology . . . cast in the form of a cosmogony"; Plato is not
proposing a theory of the universe's origin for its own sake,
but in order to purvey an image of a rational macrocosm as an
analogy and vindication of his teachings about the philosophical
microcosm, the just soul. He makes this clear, in his own indi-
rect fashion, by having Timaeus preface his narration of how
the world came to be with the disclaimer that he can only give a
"likely" account of the process, i.e., a fiction that conforms to
(and reasons backward from) the observable world as Plato un-
derstood it. (Certainty is only possible concerning the true and
immutable realm of forms or ideas known by the intellect; the
mutable, physical world, being less real, can only be known
through the senses and the subject of opinion, the epistemologi-
cal category analogously inferior to true knowledge.)

According to Timaeus' account, the visible world comes
into being because its creator, the *Demiurgos*, "was good, and
what is good has no particle of envy in it; being therefore
without envy he wished all things to be as like himself as pos-
sible. . . . God therefore, wishing that all things should be
good, and so far as possible nothing be imperfect, and finding
the visible universe in a state not of rest but of inharmonious
and disorderly motion, reduced it to order from disorder, as he
judged that order was in every way better." The resulting uni-
verse, not created *ex nihilo* but reduced to order from primal

chaos, is, according to Timaeus, "a living being with soul and intelligence," produced by a maker who used "as his model the highest and most completely perfect of intelligible [i.e., unchanging, suprasensory] things . . . [a] perfect living creature" (42-43). The visible world is a likeness, imperfect because mutable, of an unchanging pattern available to the Demiurgos, presumably by intellection (as the unchanging world of Platonic forms is available to the philosopher only by intellection).

The elements of the Timaean cosmogony, then, are the creating (more properly, ordering) Demiurgos; the primordial matter (which is actually pre-elemental "pre-matter," characterized elsewhere by Timaeus as necessity, space, "the receptacle and, as it were, the nurse of all becoming and change" [66]); the pattern of Being which the Demiurgos imposed on "matter" to make it into a world of Becoming, midway between Being and chaos; and the goodness which leads him so to act. The soul and body of the resultant universe (also called by Plato the Same and the Different, respectively) are linked by mathematical proportions exhaustively described by Timaeus, and the stately, perpetually cyclical movements of the heavens (dwelling place of the immortal gods who, formed directly by the Demiurgos, in turn created the less perfect, mortal bodies and souls of humankind) constitute a "moving image of eternity" (50). As we shall discover, all these central Platonic concepts inspired Christian responses: in some cases, the claim of orthodoxy, or near orthodoxy, for the Timaean text; in others, ingenious attempts to reconcile *Timaeus* and *Genesis*; and in still others, the outright rejection of the Platonic scheme. Underlying medieval attempts to deal comprehensively with the *Timaeus* as a cosmogony is the fact that the period knew the work only in Calcidius' fourth-century Latin translation, which lacks the entire latter part of the dialogue describing the fabrication (i.e., the potential excellence) of the microcosm, the human body and faculties.[5] In this truncated form, the dialogue appeared to be an obvious analogue to Genesis 1, in some respects remarkably orthodox, in others dangerously heterodox. In particular, the notion of a Creator forming the world in accordance with a pre-existent pattern will contribute, in the twelfth century, to the establishment (or re-establishment) of an important analogy between the creating God and the fabricating (in both senses of the term) artist.

II

The commmentaries on Creation known directly or indirectly by twelfth century thinkers and artists were many and varied, but only two late classical authors, Augustine and Boethius, exercised such an influence as to demand notice here. Augustine's is by far the more complicated case. Of his volumi-

nous writings on scripture, many were occasional and apolo-
getic--inspired by crises or heresies facing the Church to which
he came as a convert and which he served as a bishop; the
resultant corpus, therefore, cannot be considered a systematic
program of exegesis aiming to arrive at a single, coherent inter-
pretation of the Bible. Faith, not a spirit of rational inquiry,
motivated Augustine. Furthermore, he believed that the Bible,
besides being the Word Of God and therefore the repository of
divinely guaranteed truth, was also an encyclopedia containing
all knowledge and requiring all human studies and disciplines to
be brought to bear on it. To get at the biblical deposit of
truth, one needed to excavate now according to one sense, now
another: literal, allegorical, tropological, anagogical. Different,
even apparently contradictory readings of a book or passage of
the Bible could all contribute to the ultimate goal of under-
standing God's word, provided always that exegesis be under-
taken in the light of faith and with proper humility about the
difficulty with which fallen human minds can grasp the great
mysteries contained in the sacred text.[6]

The Augustinian exegetical rationale, as embodied in his
several treatments of the Genesis Creation account--*De Genesi
contra Manichaeos*, *De Genesi ad litteram liber imperfectus*,
Books xi-xiii of the *Confessions*, *De Genesi ad litteram* in twelve
books, *De civitate Dei*, Books xi-xii--and sermons on the Johan-
nine Gospel, yields to the twentieth-century reader a vivid im-
pression of Augustine circling and weaving around the biblical
text like a skilled and prudent prizefighter warily testing the
reflexes of a potentially devastating opponent. He characteris-
tically asks questions, rather than making unequivocal declara-
tions, about a word or sentence; he proposes many possible
solutions to the meaning of a problematic passage, often without
espousing any of them. He meditates on the holy words and
uses a phrase in one biblical book to elucidate a point made in
another. To Augustine, exegesis is close to prayer; undertaken
in faith, it testifies to, even as it attempts to bridge, the gap
between the divine Word and its human auditors.

Augustine's understanding of Creation illustrates his con-
viction that God and humanity remain far apart, except as God's
grace and Christ's redemptive sacrifice bring us closer to our
Maker. A Platonist before he became a Christian, and much
influenced by Platonic thought even after his conversion, Au-
gustine identified as imperfect, because mutable, the world he
experienced through his senses. God, perfection itself, must in
his essence be immutable. To conceive of God exercising his
creative power in time is to obscure the qualitative difference
between Creator and Creation, and to open God to accusations
of mutability and hence imperfection: did he change his mind
when he decided to create the world? did he need the world in
order to be perfect? If the world is good (cf. Gen. 1.10, 12,
18, 21, 25, etc.) why didn't he create it sooner?[7] Augustine,

throughout his many considerations of the Genesis hexameron, sought to guard God from such misunderstanding, primarily by insisting that God, existing eternally outside and above time, created all things at once (*creatio simul*; cf. Ecclus. 18.1) in an atemporal *ictus* that marks as well the beginning of time, the medium of mutable, imperfect phenomena. (In the *Confessions*, Augustine ties time more closely still to our imperfect perceptions and mortal condition by defining it as our purely subjective extension of experience to the past, through memory, and the future, through anticipation.[8])

Creation *simul* forces Augustine to confront other problems: if God created everything at once, why does the biblical account describe Creation stretched out over six days; furthermore, how, if not temporally, are we to understand the sequential coming into being of the various orders of living things from the third to the sixth days? Augustine's primary answer to the first question involves identifying the heaven God creates in Gen. 1.1 with the angelic essence, and defining the six days as atemporal stages in the angels' achievement of full understanding of Creation, thanks to their *conversio* to God, i.e., their offering of love, and subordination of will, to their Creator. His answer to the second is the concept of *rationes seminales*, the potential seeds of all subsequent living things, implanted in the Creation by God as part of his *creatio simul*.[9] The import of Augustine's exegetical strategy here and elsewhere is implicitly to deny close analogies between human and divine existence (and hence power) and to eliminate the possibility of forging a single, self-consistent, rational explanation of Creation based on taking the biblical text at face value. Approaching the hexameron as a document of, and stimulus to, faith, Augustine made impossible, for those who accepted his exegetical perspective, any parallelism between divine and human creativity and any opportunity for the exaltation of human powers implicit in an analysis more autonomous, more strictly logical, than his. The twelfth century, while broadly and deeply influenced by Augustine's hexameral commentaries, largely reversed these key features of it, establishing in the process a climate much more hospitable to speculation about the artist's power and limits as an earthly, imperfect version of the Creator.

Augustine's meditative, faith-guided, occasional, multifaceted, and non-definitive approach to the Bible as repository of all truth and all knowledge proved highly influential in early medieval European Christianity. In the monasteries that dominated and propagated the Christian culture of the period, biblical study on the Augustinian model, the *lectio divina*, took its place alongside the communal chanting of the psalms, private meditation on other biblical texts, and reading aloud from the sacred page in the refectory. The monk's day was saturated with the scriptures, which the Benedictine Rule pressed into service to aid in turning his attention away from this world and

toward the next. Monastic learning, including scriptural exege-
sis, was primarily utilitarian and preservation-oriented in na-
ture; patristic *auctoritates* dominate most commentaries on books
of the Bible. Personal initiative in the face of central passages,
such as the hexameron, and finding parallels in the secular
world to the creating activities of God were equally rare.[10]

However, a Platonic tradition survived in early medieval
Europe, thanks in good measure to the activities of Boethius,
important transmitter of classical philosophy to the Middle Ages,
and the writings of the pseudo-Dionysus and his Carolingian
follower, John Scot Eriugena.[11] Boethius, a sixth-century
Christian statesman and scholar, embedded an influential digest
and adaptation of the Timaean cosmogony in the ninth meter of
Book Three of his most widely read work, the *Consolation of
Philosophy*. The poem transforms Timaeus' account into a hymn
to the Creator, culminating in Philosophy's prayer that her mind
may rise to the contemplation of the Maker, a powerful expres-
sion of the Platonic conviction that the highest goal of intelli-
gence is the discovery and attainment of its eternal source.
This aspiration, more or less Christianized, will underlie many
of the twelfth century's new perspectives on the subject of
divine creation.

III

The texts and commentaries handed on to the twelfth
century by the early Middle Ages became caught up in an edu-
cational revolution at the center of which burgeoned a new,
heightened appreciation of human faculties, especially reason.
The two consequences of this revolution relevant to our present
concerns were: (1) a marked increase in biblical study, and
hence Creation exegesis--verbal and pictorial--designed to elu-
cidate and synthesize received traditions; and (2) a change in
perceptions about Creation and interpretation, resulting in a
suggestive rapprochement between divine and human powers.

Early medieval education, as just noted, took place pri-
marily in monasteries and thereby served the monastic ideal.
While some monastic schools figured prominently in twelfth-
century educational innovation--one thinks of Bec, home of Lan-
franc and Anselm--the major foci of the revival were cathedral
schools in newly prosperous and expanding towns. The relative
political tranquility that followed the end of the age of Germanic
migration across Europe created the conditions--calm, leisure--
for the growth and pursuit of the intellectual life, by those
drawn to it, as an end in itself; furthermore, the institutions of
Church and state, able in a time of increased stability to expand
rather than merely survive, required educated (and non-clois-
tered) men in greater numbers to staff chanceries and function
as a civil and diplomatic service.[12] Both practical and felt
needs turned education away from the *lectio divina*--an ideal of

study focused on the Bible as an aid to the monastic vocation--
toward the study of the world in all its major categories: God,
nature, human culture. The basic implements for realizing a
new ideal of study were the seven liberal arts inherited from
classical education, but pursued with a rigor and a theoretical
justification unparalleled for several centuries past.[13]

What ultimately justified the intense cultivation of the
liberal arts was a heightened cultural commitment to *ratio*. In
seeking evidence of the privileged position of rationality in
twelfth-century education we need look no farther than the
statements of intent and plans of procedure in the age's trea-
tises and textbooks; the schematic clarity of these introductory
divisiones makes them, irrespective of their particular subjects,
de facto manifestos of the universal validity of *ratio* as an in-
strument of pedagogy and instruction.[14] The preface to Hugh
of St. Victor's *Didascalicon*, a treatise on "reading" (i.e., the
systematic study of secular and sacred writings), provides one
instance that may stand for many:

> The things by which every man advances in knowledge
> are principally two--namely, reading and meditation. Of
> these, reading holds first place in instruction, and it is
> of reading that this book treats, setting forth rules for
> it. For there are three things particularly necessary to
> learn for reading: first, each man should know what he
> ought to read; second, in what order he ought to read,
> that is, what first and what afterwards; and third, in
> what manner he ought to read. These three points are
> handled one by one in this book. The book, moreover,
> instructs the reader as well of secular writings as of the
> Divine Writings. Therefore, it is divided into two parts,
> each of which contains three subdivisions. In the first
> part, it instructs the reader of the arts, in the second,
> the reader of the Sacred Scripture. It instructs, more-
> over, in this way: it shows first what ought to be read,
> and next in what order and in what manner it ought to be
> read. But in order to make known what ought to be
> read, or what especially ought to be read, in the first
> part it first of all enumerates the origin of all the arts,
> and then their description and division, that is, how each
> art either contains some other or is contained by some
> other, thus dividing up philosophy from the peak down to
> the lowest members. Then it enumerates the authors of
> the arts and afterwards makes clear which of these arts
> ought principally to be read; then, likewise, it reveals in
> what order and in what manner. Finally, it lays down for
> students their discipline of life, and thus the first part
> concludes.

In the second part it determines what writings ought to

be called divine, and next, the number and order of the
Divine Books, and their authors, and the interpretations
of the names of these Books. It then treats certain char-
acteristics of Divine Scripture which are very important.
Then it shows how Sacred Scripture ought to be read by
the man who seeks in it the correction of his morals and a
form of living. Finally, it instructs the man who reads in
it for love of knowledge, and thus the second part too comes
to a close.[15]

We find analogues to Hugh's plan for the *Didascalicon* in
his *De sacramentis*, in Abelard's *Ethics*, in the philosophical
works on creation by Thierry of Chartres and William of
Conches to which reference will shortly be made, in the *acces-
sus*, or introductory statement, prefixed to twelfth-century
editions of and commentaries on classical authors[16]--even in the
opening lines of Andreas Capellanus' parodistic treatise, *De
amore*. They are, in effect, the first modern tables of con-
tents, and they reflect a penchant for a universally applicable,
transparent method of scholarly inquiry, and an assumption, in
R. W. Southern's words, that "finally the whole universe ap-
pears intelligible and accessible to human reason"; the schools
that employed such a method "were dedicated to the task of
extending the area of intelligibility and order in the world in a
systematic way," and "they brought the idea of an indefinitely
expanding order and rationality into every area of human exper-
ience."[17] Even the Cistercians, whose ideals of strict adherence
to the Benedictine Rule and complaints against what they saw as
the excesses of the rational study of God by Abelard and others
set them apart from the mainstream of twelfth-century intellec-
tual life, were not immune to its appeal: the treatises of Ber-
nard of Clairvaux reveal that same inherent orderliness of pro-
cedure we identify with the first age of scholasticism.[18]
 At least three "areas of intelligibility and order" cultivated
by twelfth-century educators had special relevance for the age's
study of divine Creation and its self-consciousness about human
creativity: humanism, theology, and biblical study. I have al-
ready alluded to the thoroughgoing application of analytic tech-
niques to the *accessus* (and thence the interpretation) of clas-
sical texts as an instance of dedication to rational method.
Another noteworthy characteristic of twelfth-century humanism
was its perception of the poetic text of a pagan *auctor* as an
integumentum, or ornate covering for hidden truths. Bernard
Silvestris, *magister* of Tours and himself, as we shall see, a
philosophical poet, declares in the prologue to his allegorizing
commentary on the first six books of Vergil's *Aeneid*: "the in-
tegument is a type of exposition which wraps the apprehension
of truth in a fictional narrative, and thus it is also called an
involucrum, a cover."[19] The concept of the integument in ef-
fect recognizes the role of the poet as a purposeful creator,

albeit of fictions--one who constructs an ornate world of words
at once to hide a set of truths and to lure (properly trained)
readers on to discover what has been hidden.[20]

Underlying this implicit approbation of the artist's creative
power is a tradition, based in Platonic analogical thought, that
the work of art is a microcosm, a miniature version of the uni-
verse. Here is an anonymous fifth-century Neoplatonic com-
mentator discussing the Platonic dialogue:

> We must now mention why Plato used this literary form.
> He chose it, we say, because the dialogue is a kind of
> cosmos. For in the same way as a dialogue has different
> personages, each speaking in character, so does the uni-
> verse comprise existences of various natures expressing
> themselves in various ways; for the utterance of each, is
> according to its nature. . . . As we have seen, then,
> that the dialogue is a cosmos and the cosmos a dialogue,
> we may expect to find all the components of the universe
> in the dialogue.[21]

Macrobius, writing of the *Aeneid* in his *Saturnalia*, declares: "if
you look closely into the nature of the universe, you will find a
striking resemblance between the handiwork of the divine
craftsman and that of our poet. Thus, just as Vergil's language
is perfectly adapted to every kind of character, being now copi-
ous, now dry, now ornate, and now a combination of all these
qualities, sometimes flowing smoothly or at other times raging
like a torrent; so it is with the earth itself, for here it is rich
with crops and meadows, there rough with forests and crags,
here you have dry land, here, again, flowing streams, and
parts lie open to the boundless sea."[22]

We see, then, that in the twelfth century the text of the
pagan poet--Ovid, Vergil, etc.--as studied in the schools pro-
vided a meeting ground for two complementary forces: the poet's
power to create a microcosmic structure enclosing moral or re-
ligious truths, and the reader's power (maximized by study of
the liberal arts) to get at those truths in an orderly fashion.

The new discipline of theology--the application of dialectic
or logic (and to a lesser extent, grammar) to the study of
God--also proceeded from confidence in human rationality. The
first great scholastic philosopher, the monk Anselm of Bec,
"expressed his confidence in the power of reason in a most
uncompromising way at the beginning of his earliest theological
work. His pupils, he said, had asked him to prove that God's
nature is as the Christian religion declares, and to do this
simply by rational argument without any support from authori-
ty. . . . Anselm spoke a language that they wished to hear; it
was the language of rational argument. . . ." Anselm's "ration-
al enquiry, his rigid exclusion of any appeal to authority," was
based on twin assumptions: God's absolute rationality, issuing in

the intelligibility of his Creation, and humanity's rationality--
constituting the *imago Dei* in which it has been created--that
permits the understanding of both Creation and Creator as they
really are.[23] Anselm described his enterprise as *fides quaerens
intellectum*; the articles of Christian faith, even without explicit
confirmation from biblical or ecclesiastical authority, provided
the indispensible matrix for his philosophical activities. None-
theless, he and the *magistri* who followed him in the twelfth-
century schools exalted reason almost to the level of faith by
their investigations, and in the process lessened the gap be-
tween God and humanity that figures so centrally in the Augus-
tinian tradition of seeking God by a faith-inspired pondering of
the supreme *auctoritas*, the Bible. (The resulting shift was, of
course, of immense importance for drama and art, making pos-
sible the humanizing of the Passion, for example, both in the
visual arts and on stage.)

 While Anselm, Abelard, and others developed--and the
Cistercians Bernard of Clairvaux and William of St. Thierry at-
tacked--theology,[24] the study of the Bible also received new
impetus from the twelfth-century educational revolution. Hugh
of St. Victor articulated, with characteristic rational clarity, a
theory of scriptural exegesis according to three senses--histori-
cal, allegorical, tropological--based on the seven liberal arts:

> In other writings words alone are found to have meaning,
> but in [the Bible] not only words but things are signi-
> ficant. Hence, just as wherever the sense between words
> and things is uncertain, the knowledge of words is neces-
> sary, so in the case of that which exists between things
> and mystical acts done or to be done, the knowledge of
> things is necessary. But the knowledge of words is con-
> sidered under two heads, namely: pronunciation and
> meaning. To pronunciation alone grammar applies, to
> meaning alone dialectic applies; to pronunciation and
> meaning together rhetoric applies. The knowledge of
> things is concerned with two points, form and nature.
> Form is in the exterior disposition; nature, in the interior
> quality. The form of things is considered either under
> number, to which arithmetic applies, or under proportion,
> to which music applies, or under dimension, to which
> geometry applies, or under motion, to which astronomy
> applies. But the consideration of the interior nature of
> things belongs to physics. Therefore it is clear that all
> the natural arts serve divine science, and that the lower
> wisdom, rightly ordered, leads to the higher. According-
> ly, under the sense of the significance of words in rela-
> tion to things history is contained, which, as has been
> said, is served by three sciences: grammar, dialectic,
> and rhetoric. Under that sense, however, consisting in
> the significance of things in relation to mystical facts, al-

legory is contained. And under that sense, consisting in the meaning of things in relation to mystical things to be done, tropology is contained, and these two are served by arithmetic, music, geometry, astronomy, and physics.[25]

Innovations in scriptural study resulting from the attitude embodied in Hugh's formulation include: (1) a more systematic attention to the historical level of the text-- the *historica radix et veritas rei gestae*, as Abelard calls it[26]--bringing into play the scientific study of the natural world that began to flourish in the twelfth century; and (2) a method of exegesis dependent more upon *ratio* than *auctoritas*, i.e., on the orderly pursuit of a logical argument rather than on recourse to other scriptural texts and the deposit of faith. The *accessus* to Thierry of Chartres' brief treatise on the hexameron exemplifies both these new tendencies:

> Being about to treat, scientifically [*secundum physicam*] and literally, the first part of Genesis, concerning the seven days, and the distinctions among the six works, of creation, I will first offer a few words concerning the intention of the author and the usefulness of the book; afterwards I will come to the historical sense of the text that is to be expounded, completely avoiding an allegorical and moral [i.e., tropological] reading, which the holy interpreters have clearly set forth. The intention, therefore, of Moses in this work was to show the creation of things and the generation of men to have been accomplished by one God alone, to whom alone adoration and reverence are due. The utility, in truth, of this book is the knowledge of God from his works, he to whom alone the reverence of worship should be shown.

> *In principio creavit Deus caelum et terram*, etc., demonstrates rationally [*rationabiliter ostendit*] the causes from which the world takes its existence and the temporal sequence [*temporum ordinem*] in which that world was created and adorned. First, therefore, we will expound the causes, then the temporal sequence.[27]

By contrast, Augustine's *De Genesi ad litteram*, which also claims to eschew allegory, begins by affirming the multiple senses in which the Bible can be understood, and supports its argument by figurative readings of three *auctoritates*, passages from the New Testament (Matt. 13.52, I Cor. 10.11, Ephes. 5.32).[28]

The increased production of treatises on Creation in the twelfth century can best be understood, then, as a facet of the age's thriving educational life and a symbol of its intellectual

confidence; to the *magistri* of the schools, Creation was a fit subject of study, as an expression of divine rationality, a nexus between God and humanity, and a source of insight into human as well as divine powers. Their confidence that reason could make sense of both the process and the product of God's creative activities inspired new explanations of the hexameron and the Timaean cosmogony, and new attempts to reconcile them. After all, both authors could be presumed to have set out to show, *rationabiliter*, the nature of a rationally ordered cosmos, and were thus open to synthesis by those trained, by means of the liberal arts, to find reason in all human and divine works. Many instances of synthesizing the biblical and Platonic texts could be summoned in support of this generalization, of which the most controversial in its day was the equation of the *Spiritus Dei* of Gen. 1.2 with the *anima mundi*, the soul with which the Demiurgos endows the living world he has created in the likeness of the eternal pattern.[29] As our purpose here is, however, confined to documenting the formation, amidst this exegetical activity, of an intellectual climate hospitable to the exploration of human creativity in literature, we may legitimately treat the Genesis and Timaeus commentaries as one intellectual corpus and concentrate on three apposite features of it: the parallels drawn between divine activities and those of an artist; the insistence on the rationality of Creation, and the consequences of that insistence; and the role of the arts in overcoming the effects of the Fall, i.e., in re-creating humanity.

The image of God as a craftsman (*faber*) or artist (*artifex*) appears, or is implicit, in some of the twelfth century's most adventurous and influential scholastic thought about Creation.[30] William of Conches, *magister* of Chartres--perhaps a focal point of speculation on the subject--introduces the comparison into his *Gloss* on the *Timaeus*, in a passage from which the present essay derives its title. Speaking of the eternal wisdom of God (*Sapientia Dei*) by which the Creator made the world, William declares, "for as a craftsman wishing to make something first arranges it in his mind and afterward, having procured material, forms it according to his idea [*juxta mentem suam*], so the Creator, before he was to create anything, had an idea of it in his mind and thereafter performed it by his act." Plato, William adds, calls the idea the *archetypus mundus*, while the Chartrian master himself identifies it as the world's formal cause. Similarly, in his *Gloss* on Boethius' *Consolation of Philosophy*, discussing the Timaean hymn (iii.m.9), William equates *archetypus mundus*, *Sapientia Dei*, and the *principalis figura mundi*, continuing, "just as someone wishing to make something first foresees what it may be, and thereafter seeks raw material which he changes and labors over in accordance with what he has in mind, so the divine goodness, wishing to create the world, eternally foresaw how and at what time and place he might create everything."[31]

The model of artistic creation in these examples is based
on the Platonic notion of a changeless world of perfect forms, of
which the sensible world is an imperfect reflection. (Abelard
introduces this idea into his *Expositio in hexameron* [737-38],
teaching that there are two worlds, one intelligible, one sensi-
ble.) The notion of a metaphysical relationship between two
worlds becomes galvanized when applied to the Timaean Demi-
urgos, who actually creates the visible world in the likeness of
an invisible, perfect, eternal pattern. The application of this
model of creation to the artist was perhaps aided by the fact
that the Demiurgos, like a craftsman, worked with pre-existent
matter on which he imposed order, as opposed to creating *ex
nihilo*. In the course of its evolution in Western artistic theory,
long since traced by Erwin Panofsky, the artist-God simile
sponsored a crucial relocation of the idea according to which the
divine or human *artifex* works: from a remote, external sphere
of immutable existence it passes to a position within the maker's
mind.[32] The simile's adoption and adaptation by Christian
exegetes results directly from the influence of the Johannine
prologue, in which God creates through the Logos/Verbum. Al-
though neither *Timaeus* nor John's Gospel introduces the com-
parison of the artist to God into its cosmogony, as developed in
the twelfth century it became a pedagogical tool applicable not
only to the Platonic version of Creation, as in William's two in-
stances, but also to Genesis. God, as artist, shapes the world
in accordance with his divine Wisdom, expressed in his Word--
"Dixitque Deus: Fiat lux. Et facta est lux" ("And God said: Be
light made. And light was made") etc.--and perfectly embodied
in the material world, hence the Creator's approbation: "et vidit
Deus quod esset bonum" ("And God saw that it was good") etc.
Of course, the twelfth-century expositors believed that the God
of Genesis creates *ex nihilo*, as Genesis 1.1 tells us: "in prin-
cipio Deus creavit coelum et terram" ("In the beginning God
created heaven and earth"). But, under Platonic influence,
these same expositors intepreted the phrase "coelum et terram"
as signifying the four elements, created in primal confusion at
the beginning of time--both Thierry of Chartres and Abelard
equate the phrase with the *hyle* or *Chaon* of the *philosophi*--and
then shaped by the artist-God to conform to his eternally-con-
ceived Wisdom about them.[33]

The comparison between *faber* and *Creator* informs the
explication of Creation in a number of ways. Abelard, for
example, argues at the beginning of his hexameral treatise that
a knowledge of the process of Creation leads us to its Maker;
he continues, "whoever wishes to know of a certain artist if he
is good or skillful in his labors, ought to consider not him but
his works. And thus God, who is invisible and incomprehensi-
ble in himself, first confers on us knowledge of him by means
of the greatness of his works" (733A).[34] More importantly,
Abelard adapts our image in order to solve the notorious problem

concerning the meaning of the six days of creation, each referred to under the formula "et factum est vespere at mane, dies unus, secundus, etc." Augustine, we recall, had explained this formula as a reference to the *conversio* of the angelic essence (created with the beginning of time) to its Maker, in love and gratitude; *vespere* represents the unenlightened knowledge of the angels about each successive aspect of the Creation, and *mane* the enlightenment that comes with seeing the Creation in the love of the Creator. By contrast, Abelard claims that *vespere* means the concept of divine mind in its laying out the pattern of its future acts, and *mane* signifies the working out of the divine conception and plan in the actions recounted during a "day," i.e., the period of time chosen by God to effect a particular work. In other words, to Abelard the passage of a segment of creation from idea to actuality is not (as in pure Platonism) a descent from perfection to imperfection, but a bringing to light of divine conceptions--an embodiment of them in forms that allow us to know the artist from his work.[35]

Thierry of Chartres, in his treatise *De septem diebus*, proposes, as noted above, to reconcile the Christian *Sanctus Spiritus* with the Platonic *anima mundi*, using as least common denominator the phrase *Spiritus Dei* in Genesis 1.2. Thierry defines this spirit as *virtus artificis* and says that it works on the basic confusion of elements, created at the beginning of time, to produce whatever forms we see existing on earth or in the heavens. "For as that [primal] matter is without form in and of itself, it cannot acquire form in any way except by means of the power of the Creator-artist (*artificis*) working on it to order it" (193.25).

It seems safe to argue that both the cause and the effect of the extensive overt and implicit use of the artist-God simile by twelfth-century students of Creation was an elevation in the perceived value of the artist or craftsman in intellectual circles. Of course, the human *faber* or *artifex* could neither create *ex nihilo* nor expect to embody his preconceived idea perfectly in his chosen material. As William of Conches points out in comparing the Calcidian *tria opera--opus Dei, opus naturae, opus artificis imitantis naturam*--the work of the Creator, because of its artist, exists perpetually; the work of nature persists by the propagation of species; but the work of the human artist is entirely transient (148.6-12). Nonetheless, the received similitude between the heavenly and earthly maker, both actualizers of antecedent designs, conferred philosophical, rational dignity, as it were, on the process by which structures of stone, wood, paint, or words come into existence.

That Creation was rationally structured, and therefore susceptible of rational understanding, was an axiom of twelfth-century intellectuals. The rationality of the world, a Platonic legacy, resulted not so much from its being created by God *ex*

nihilo as from its having been subsequently framed and ordered,
as we have seen, through the Word, or eternal Wisdom, the
Creator. In other words, an Artist who is supremely powerful
can make the material as well as the form of his work of art,
but only an Artist who is both supremely wise and supremely
powerful can have a perfectly rational idea of his work before
he begins it, and then make the result correspond perfectly to
its preconception and thus earn its Maker's praise and blessing
(cf. Genesis 1.21-22: "et vidit Deus quod esset bonum, bene-
dixitque eis dicens. . . ."). This rational world's susceptibility
to rational understanding was based on a traditional Christian
interpretation of Genesis 1.27--"et creavit Deus hominem ad
imaginem suam" ("And God created man to his own image")--as a
reference to the rationality of humankind, which sets it above
the rest of Creation.[36] Human reason, the Creator's highest,
distinguishing gift to humanity, can thus respond directly to
the divine rationality by studying its visible manifestation:
hence Thierry's definition of the *utilitas* of Genesis as the "cog-
nitio Dei ex facturis suis" (*De septem diebus*, accessus); Abe-
lard's statement that "Deus . . . ex operum suorum magnitudine
primam nobis de se scientiam confert" (*Expositio in Hexameron*
733A); and William of Conches' explanation that "ante vidit
sapiens rationabilem dispositionem rerum et per hoc cognovit et
per alicujus rationem eas esse factas" ("the wise person first
sees the rational disposition of things [i.e., the world] and from
that recognizes that they have been made according to someone's
reason," *Gloss* on the *Consolation of Philosophy*, 125.19-21).
Linking these statements, and others that could be culled from
twelfth-century writings, is a preference for *ratio*, as a path to
the Deity, over *auctoritas*, the revelation of God through the
history of salvation recounted in the Scriptures and taught by
the Church.[37]

 By stressing rationality as the nexus between God and his
Creation, and thus between God and humanity--a line of ar-
gument not invented by the twelfth century, but pursued by it
with unprecedented vigor--the scholastic cosmologists (to use
the term preferred by Tina Stiefel in her assessment of the
Chartrian philosophers[38]) in effect re-created God in the image
not of an artist, but of a *magister*; Creation is his treatise, laid
out with the optimal clarity and order promised by the prefatory
schemas of Hugh of St. Victor, and intended for the education
of students whose rationality, sharpened by liberal arts train-
ing, allows them to follow God's argument about himself and to
elucidate it in their glosses. Thierry's derivation of the causes
of Creation, at the beginning of his scientific (*secundum physi-
cam*) explanation of the Hexameron, offers perhaps the age's
most striking instance of its use of Creation as a text expres-
sing the nature of its author.[39]

 Thierry starts not from the biblical account, but from the
Aristotelian notion (cf. *Physics* ii.3) that all things have four

causes: efficient, material, formal, and final, and no more.
With respect to the created world, Thierry distinguishes the
four causes, and links them to God, entirely by the exercise of
reason (i.e., logical deduction).[40] The argument proceeds as
follows: the observed mutability of the world argues for its
having an (unmoved) *auctor*. (Note that Thierry uses a term
with intellectual and literary, not artistic, overtones.) Because
the world is rationally and beautifully ordered, it must have
been created according to wisdom. Since the Creator, by truly
rational consideration (*juxta veram rationem*), would lack noth-
ing, and would find the highest good and sufficiency in himself,
he would create only out of love and goodness, so that he might
have something with which to share his blessedness. Finally,
since order must be applied to pre-existent disorder, such dis-
order must come first, so that order could be imposed on it in
accordance with wisdom, and thus the Creator's wisdom might
become manifest. Thierry concluded: "whoever, therefore,
carefully considers the fabric of the world will recognize God as
its efficient cause, the wisdom of God as its formal cause, his
goodness as its final cause, and the four elements, which the
Creator created *ex nihilo* in the beginning, its material cause"
(184-85.1).

Thierry examines the rationally (*rationabiliter*) disposed
cosmos, draws the necessary, inevitable conclusions, and ar-
rives at a neat pairing of causes and attributes or deeds of
God. Only after this purely rational demonstration does he turn
to the text of Genesis to find the same information--not surpris-
ingly, since, as he has declared in his *accessus*, the biblical
text "rationabilitier ostendit causas ex quibus habeat mundus
existere." Finally, he brings into concordance three of the
world's causes and the persons of the Trinity: "therefore the
supreme Trinity operates in matter, which comprises the four
elements, creating that matter, in which sense it is the efficient
cause; forming and ordering the created material, in which
sense it is the formal cause; loving and governing the formed,
ordered creation, in which sense it is the final cause. Now the
Father is the efficient cause, the Son is the formal cause, and
the Holy Spirit is the final cause . . ." (185.3).

Behind Thierry's audacious award of priority to *ratio*
over *auctoritas* in his commentary lies a complex tradition of
Christian thought and belief about the Trinity and its role in
creating the world. Augustine's treatment of the issue in the
eleventh book of *De civitate Dei* is Thierry's most important
antecedent; similarities and contrasts between the two thinkers
are, as usual, useful in defining the twelfth century's more
rational orientation. Augustine first explains the Trinity doc-
trinally, as a distinction of divine persons within a simple divine
nature. The Father is the simple, unchangeable good that has
created all non-simple, changeable things. The Son is begotten
(not made) by, and the same as, the simple good. The Holy

Spirit is different from Father and Son as a person, but equally
with them "the simple good, unchangeable and co-eternal"
(xi.10). Thierry will develop this explanation with a much more
rigorously logical argument in the last, incomplete section of *De
septem diebus*, demonstrating that the divinity is comprised of
Unity, Equality-to-Unity, and the Connection between them;
while he declares that Unity begets Equality-to-Unity, he is not
interested in the persons of the Trinity, concerning himself
instead with the logically derived relations as the divinity's de-
fining mark.[41]

Augustine next interprets the biblical statement "and God
said, let there be . . . and there was . . . and God saw that
it was good" as a clue to three causes of the universe: who
made it (God), by what means (his Word), and why (because it
was good); i.e., the efficient, formal, and final causes (xi.21).
Then, hesitantly, he raises the question whether the Trinity is
also "mystically intimated" in this display of causes (xi.23).
Augustine knew from the Johannine prologue that the Word of
God--his Wisdom, or design for Creation--was also the only-
begotten, coeternal Son. The Spirit *may* be the goodness or
holiness of Father and Son, but not merely as an attribute,
rather as a third person and the divine substance. If the Spir-
it-goodness identification is correct, then the Trinity is revealed
in the Genesis Creation account (xi.24).

Augustine's wariness about equating the persons of the
Trinity with attributes of God was shared by many subsequent
Christian thinkers, who worried about denying, even implicitly,
that all the divine attributes belong to all three persons, and,
conversely, about reducing the distinction of persons to a mere
catalogue of divine attributes.[42] In the twelfth century,
however, scholastic thinkers such as Abelard were attracted to
the attributes precisely as a way of explaining the Trinity ra-
tionally. Their initiative was attacked by those (e.g., William of
St. Thierry) who wished to defend the Trinity's status as a
mystery not susceptible of rational proof.[43] That William had
grounds for concern becomes clear from the fact that several
contemporary commentators, including William of Conches in his
Philosophia mundi and John of Salisbury in his *Policraticus*,
found the Trinity in the Timaean cosmogony, present as the
Demiurgos (*Potestas Dei*), the pattern according to which he
created (*Sapientia Dei*), and the goodness that motivated him
(*Bonitas Dei*). Both William and John also applied the concept
of the four causes to the *Timaeus* (*Gloss* on the *Consolation of
Philosophy*, 124.14-18; *Gloss* on the *Timaeus*, 142.2-143.3; *Poli-
craticus*, vii.5). William's longer explanation is based on the
idea that Timaeus wishes to prove rationally the perpetuity of
the world by showing that the causes of its existence are divine
and therefore immortal.[44]

Thierry, then, is in good intellectual company, but he
goes farther than any of his contemporaries in deriving the four

causes of the world independently of any text, as an exercise in
reasoning directly from the world to its Maker. He shows the
extent to which, in twelfth-century educational circles, human
rationality achieved exalted status and in the process accomp-
lished a practical reversal of Anselm's description of his use of
reason: *intellectus quaerens fidem* more exactly describes
Thierry's enterprise than would *fides quaerens intellectum*. The
clear implication of such application of logic to the process of
Creation is that our rationality allows us to elucidate and share
in the Wisdom of God, the ordering power of the universe, by
means of our capacity to construct well-ordered arguments,
treatises, systems, and, as we shall see, artifactual and verbal
microcosms.

For a last dimension of twelfth-century Creation thought,
one especially relevant to our concern with human creativity, we
must return to Hugh of St. Victor. Hugh, as we have seen,
championed the utilization of all the liberal arts in the study of
the three senses, or levels, of Scripture. He considered the
Bible to be above all the record of the "work of restoration" by
which the alienating effect of the Fall on humanity is overcome,
most centrally through the life, death, and resurrection of
Christ, but also by the lives of holy folk before and after
Jesus, and by the sacraments of the Church (*De sacramentis*
I.prol.2). The liberal arts play a special role in the work of
restoration: "this then is what the arts are concerned with, this
is what they intend, namely, to restore in us the divine like-
ness, a likeness which in us is a form, but to God his nature"
(*Didascalicon* ii.1).[45] Hugh here adapts the Platonic doctrine of
recollection: the recovery, by means of philosophy, of the image
of the divine in us which has been effaced by too great involve-
ment in the changeable world. His understanding of this doc-
trine centers on the potentiality of each art to impose order on
its subject, and thus participate in the orderliness of the uni-
verse which reflects and exemplifies the divine wisdom. "All
sciences, indeed, were matters of use before they became mat-
ters of art. But when men subsequently considered that use
can be transformed into art, and what was previously vague and
subject to caprice can be brought into order by definite rules
and precepts, they began, we are told, to reduce to art the
habits which had arisen partly by chance, partly by nature--
correcting what was bad in use, supplying what was missing,
eliminating what was superfluous, and furthermore prescribing
definite rules and precepts for each usage" (*Didascalicon* i.11).
Hugh seems to be speaking of a progression from customary,
unexamined actions to heightened consciousness about the nature
and goal of such actions, and finally to a rationalization of them
for maximum effectiveness and, in effect, a more adequate *imita-
tio* (or *imago*) *Dei*. In this way, we provide an improvement of
undisciplined humanity by reason that parallels the restoration

of fallen humanity by divine grace.

There is, however, an implication in Hugh's *Didascalicon*
that the work of restoration also has room for activities closer
to those of the *faber/artifex*. Book I, Chapter 9 deals with
the *tria opera*: the three works of God, of Nature, and of the
artist-craftsman imitating Nature. The topos of the *tria opera*
originates in Calcidius' commentary on the *Timaeus*;[46] to put
Hugh's use of it in context, we may turn to William of Conches'
adaptation of it in his *Glosses* on the *Consolation of Philosophy*
and the *Timaeus*. In his brief comment on the *opus artificis
imitantis naturam*, William stresses that *indignetia* is the exter-
nal cause leading the human *artifex* to imitate nature, e.g., by
making clothes to protect him against cold or shame; the best
William seems to expect from this situation is that the *artifex*
will observe his model carefully and learn from it, noticing, for
instance, that water gathered on a flat, wooden surface will rot
it, and thence designing a house with a concave roof (*Timaeus*
147.19-148.5; *Consolation* 127.26-128.17).

Hugh's treatment of the *tria opera*, while brief, is more
complex than William's. He assimilates the topos to the biblical
account of Creation and Fall: "the work of God is to create
that which was not, whence we read, 'In the beginning God
created heaven and earth'; the work of nature is to bring forth
into actuality that which lay hidden, whence we read, 'Let the
earth bring forth the green herb,' etc.; the work of the arti-
ficer is to put together things disjoined or to disjoin those put
together, whence we read, 'They sewed themselves aprons'." In
this initial presentation, the work of the artificer "restores" the
fallen state of humanity at the most basic and practical level.
Hugh then defines the *opus artificis* as "mechanical, that is
adulterate," no great compliment. But the further examples he
proceeds to enumerate--casting a statue, building a house the
roof of which sheds water, designing clothes--stress the careful
observation and deduction of the artist, who turns the Crea-
tion--the *opus Naturae* perpetuating God's initial creative acts--
to his use. Hugh waxes increasingly circumstantial and almost
lyrical: "He who first invented the use of clothes had consid-
ered how each of the growing things one by one has its proper
covering by which to protect its nature from offense. Bark
encircles the tree, feathers cover the bird, scales encase the
fish, fleece clothes the sheep, hair garbs cattle and wild
beasts, a shell protects the tortoise, and ivory makes the ele-
phant unafraid of spears." He then considers the *indigentia* of
humanity, that leads it to create in imitating nature, from a far
more flattering perspective than William's, and in doing so
brings the chapter to a conclusion with what becomes practically
a paean of praise to the artistic (not merely fabricating) power
of humanity and to its aesthetic, as opposed to practical, ef-
fects:

But it is not without reason that while each living thing is born equipped with its own natural armor, man alone is brought forth naked and unarmed. For it is fitting that nature should provide a plan for those beings which do not know how to care for themselves, but that from nature's example, a better chance for trying things should be provided to man when he comes to devise for himself by his own reasoning those things naturally given to all other animals. Indeed, man's reason shines forth much more brilliantly in inventing these very things than ever it would have had man naturally possessed them. Nor is it without cause that the proverb says: "ingenious want hath mothered all the arts." Want it is which has devised all that you see most excellent in the occupations of men. From this the infinite varieties of painting, weaving, carving, and founding have arisen, so that we look with wonder not at nature alone but at the artificer as well.

Hugh arranges his presentation of the three works, and especially the third, so that it moves from Creation to Fall to utilitarian restoration, to increasingly dignified and effective activity, to the exercise of human reason in inventing things that give pleasure and inspire wonder even as they satisfy needs. It is surely no accident that the last activities mentioned by Hugh are those which have a large aesthetic component--painting, weaving, carving, founding (e.g., statues). Hugh's message seems to be that, at his best, the *artifex* can become, in his admittedly fallen world, a rational maker inspiring awe and wonder--a little version of the Creator himself.

IV

The innovations in twelfth-century thought about divine Creation that influenced attitudes about human creativity find echoes or parallels in the visual and practical arts of the high Middle Ages. This was a period of artistic, as intellectual, vitality and variety, and although we must extend the time frame of our inquiry to encompass more years than we have thus far dealt with--the thirteenth as well as the twelfth century will supply us with examples--we will not thereby vitiate our argument, as the arts and disciplines of a particular culture rarely evolve *pari passu* in either style or content.[47]
The preference for *ratio* over *auctoritas* expressed by twelfth-century thinkers from the monk Anselm to the *magister* Thierry would appear difficult to express in images instead of words, but such a statement seems to be made, with some comic force, in a series of illustrations in an early twelfth-century English Gospel book now in the Morgan Library in New York City (MS. 777) (fig. 54). The illustrations, depicting each of the four evangelists mounted--precariously, to be sure--on his

traditional symbol (derived from the Book of Revelation, and ul-
timately from the Old Testament Book of Daniel) are unique in
this configuration, and have occasioned much comment about
their possible antecedents, though less about their possible sig-
nificance. In early medieval Gospel books, the symbolic crea-
tures usually appear either placed above their respective evan-
gelists or in a pose, with a scroll or book, that suggests they
are dictating the Word of God to their human counterparts.[48]
In short, they represent the divine inspiration--the ultimate
auctoritas which, according to the Church, guarantees the truth
of the Scriptures. Can we not, therefore, see the eccentric
placement of the evangelists astride their symbols as a tongue-
in-cheek response to the reevaluation of human *ratio* vis à vis
scriptural *auctoritas* in contemporaneous thought and practice?
The beneficiaries of the pictorial *bouleversement* are, after all,
precisely those human beings who, like Moses before them and
the twelfth-century scholastics after them, undertake to make
God known to human reason through his works--in this case,
through the words and deeds of his incarnate Wisdom.[49]

 Turning to more substantive, less speculative areas of
inquiry, we find in high medieval art numerous versions of the
analogy between God and the artist and a variety of innovative
constructs to represent, explain, or imitate the rationality and
order of Creation. A succinct, and famous, statement of the
parallel between divine and human creators is the signature
which Giselbertus, one of the greatest French romanesque
sculptors, placed beneath the feet of Christ--represented in
majesty as the apocalyptic Judge (Apoc. 20.11f)--on the tympa-
num of the west façade of the church of St. Lazarus, Autun
(c.1125-35) (fig. 51). In an age in which "the artist claimed
for himself the right of special recognition," a sculptor's inclu-
sion of his name on his work was not unusual, but the place-
ment of this one--"Giselbertus hoc fecit"--is.[50] Not only does
it immediately call the attention of anyone entering the church
to the artist who decorated it with sculpture of great originality
and brilliance, but also it makes a statement about Giselbertus
as an earthly surrogate of God the Creator. Giselbertus could
assume universal recognition that the Christ of the Last Judg-
ment is identical with the Logos-Creator. As the image of
Christ stands for, and leads us back to, the Wisdom through
whom God began the world, so the words at his feet stand for,
and lead us back to, the artist who now depicts the promised
end of that world. The equation is precise: behind Christ the
Judge, God the Creator; behind the depiction of Christ the
Judge, Giselbertus the Creator.

 One hundred years after Giselbertus' work at Autun (c.
1240), an anonymous sculptor carved a series of images depict-
ing the Creation on double archivolts of the central portal of
Chartres Cathedral's new north porch. These archivolts can
legitimately be considered a last flowering of the Chartrian tra-

dition of Creation speculation and analysis. They express the creative power and love of the Deity with an extraordinary eloquence that draws our attention as much to the supreme Artist as to his great Work. The Logos-Creator, identified as always in medieval art by his cross-nimbus, assumes a rich variety of postures, some of which seem theologically motivated: as he creates the birds and fishes, for instance, a human face peers over his shoulder. This figure may represent the creating Trinity, especially if we interpret the two figures in the light of Thierry of Chartres' analysis of the divinity as the One (or Unity) and the One Equal to One (or Equality) in the latter part of *De septem diebus*; it may, on the other hand, be the idea of Adam in the Creator's mind--the last stage of Creation and the destined master of all other creatures.[51] Above all, however, the Creator's actions are those of an *artifex*: he is shown deeply engaged in thought, or reading a book open on his lap--references to the pattern or idea in the mind of the Creator (the *Sapientia Dei*) on the basis of which the world is made, and activities that recall the Chartrian master William of Conches' "ut faber, sic creator" simile. Elsewhere God holds one of the heavenly orbs in his hands, and acts out the labor of separating the heaven from the earth (fig. 53). Finally, as God forms Adam, the creature's head lies in his Creator's lap, and the latter seems at once to mold and to caress that part of the human anatomy containing the rational faculties through which Adam and his descendants will be able to understand, as well as believe in, the Creator.[52]

The presentation of God as supreme Craftsman could derive support from the Bible as well as Platonic epistemology. Wisdom 11.21, we recall, says of God, "omni in mensura, et numero, et pondere disposuisti," a statement that inspired, from Anglo-Saxon England onward, cosmograms in which God, armed with various instruments of measurement, imposed precise dimensions on the world.[53] The thirteenth century saw the rise of an analogous image of God, as divine architect, superimposing the ordered cosmos on the primal elements by means of a compass (frontispiece). Although other biblical sources besides Wisdom 11.21, notably Proverbs 8.27 and various exegetical traditions have been proposed to explain this popular depiction,[54] it surely reflects as well the new dignity attained by the architects and masons who from the twelfth century onward developed and perfected the monumental style of building we call the Gothic. (As a sign of this dignity, the title of *magister* was borrowed from the world of education and bestowed on the designers and builders of cathedrals.) In the Gothic style, the creative power and wisdom of God--attributes, as we have seen, assigned to the first and second persons of the Trinity, respectively--find earthly expression: the former in the enormous size and complexity of the cathedrals, the latter in their clear embodiment of rationality as a guiding principle, revealed in the

self-consciously articulated clarity, regularity, and unity of its
basic architectural units. The observer of the Gothic cathe-
dral's geometrically precise system of bays and rib vaulting, its
carefully composed façades and networks of buttresses was in-
vited, nay compelled, to see in the ensemble an impressive mi-
crocosm of what Hugh of St. Victor called the "work of founda-
tion"--the divinely ordered Creation--even as the cathedral's
elaborate exegetical programs in stone and stained glass, and
the homilies preached within it, made it a microcosm of the
"work of restoration."[55] Surely a creator with a compass, en-
dowed with practically divine gifts, had been responsible for
such an inspired construction!

 The precision and order of Gothic design and the analytic
response it evokes have brought us to our second area of in-
quiry in the visual arts, viz., how the age generated images that
explained and imitated, like scholastic treatises, the supreme
rationality of the Creation, and thus declared, by their form
and meaning, a human rationality ordained by God to reflect his
own. It is the same rationality that is conveyed by God to the
first man in the Anglo-Norman *Adam* (21). The main medium for
such images was the illuminated or illustrated manuscript, and
the twelfth century saw a marked increase over its predecessors
in the production of manuscripts depicting the Creation--sixty-
two, as opposed to seven in the eleventh century. (The thir-
teenth century saw that number jump to 233, after which it
declined for the remainder of the Middle Ages.) The majority
of twelfth-century Creation images--thirty-six of sixty-two--are
illustrations of Genesis 1 in manuscripts of the Bible, with the
remainder divided among other religious, historical, and scien-
tific texts, including, in the latter category, the *Clavis physi-
cae* of Honorius Augustodonensis, based on John Scot Eriugena's
Periphyseon, and containing a remarkable series of Christian-
Platonic cosmograms.[56]

 The dominant type of twelfth-century Genesis illustration,
at least in northern Europe, was the historiated initial I (some-
times IN entwined in a monogram) that begins the text. Harry
Bober has noted that, "among Old Testament illustrations, Gene-
sis initials in medieval Bibles are usually the very ones which
most pointedly undertake exegetical functions, transcending
mere history, narrative, or description." Bober traces the
origin of the decorated or historiated initial back to Carolingian
and Ottonian times, in manuscripts, not of Genesis, but of
John's gospel, which, like Genesis, begins in Latin, "In princi-
pio." The Ottonian images, which present Christ in majesty
surrounded by the four evangelical symbols, were gradually
transferred, by the twelfth century, from John to Genesis, with
suitable change of subject matter. Of the Johannine depictions,
Bober says, "as initials enlarged to full page size, the first
word is glorified to the maximum possibility of manuscript art.
As carriers of iconographic content, they serve to express the

Majesty of Christ as the Logos Incarnate, and with it, the
meaning of the first sentence of the Gospel of St. John."[57]
One might indeed suggest that the historiated initial tradition
develops at the beginning of John's gospel to suggest a parallel
between "in the beginning was the Word" and "in the beginning
is the image," and thus not only to endow the image with exe-
getical status, but also to call attention to the analogy between
its explanation of the Johannine text and that text's explanation
of the Creating God of Genesis.

The simplest form of historiated Genesis initial depicts the
works of Creation in narrative sequence, usually in medallions
descending down the I that begins the text, and usually,
though not always, with one image allotted to each day's work.
The column of medallions is sometimes presided over by a cross-
nimbed Logos-Creator, whose simultaneous identity as the eter-
nal Wisdom of God and the Word made flesh in Jesus reminds the
viewer to understand the Creation both historically, as the work
of foundation in six days, and sacramentally, as a prefiguration
of the work of restoration in six ages of the world (allegorical
sense) or the individual Christian (tropological sense).[58]

Much more complex and composite Creation images are also
to be found in twelfth-century manuscripts--both in Genesis
initials and in illustrations of other types--as well as in other
media. A few examples must suffice. Harry Bober has demon-
strated that the IN-monogram introducing Genesis in the St.
Hubert Bible (Brussels, Bib. roy., MS. II.1639) synthesizes
Christian and Platonic Creation thought at the very beginning
of our period (c.1070) (fig. 55).[59] In the center of the image,
where the arm of the N intersects the I, is a medallion showing
the Logos-Creator in an attitude of blessing; he holds a book in
his other hand (a symbol of his status as *Sapientia Dei*), and
the Greek letters alpha and omega effectively place the Lo-
gos/Son outside time (the medium of hexameral creation) and in
control of it as its beginning and end (cf. Apoc. 1.8). Finally,
the letters L, U, X, (light) are fixed, one each, into the three
visible arms of the cross in his nimbus. Instead of illustrating
the works of the six days, the other medallions, four in num-
ber, are labeled as the four elements, each holding symbolic
attributes. In the roundel surrounding each element is a differ-
ent mathematical formula and a Roman numeral--8, 12, 18, 27--
which is the product of the formula in each case. The numeri-
cal scheme represents the harmonious binding together of the
elements as a mathematical sequence from the cube of two to the
cube of three, the other two numbers establishing a uniform
ratio, in which each succeeding number is one and one-half
times greater than its predecessor. In other words, the se-
quence of interlocked numbers represents the Idea or Form of
the Creation in the mind of the Creator before he actually
brings the four elements into being and begins to order them.
The source of the mathematical model from which the visi-

1. Man shooting with bow and arrow at man exposing his hind-quarters (lower left corner of folio). *Romance of Alexander.* c.1340. Oxford, Bodleian Library, MS. Bodley 264, fol. 3.

2. *Fiery dragon, nude man. Book of Hours. Early 14th-century. Pierpont Morgan Library MS. M.754, fol. 45.*

3. *Nude man confronting dragon rampant. Book of Hours. Early 14th-century. Baltimore, Walters Art Gallery MS. W.85, fol. 39.*

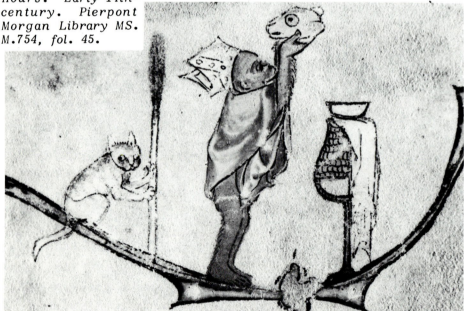

4. *Ape wearing bishop's mitre presenting offering at altar, accompanied by cat with asperge. Book of Hours. Early 14th-century. Cambridge, Trinity College MS. B.11.22, fol. 4.*

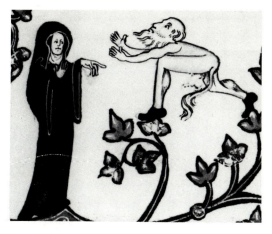

5. *Nude man with tail, exposing genitalia to nun. Gorleston Psalter. c.1320. British Library Add. MS. 49622, fol. 90ᵛ.*

6. *Nude man embracing hare.* **Voeux du Paon.** *Mid 14th-century. Pierpont Morgan Library MS. 24, fol. 41.*

7. *Nude hunter with trumpet. Book of Hours. Early 14th-century. Baltimore, Walters Art Gallery MS. W.90, fol. 90.*

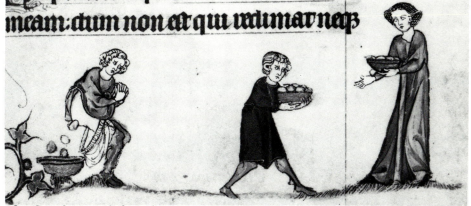

8. *Gentleman defecating, servant carrying bowl of faeces to lady. Book of Hours. Early 14th-century. Cambridge, Trinity College MS. B.11.22, fol. 73.*

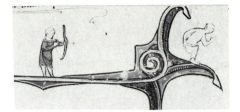

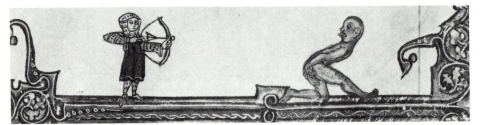

10. Knight shooting arrow at hindquarters of nude man bending over. Breviary (2 vols.). Late 13th-century. Cambrai, Bibliothèque Municipale MS. A.102, fol. 462.

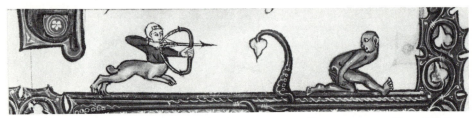

11. Centaur shooting at hindquarters of ape-man. Breviary. Late 13th-century. Cambrai, Bibliothèque Municipale MS. A.102, fol. 179v.

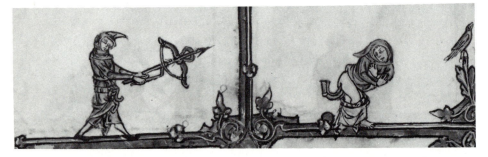

12. Man shooting crossbow at exposed hindquarters of man. Missal. 13th/14th-century. The Hague, Koninklijke Bibliotheek MS. 78 D 40, fol. 158v.

13. *Above: Devil on stool, defecating. Psalter (2 vols.). Early 14th-century. Oxford, Bodleian Library MS. Douce 6, fol. 181ᵛ.*

14. *At right: Ape defecating into open jaws of diabolic hybrid monster. **Voeux du Paon**. Mid 14th-century. Pierpont Morgan MS. Glazier 24, fol. 23ᵛ.*

15. *Above: Ape defecating in front of human face. Decretals of Gratian. 1314. Paris, Bibliothèque Nationale MS. Latin 3893, fol. 96.*

16. *Man bent over and defecating in front of nun. Romance of Alexander. c.1340. Oxford, Bodleian Library MS. Bodley 264, fol. 56.*

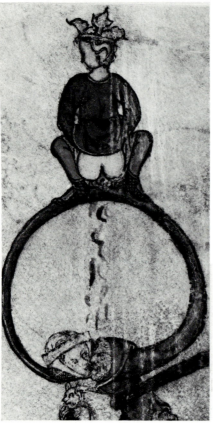

18. *Nude youth, defecating into stream. Book of Hours. Early 16th-century. Oxford, Bodleian Library MS. Douce 276, fol. 18a.*

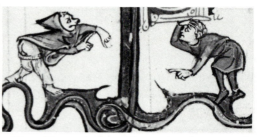

17. *King (Saul?) defecating. Arthurian Romance. c.1315. British Library, Add. MS. 10294, fol. 1.*

19. *Man defecating in front of another. Breviary. Late 13th-century. Baltimore, Walters Art Gallery MS. W.109, fol. 197v.*

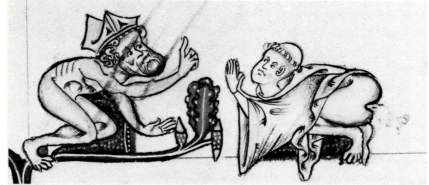

20. *Cleric defecating, reprimanded by nude bishop. Gorleston Psalter. c.1320. British Library Add. MS. 49622, fol. 82.*

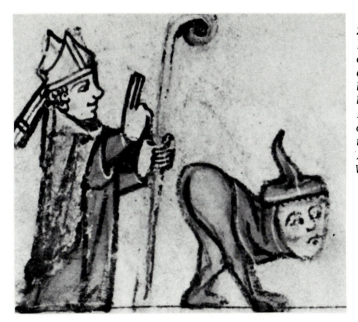

21. At left: Bishop blessing exposed hind-quarters of hybrid with human head. Book of Hours. c.1300. Baltimore, Walters Art Gallery MS. W.88, fol. 106.

22. Nude hybrid with human head presenting hindquarters, bishop with censer. Book of Hours. Early 14th-century. Pierpont Morgan Library MS. M.754, fol. 81ᵛ.

23. Hybrid mitred bishop kissing hindquarters of ape with bow. *Voeux du Paon.* Mid 14th-century. Pierpont Morgan Library MS. Glazier 24, fol. 72ᵛ.

24. *Templar kissing clerical monster's rump.* **Voeux du Paon.** *Mid 14th-century. Pierpont Morgan Library MS. Glazier 24, fol. 70.*

25. *Hybrid beast kissing ape's hindquarters.* **Voeux du Paon.** *Mid 14th-century. Pierpont Morgan Library MS. Glazier 24, fol. 79.*

27. *Above: Hybrid man with exposed buttocks, about to kiss exposed hindquarters of man with tail. Gorleston Psalter. c.1320. British Library Add. MS. 49622, fol. 157v.*

26. *Above: Man about to kiss rump of nude cleric with tail. Gorleston Psalter. c.1320. British Library, Add. MS. 49622, fol. 206v.*

28. *Simone Martini, Annunciation (detail).* *Galleria degli Uffizi, Florence.*

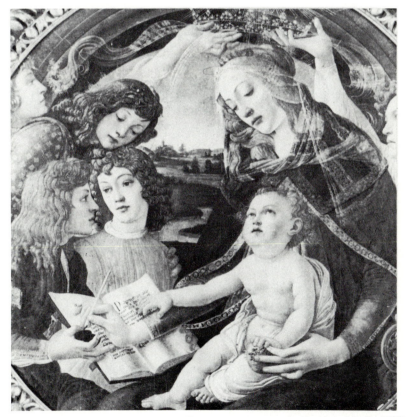

29. *Botticelli, Madonna of the Magnificat.* *Galleria degli Uffizi, Florence.*

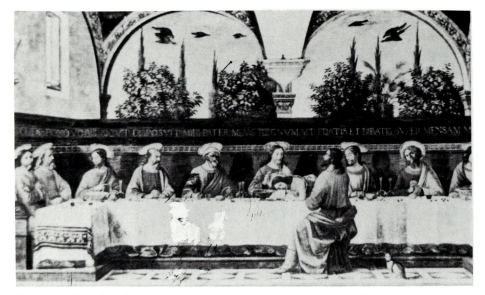

30. Da Maiana (?), The Last Supper. Museo di San Marco, Florence.

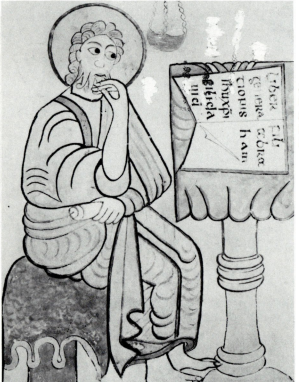

31. At left: St. Matthew. Vienna, Österreichische Nationalbibliothek, Cod. 1224, fol. 17ᵛ.

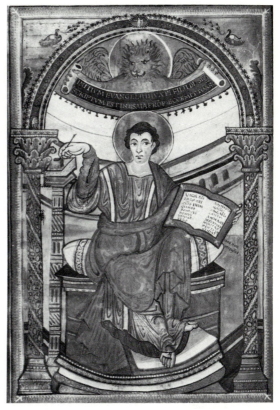

32. At right: St. Mark. Aachen Palace School Gospel Book. By permission of the British Library, London.

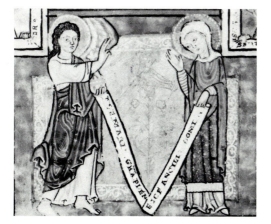

33. At left: Annunciation. Psalter of Henry of Saxony. By permission of the British Library, London.

34. Orcagna. Hell. *Museo di Santa Cruce, Florence (by permission of the rector).*

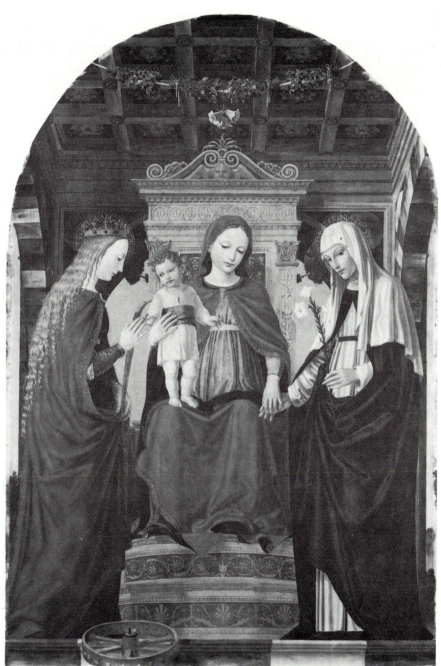

35. *Bergognone, Madonna and Child with Sts. Catherine of Alexandria and Catherine of Siena. (Reproduced by courtesy of the Trustees, the National Gallery, London.)*

36. Last Judgment. Wall painting (restored), with hell mouth. Church
of St. Thomas of Canterbury, Salisbury. 15th-century. Photograph:
National Monuments Record.

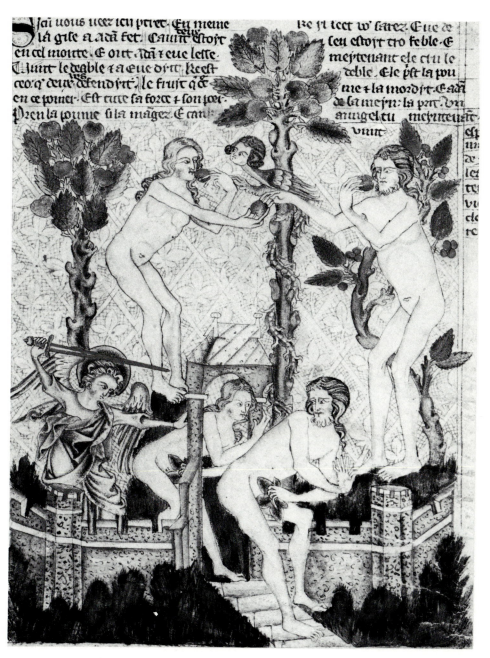

37. *The Fall. Holkham Bible Picture Book, fol. 4. 14th-century. British Library.*

38. *Staging Diagram for* **The Castle of Perseverance**. *15th-century.*
Folger Shakespeare Library.

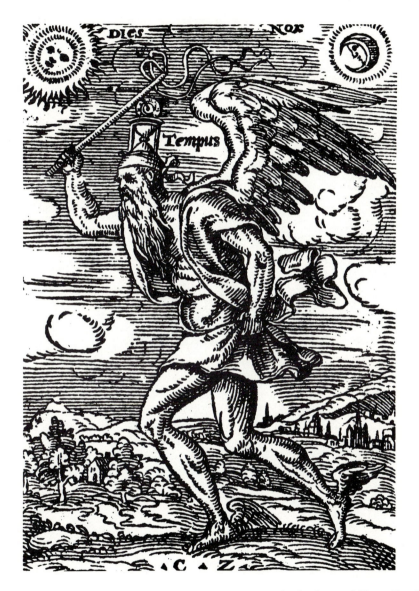

39. *Cruel Time*. *Woodcut from Giovanni Andrea Gilio,* **Topica Poetica** *(Venice, 1580).*

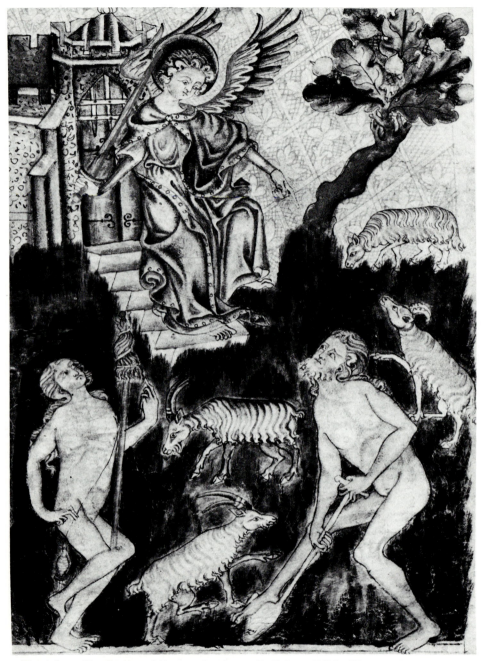

40. *Adam digging and Eve spinning. Holkham Bible Picture Book, fol.
4ᵛ. British Library.*

41. *Doctor Faustus. Woodcut from title page. Christopher Marlowe,* **The Tragicall History of the Life and Death of Doctor Faustus** *(London, 1624).*

42. *At right: Truth as the Daughter of Time. Woodcut in Lancelot Andrewes,* **The Wonderfull Combat** *(1592).*

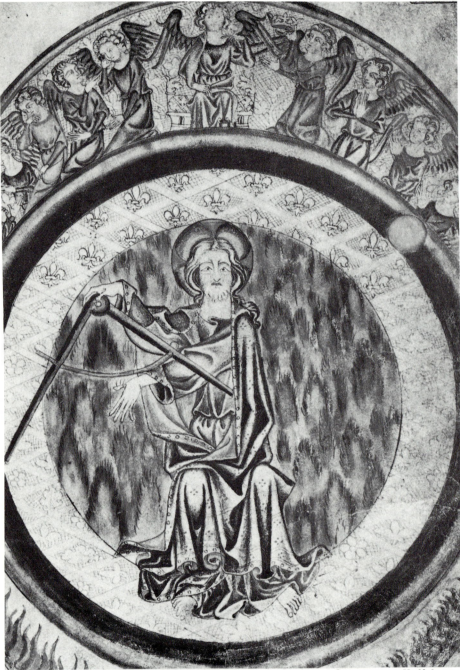

43. *The Pride of Lucifer (top) and God as Creator. Holkham Bible Picture Book, fol. 2 (detail). British Library.*

44. *Holy Women at Sepulcher. Benedictional of St. Ethelwold, fol. 51ᵛ. 10th-century. British Library.*

45. *Resurrection. Alabaster, Hildburgh Collection. 15th-century.*
Victoria and Albert Museum (A.110-1946).

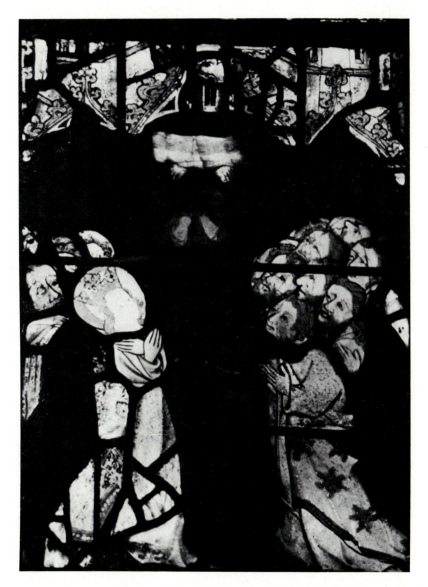

46. *Ascension. c.1370. Painted glass now in West Window of Church of All Saints, Pavement, York. Photograph: David O'Connor.*

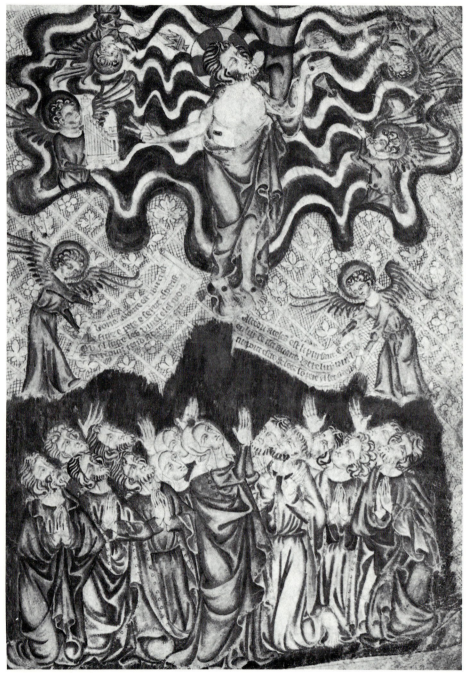

47. *Ascension. Holkham Bible Picture Book, fol. 38. British Library.*

48. *Coronation of the Virgin (restored; heads are replacements).*
c.1470. Painted glass, Church of the Holy Trinity, Goodramgate,
York. Photograph: David O'Connor.

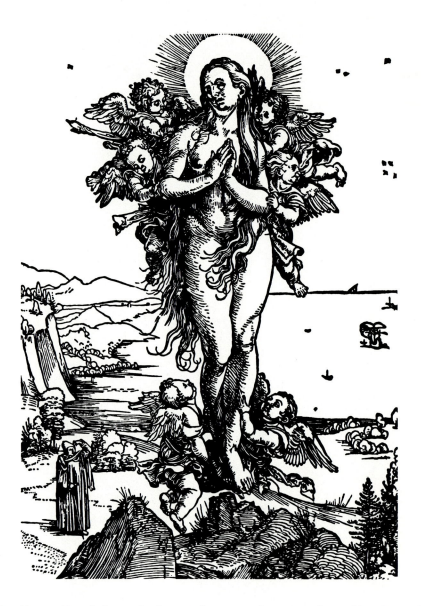

49. *Mary Magdalene being taken up by angels. Woodcut by Albrecht Dürer.*

50. *Last Judgment with Seven Deadly Sins and Corporal Acts of Mercy. Late 14th-century. Wall painting, Trotton, Sussex. Photograph: National Monuments Record.*

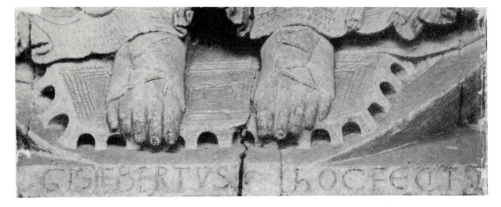

51. *"Giselbertus hoc fecit."* *Signature of the artist placed at the feet of Christ enthroned as Judge. Tympanum over West Façade Entrance, Cathedral of St. Lazarus, Autun. c.1125–35.*

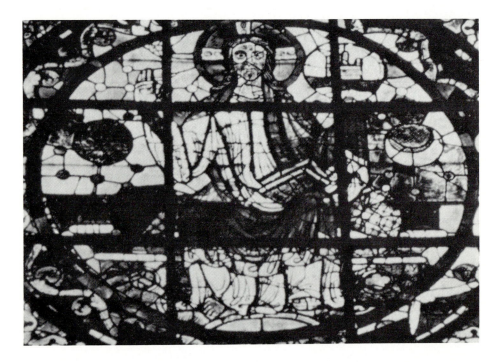

52. *Logos Creator. Stained glass rosette, clerestory window, east side of North Transept, Chartres Cathedral. Early 13th-century.*

53. *Creation of Heaven and Earth. Central Portal Archivolt, North Porch, Chartres Cathedral. c.1240.*

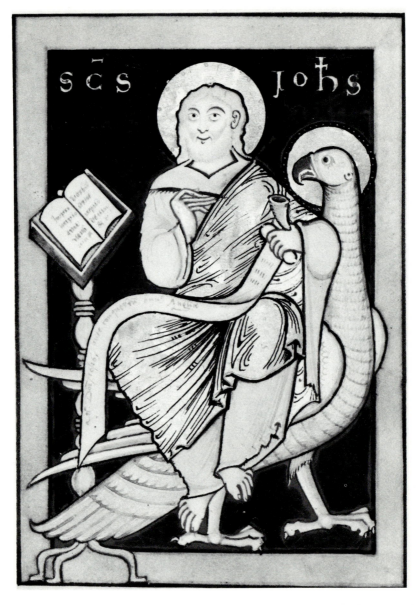

54. *St. John the Evangelist mounted on his symbol. English Gospel Book. c.1120. Pierpont Morgan Library MS. 777, fol. 58ᵛ.*

55. *IN initial at beginning of Book of Genesis. St. Hubert Bible. c.1070. Brussels, Bibliothèque Royale, MS. II.1639, fol. 6ᵛ.*

56. *The Six Days of Creation. c.1100. Verdun, Bibliothèque Muni-
cipale MS. 1, frontispiece.*

ble world is created is, of course, the *Timaeus*, while the Crea-
tor's activity in binding together the elements of nature in a
system as perfectly ordered as numerical ratios receives praise
in the Timaean Creation-hymn of the *Consolation of Philosophy*.
In this image, then, the Demiurgos and the Logos-Creator coin-
cide, and the latter is shown as the divine *lux* of the Johannine
prologue. But the presence of animals in the decorative foliate
background of the initial also adumbrates the creation of the
various species; there is even a serpent to foretell the Fall of
humanity.[60] So we have a wedding of Christian and Platonic,
artistic and scientific, rational and revealed elements in this
depiction of Creation as both a system and a series of actions in
time--a cosmology and a hexameron--by a Creator who lives
outside of, and controls, time and matter. Antedating Chartrian
and other twelfth-century cosmologists by several decades, the
St. Hubert Bible initial shares their synthetic impulse and faith
in the rational scheme of Creation.

A miscellaneous manuscript now in Verdun (Bibl. Munici-
pale, MS. 1) begins with a full page illustration which offers
another instance of ingenious visual exegesis of the Creation
account in Genesis (fig. 56). Following a formal scheme set
forth most notably in the late eleventh-century Gerona tapestry,
the works of the six days are presented in a circular band
around a central figure of the Creator. Surrounding the circle
outside it are allegorical figures: *lux* and *tenebrae*, the four
winds, and the four seasons which, in Adelheide Heimann's
words, "frame the whole work of Creation, and so indicate the
forces and the orderly course of nature."[61] Heimann sees the
disposition of the days of Creation in the circular band as an
adaptation of depictions of cycles of the months, grouped around
a central figure symbolizing *annus*; furthermore, each day's
labor of Creation departs from traditional modes of representa-
tion in that, instead of God being shown in the creative act, an
allegorical figure, representing the day itself, holds the day's
creation in his hand. This "peculiar and beautiful fusion of
cosmological and religious allegory," as Heimann calls it, sur-
rounds an equally unusual depiction of the Logos-Creator on the
seventh day, resting on his throne, embracing and blessing
Adam who kneels beside him (cf. the Chartres archivolts).[62]
(By contrast, the Gerona tapestry shows the expected Logos-
Creator, one hand upraised in blessing, the other holding an
open book.) What must strike the viewer is the depiction of
such as intimate relationship between God and his prime creation
(made in his image), placed within an overall design stressing
the orderly, quite autonomous procession of the days of Creation
and seasons of the year. The Verdun image manifests an opti-
mism, familiar to us from Abelard, William, and Thierry, that
both humanity and nature participate in the rationality of the
Logos, which ordains the Creation to proceed in a comprehensi-
ble sequence of times and seasons from the first moment of time

and allows humanity to share, in a particularly privileged fashion, in the life of God by the exercise of rational speculation.

A direct response to Chartrian analyses of the Trinity in terms of the four causes of Creation has been found by Jan van der Meulen in an early thirteenth-century stained glass rosette in a clerestory window on the east side of the north transept in the cathedral of Chartres itself[63] (fig. 52). In the window, the Christ-Logos is enthroned as the Creator, holding the globe of the universe and blessing it. On the globe can be seen a castle, representing humanity, and disposed around the central figure are symbols of the four elements of which the material universe is composed. Van der Meulen interprets the central figure as the *Trinitas Creator*; the throne on which he sits represents the sovereignty of the Father; the book that floats open before him, the Word and Wisdom of God, or the Son; and the gesture of benediction, the Love and Goodness of God, the Holy Spirit. The iconically present four elements represent the material cause of the universe, and the Trinity therefore is to be understood as present in its existence as the other three causes. Furthermore, humanity's presence, figured in the castle, points to the identity of the Logos as the divine providence, acting in time, as well as the Creator acting before, and outside, time.[64] Altogether the image in the Chartres window offers a synthesis of an appreciation of creation as both a system and an ongoing process open to human perception through reason.

Van der Meulen's insistence on finding the creating Trinity in a wide range of medieval Creation images has not received universal approbation. His recent interpretation of the tympanum sculpture above the north portal on the west façade of Chartres Cathedral as an image of the *Trinitas Creator* involves rejecting the traditional reading of that tympanum as a representation of the Ascension of Jesus.[65] Van der Meulen bases his argument on the similarities between the composition of the portal and the so-called Roman-type hexameral image (a tradition stretching back, in all probability, to the fifth-century Roman churches of St. Peter and St. Paul) in which the first five days of Creation are not represented, and in their stead a single exegetical image precedes the creation of Adam and Eve. The single Roman image shows the Logos-Creator flanked by angels and by symbols representing *lux* and *tenebrae*, and betrays the influence of Johannine light-darkness exegesis as well as the Augustinian interpretation of the separation of light from darkness as the expulsion of the rebellious angels from heaven. At Chartres, the presence of two angels flanking the central Christ figure, and of four more descending below his feet, suggests to van der Meulen the Augustinian tradition, while the partially defaced dove over Christ's head is the normal image of the Spirit as part of the Trinity. (In the Chartres archivolts of the following century, there are still representations of angels in

some of the days of Creation.) Finally, the ten apostles below the image of Christ "symbolize man as created in the beginning and recreated in Christ," and "are a most fitting expression of man's creation in a universe imbued with both physical and especially spiritual order"--an exegesis which, if correct, suggests a formulation like that of Hugh of St. Victor, who links together the work of foundation and the work of restoration.[66]

V

We may, then, justly conclude on the basis of exegetical evidence drawn from several areas of twelfth-century culture--study of the liberal arts, philosophical and scientific speculation, developments in the visual arts--that heightened, sympathetic interest in human creative capacities, especially those of invention and design, was a concomitant, if not a byproduct, of the age's preoccupation with God's essence and work as a Creator. It remains to survey the presentation, positive and negative, of these capacities in twelfth-century courtly literature. Fortunately, we possess in Bernard Sylvestris' Latin prosimetrum, the *Cosmographia* (c.1147), an ideal bridge between learned cosmological analyses and self-conscious courtly fictions.[67] Bernard's two-part work, comprising the *Megacosmus*, or making of the universe, and *Microcosmus*, or making of humanity, audaciously combines elements of Timaean cosmogony, hexameral narrative, and quest romance; the resulting *integumentum* allows the author to explore, among other things, the powers and limits of poetic art itself. The *Cosmographia*, seen from this perspective, becomes the twelfth century's supreme self-conscious fiction, using universal creation as a metaphor for human creativity, and the divine ordering of the universe as an aid in understanding the task of the verbal artist.

Book I of the *Cosmographia*, the *Megacosmus*, deals primarily with artistic vision. Nature, in many respects the poem's protagonist, pleads with Noys, the divine providence, to beautify Silva, the chaotic, pre-existent matter of the universe, by giving it new birth through the imposition of order. Noys agrees, and the remainder of the book describes "the ordered disposition of the elements"[66] that make up the universe created by Noys' activity. At one level, *Megacosmus* offers a metaphoric representation of artistic creation analogous to Hugh of St. Victor's characterization of all arts as the imposition of rational order on material previously subject, like Silva, to movements of chance and necessity. Nature represents the artist as the broker, as it were, between the original, divine creative impulse and the fallen state of humanity which, as Hugh points out in the *Didascalicon*, now requires human artfulness to restore it at least in part to its divine maker. As composer of ordered fictions, the artist partakes of a divine gift. But because Silva is tainted with evil, her "wild and perverse quality cannot be

perfectly refined away or transformed," even by Noys (69).
She will never be completely ordered. This pre-existent taint
of Silva is, as Winthrop Wetherbee suggests, "a metaphor for
the effects of original sin in human life" (Introduction, 38);
that is, Bernard transfers the result of the Fall from its place
in Genesis to an anachronistic position before Creation in order
to construct a model more relevant to an allegory of human
creativity. Fallen Silva inspires the artist to a socially useful
(because restorative) creative vision, yet simultaneously places
a limit on that vision, thereby distinguishing the human creator
from his divine analogue or, to put it differently, accentuating
the inherent fictionality of a poem about universal order.

 In Book II, the *Microcosmus*, Nature is charged by Noys,
"the careful craftsman," to make man, in order to "complete the
success and glory of the creation" (94). Nature must find
Urania and Physis to aid her in the task, and, as she proceeds,
her limitations are repeatedly stressed. She particularly lacks
heavenly insight, and all three goddesses have great difficulty
finding the exemplars they need to create humanity, even with
the special aids given them by Noys. When the creature does
take shape, the "glory of creation" turns out to be flawed and
weak, though full of potential. If Book I extols an idealizing
artistic vision which can construct an orderly cosmos out of the
world's imperfect material, Book II, by contrast, shows the dif-
ficulty of imposing a flawed or limited vision on material itself
fallen, whatever its divine potential. The two books, in other
words, look at the artist's task from two different perspectives
and pronounce diverse judgments on what they see. In Book I,
Nature associates herself with Noys in triumphantly recreating
Silva, which has yearned for such transformation. In Book II,
however, Nature, though commissioned by the divine, shows
herself more allied to the fallen and imperfect world. The ideal-
ism of Book I gives way to Noys' darker views of creation in
Book II: she tells Nature to make the body of man from "those
elements extracted from the mass of chaos" (i.e., Silva), and
adds, "are you aware of what zeal, what perseverance, what
effort the molding of these demands? It is indeed a weighty and
intricate task, involving most difficult calculations, that I have
imposed" (114). There is little glory for the *artifex* here, but
much trouble, as the limited creator deals with flawed materials.
The aids Noys gives the three goddesses--the mirror of provi-
dence, the tables of destiny, the book of memory--each consti-
tute a different, large-scale perspective on creation, and each
is more a hindrance than a help because it overwhelms the view-
er and hides the genius of a moral, perfected humanity from
ready scrutiny. In each case there is a failure of focus, an
inability to pick out the individual human form from amidst a
cosmography that looks suspiciously like Bernard's own Book I.

 Reading these two opposed poetic myths analogically, as a
parable of the artist's task, we find that at one extreme he

ascends almost to the level of divine creativity, while at the other he struggles to perceive, even dimly, an adequate image of humanity, and even then can hardly impose it on the recalcitrant, fallen material with which he must work. The artist is a pivotal figure; he shares a creative vision and task with God, but with his human subject a fallenness and limitation that threaten constantly to frustrate the translation of vision into a practical instrument of moral recreation.

The total effect of the *Cosmographia*, read in this way, is to clarify the distinction between human and divine creativity; the former is like the latter, and even partakes of its vision, but can never be confused with the *opus Dei* because of its flaws of both conception (the artist's limits) and subject (fallen humanity). This, I believe, is how twelfth-century courtly poets conceived of their own fiction-making activities: as a form of creativity modeled on the divine order but limited by fallenness. In their works, to which we now turn, we find various references to the godlike creating and ordering power of the poet; a wide-ranging awareness of his limitations as a participant in the fallen human condition; and some striking instances of concern that the artist, by the nature of his calling, risks the imputation, and even the very crime, of blasphemy--the creature's attempt to challenge the sovereignty of his Creator.

VI

Throughout twelfth-century courtly poetry we find, writ large and small, the conceit of the artist who creates in language as God does in matter. From its earliest exemplars, this simile attracts to itself sophisticated, serio-comic ambiguity of treatment. The first troubadour, Guillaume IX, Count of Poitou and Duke of Aquitaine (1070-1127), begins one of his songs, as follows: "Farai un vers de dreyt nien"--I will make a poem about (or from) absolutely nothing.[68] Depending on how one construes *de* (and the quibble is surely intended), this line suggests either that Guillaume's lyrics are exercises in vacuity, using language emptied of the truths of history and scripture, or that they are examples of almost godlike *creatio ex nihilo*. In another song,[69] Guillaume's narrator-persona asks "li pluzor" to examine and judge the *vers* which he has just brought out of his workshop, and then quickly passes his own judgment that, when he has finished it, his poem will bear witness to the unequaled artistry of its maker. This statement by a comic Demiurgos brings us close to the faith of Abelard and Thierry that the divine Creator can be known through a careful study of his Creation, as well as to Hugh of St. Victor's assertion that the beauty of the material creation provides a trace of God's wisdom, i.e., his Logos.

Guillaume's characterization of his song as a "vers de dreyt nien" suggests his heightened awareness that the world

created by the poet is ultimately an illusion--marvelous, perhaps, but fleeting and insubstantial--since it is made of human words which, as Augustine reminds his listeners in his first tractate on John's Gospel, are as impermanent as God's Word is eternal.[70] Several characters in romance narratives whose activities mark them as artist-surrogates embody this truth about art. Mélior, Empress of Byzantium and heroine of *Partonopeu de Blois*,[71] describes to Partonopeu her education by her father, the Emperor, in the seven liberal arts and *nigromance*; while he was still alive he would summon her to his chamber at midnight, and there, by her *savoir*, the room would appear to expand to encompass the entire *païs*. Mélior would then create a *clarté* so that the room was as bright as a summer's day, and summon a thousand or two thousand knights to do furious battle for as long as she pleased, after which they returned to *nient*. Such, she says, was her *poeste*, thanks to the *sens* God had given her.[72] The parallels with Guillaume IX, on the one hand, and with the *Potestas Dei* creating by means of the *Sapientia Dei*, on the other, are too clear to require further comment.

In Chrétien's *Cligès*,[73] Thessala, the nurse and *mestre* of Fénice, undertakes to save the latter from consummating her unwished for marriage with Alis, Emperor of Byzantium, and Chrétien so presents the crisis and its resolution as to create a parallel between Thessala's actions and those of an author self-consciously manipulating his plot and characters. Fénice falls in love with Cligès, Alis' nephew, but cannot reveal her passion because of her arranged betrothal to the emperor. Thessala, native of Thessaly, a country famous for its magicians, and herself adept at *nigromance* (2964-70), perceives from Fénice's behavior and complexion that her charge is in love, and forces a confession from her in a scene Chrétien's audience would recognize as reminiscent of one of the age's most famous literary love-disclosures, that of Lavine to her mother in the influential *Roman d'Eneas*.[74] Thessala, "who was very wise about love and all its ways" (3055-56), promises to help Fénice attain her desire, but the maiden (and behind her, Chrétien) now states the central problem in a self-consciously literary manner: she cannot consent to sharing herself out between uncle and nephew:

> I would rather be dismembered
> than that the two of us should remind people
> of the love of Isolde and Tristan
> of whom many foolish things are said
> which are shameful to recount.
> I would never be able to reconcile myself
> to the life Isolde led.
> Love demeaned itself too much in her,
> because her heart belonged entirely to one,

and her body was shared by two.
. . .
But I can't understand
how he could have my body,
he to whom my heart is given,
when my father is giving me to someone else
and I don't dare dispute him.
And once he is the lord of my body,
if he does with it what I don't want him to,
it's not right that another
 should gather fruit there, too.

 (3105-14, 3125-32)

And there is yet another complication: Alis has promised not to
marry, and Cligès is due to inherit the empire after his death,
but if Fénice bears Alis a son, she will bring about the disin-
heritance of her lover! Fénice presents this formidable nar-
rative knot to Thessala, asking if she has enough skill ("se vos
tant saviez d'art" [3137]) to untangle it; the *mestre* replies that
her magic (the in-plot equivalent and surrogate of Chrétien's
ingenuity) will be equal to the task. Thessala now creates a
potion which, when imbibed by Alis, induces him to fall asleep
in his nuptial bed--thereby saving Fénice's virginity and
Cligès' inheritance--and further stimulates convincing dreams
in which he makes completely illusory love to his wife: "and
then he will have such pleasure/ as one can have in a dream,/
and he will think the dream is true" (3302-04). The contrast
between Alis' imagined pleasures and actual celibacy is precisely
the gap between illusion and reality that obtains for the audi-
ence reading (or hearing) the often titillating descriptions of
lovemaking in chivalric romances. Further, Chrétien's account
of Alis' love dream, by repeating the key word *neant* (cf. Guil-
laume's *dreyt nien*) ten times in eight lines describing the re-
sults of the emperor's imagined amorous actions (3317-24),
drives home the point that Thessala's (and Chrétien's) powers
are those of a creator *of* rather than *from* nothing.[75]
 One small but important feature of Thessala's (in effect)
new version of the tale of Tristan, Isolde, and Mark deserves
attention as further testimony to Chrétien's assimilation of the
old woman's art to that of a story teller. Faced with the prob-
lem of deciding by what trick (*engin*) she can administer the
potion to Alis at his wedding banquet, Thessala notices that
Cligès is serving his uncle at table; interpreting this fact
metaphorically--"she thinks that he wastes his service/ when it
serves to disinherit him" (3229-30)--she decides that it will be
appropriate for the nephew, who has been the unwitting agent
of his own undoing by winning Fénice in battle for Alis (2819-
2915), now to become the unwitting agent of Alis' (3232-34).
Accordingly, she arranges for Cligès, in ignorance, to bring
the illusion-making beverage to the emperor (3235-86). The

self-conscious neatness of this ploy cannot but remind us that
Thessala's conspiratorial plot stands for Chrétien's narrative
plot, and that behind the *mestre* of Thessaly, manipulating her
characters to pile irony upon irony, stands the equally ingen-
ious *magister* of Troyes.

Fairly frequently, the opening lines of twelfth-century
courtly narratives include a declaration by the author that he or
she possesses wisdom which it would be wrong to hide; Marie de
France begins her *Lais*[76] on this note: "Whom God has given
knowledge and eloquence in speech/ ought not to be silent or
hide it,/ but ought rather to show it willingly" (1-3). To com-
municate wisdom is to share with others one's own participation
in the divine creative power of the Word. As the anonymous
author of the *Roman de Thèbes*[77] says in his opening words,
"whoever is wise should not hide it. . . . I don't want to hide
my understanding/ or hold back my wisdom,/ rather I take
pleasure in telling about something worthy of remembrance" (1,
9-12). Such statements call attention to their makers as secular
analogues of God, who did not hold back his Wisdom, but spoke
it, and thus created the world.

The extended prologue of *Partonopeu de Blois* makes the
analogy between divine and poetic creation clearer by adapting
to its uses the twelfth century topos of the *tria opera*, inherited
from Calcidius, that we have noted in the works of William of
Conches and Hugh of St. Victor. It begins (1-12) by blessing
the Trinity for having created (in *rois Jhesus*) all things above
and below--a clear reference to Genesis 1.1--and for having
given the narrator, among other gifts, wisdom: "whatever I
know of deeds and words." This evocation of the *opus Dei*
gives way to a longer description (13-64) of the *opus Naturae*--
the revival or re-creation of the world in springtime--which in
turn inspires in the narrator an *opus artificis imitantis naturam*;
"therefore I wish, out of joy,/ to put an adventure in writing,/
one that's beautiful, good, and marvelous" (69-71). The *aven-
ture*, although not in Latin (77-80), will still be an *integumen-
tum* containing truths in the form of examples of good and bad
conduct, from which those who subsequently read or listen to it
will, if they are *sages*, draw *sens* as a bee draws honey from a
flower (119-20). The claim underlying this leisurely prolegom-
enon to *Partonopeu* seems to be that there is a continuity
between the Creation of the world through Jesus, the *Sapientia
Dei*, and the wisdom communicated by the romance to any recip-
ient wise enough to look for it. The formulation represents,
therefore, a courtly analogue to the philosophical idea that the
universe, rationally constructed in accordance with God's Wis-
dom, can be understood by the application to it of human reason
reflecting that same divine Wisdom.

A final, parodic instance of the poet's association with the
Verbum or *Sapientia Dei* comes at the end, rather than the be-
ginning, of Renaut de Beaujeu's *Li biaus descouneus*.[78] The

hero of the romance, Guinglain, son of Gawain, has left (and therefore lost) his true love in order to fight in a tournament sponsored by King Arthur, as the prize of which Guinglain wins the hand of another beautiful woman and becomes king of her country, Wales. After briefly recounting his hero's wedding and coronation, the narrator addresses himself to the *belle dame sans merci* to whom he has dedicated his poem; he tells her that he will always love her, and continues:

> If it pleases you, he will tell more,
> or else he'll be quiet from now on.
> In return for your showing him a *biau semblant*,
> he will, for you, have Guinglain recover
> his *amie* whom he has lost,
> so that she will hold him naked in her arms.
> But if you delay that [i.e., the *biau semblant*]
> Guinglain will be left in such a state
> that he'll never have his *amie*.
> He [Renaut] will take no other vengeance
> except that, for the great injustice done him,
> he will have this vengeance on Guinglain,
> that never will I speak of him any more,
> until I have that *bel semblant* [from you].
>
> (6253-66)

The *Verbum Dei* through which the world is created here becomes the *bel semblant* of an *amie* that inspires and provides the model for the poet's verbal creation. A sign of favor from the distant beloved will bring about a happy ending in the narrator's own love affair, and will provide a likeness (another meaning of *semblant*) that he will then, "sicut faber," use to fashion a happy ending for his hero's.

In addition to making illusions and communicating wisdom by creating with words, another aspect of the courtly poets' art that invited the drawing of parallels between it and the work of divine Creation is its imposition of new order on confused primal matter. At the beginning of his first romance, *Erec et Enide*,[79] Chrétien de Troyes calls attention to the care with which he has constructed his narrative out of antecedent poetic material:

> [Crestiens] draws from a *conte d'aventure*
> a very fine *conjointure* . . .
> the *conte* is about Erec, son of Lac
> and those who wish to make a living telling stories
> have been accustomed to dismember and ruin it
> when they tell it in the presence of kings or counts.
>
> (13-14, 19-22)

Out of such basic material, which has hitherto invited chaos and disorder at the hands of inferior makers, Chrétien has made an *estoire* "which will always be remembered as long as Christianity shall last" (23-25)--a new, unforgettable poetic world analogous to the perpetual world made by the Timaean Demiurgos after an eternal likeness. The nature of the *conjointure* that characterizes Chrétien's perfected version of the Erec story has been the subject of much scholarly conjecture and disagreement. Some critics equate the term with *integumentum*: an artificial sequence of events covering a *sententia* of moral truth.[80] Others have sought its meaning in classical literary theory, and have decided that Chrétien is here praising his careful synthesis of antecedent material for maximum narrative effectiveness.[81] Most recently, T. E. Hart, analyzing instances of *(con)junctura* in mathematical theory and philosophical texts of Platonic orientation, has concluded that Chrétien's use of the term belongs within these traditions, which converge in the Timaean concept of mathematical proportion as the pre-existent pattern according to which the Demiurgos formed the sensory world.[82] Hart believes that Chrétien announces, at the beginning of his romance, his "wish to create, with verbal elements, a proportional design analogous to the model of the universe set forth in Plato's *Timaeus*, especially as this model was explained by Calcidius and Macrobius" (71), and, we might add, as it is presented, assimilated to Christian doctrines of Creation, in the exegetical cosmogram of the St. Hubert Bible.

Whatever one's interpretation of *conjointure*, there can be no doubt that at the end of Chrétien's story, when Erec has won his crucial battles and become reconciled with his beloved, a final celebratory scene gives the poet a chance to equate his hero's adventures (and the narrative recounting them) with a carefully formed universe. Erec is crowned king of his land, and dons marvelous accoutrements of kingship: a robe decorated with figures representing the arts of the quadrivium, and a scepter engraved with depictions of all the birds, beasts, and fishes (6674-6731, 6808-25). The quadrivial arts have in common measurement and proportion; they help us, Hugh of St. Victor says, to know the form and nature of the created world with respect to number, proportion, dimension, and motion; they lead us from the orderly cosmos to its Creator and, presumably, from the *conjointure* of *Erec et Enide* to its poet-creator. The ability to measure the universe (symbolized by the robe) and dominion over all animate creatures (symbolized by the scepter) constitute the glories of humanity; Erec and Enide, exalted at the end of Chrétien's romance, represent humanity placed at the summit of Creation on the sixth day in Genesis. The courtly poet has, in effect, brought about in his fiction a re-creation of humanity; *Erec et Enide* thus appears in retrospect, looking back from the coronation scene, as Chrétien's Hexameron, a

process of ordering the matter he received in confused form
from his predecessors. It is no accident that Chrétien's main
surrogate in this romance is Erec himself, who, having been
awakened to his post-nuptial *recreantise* by Enide's weeping,
proceeds to reconstruct his own life: he sets out on adventure
fully armed, having ordered Enide to ride ahead of him dressed
in her best clothes, and strictly forbidden her to speak to him,
no matter what she may see, unless he speaks to her first.[83]
Each feature of this peculiar, peripatetic paradigm, we gradually
discover, represents a part of Erec's plan for overcoming the
obstacles to a successful marriage which he has just perceived
in Enide and himself; the model, as Erec puts it into action,
initiates adventures that shape his career and Chrétien's ro-
mance.[84] Later, when these adventures have been successfully
concluded, Chrétien teases his audience, refusing to explain
why Erec set out as he did, "because you know the truth about
this and other matters very well, as I have disclosed it to you"
(6422-24). Beneath this tantalizing remark, we can see Chre-
tien establishing a parallel between an audience that can derive
a hero's (and poet's) purpose from his adventures and the
human investigator whose intelligence allows him to find God
within the rational Creation.

The analogy between the verbal artifact (poem, dialogue)
and the cosmos was, we have seen, a critical commonplace in
Neoplatonic tradition. Twelfth-century courtly literature boasts
many descriptions of marvelous artifacts intended to serve si-
multaneously as "models" of the poem that contains them and re-
minders that the poems are in turn models of the divine Crea-
tion. Jehan's tower in *Cligès*, which serves as a hiding place
for Cligès and Fénice after the latter's pretended death to
escape her marriage with Alis, is a microcosmic structure full of
secret doors and passageways known only to the maker; at its
center lies a vaulted chamber "where Jehan made his works,/
when it pleased him to make something" (5551-52). This state-
ment cannot but recall to us the image, from the Chartrian
Creation archivolt, of the Logos-Creator at work subsequent to
his initial creation of the vault, or firmament, of heaven (Gen.
1.6-8); the fact that Jehan creates when he pleases parallels the
insistence of Thierry and the Augustinian tradition (based ulti-
mately on the *Timaeus*) that God freely expressed his goodness,
not any need, when he formed the world.

In *Partonopeu de Blois*, the city of Chief d'Oire, to which
the young protagonist is magically transported, presents itself
to the astonished youth as a surpassingly beautiful, uninhabited
world, full of palaces adorned with images of animals that seem
alive (841-44) and decorated with cosmograms depicting the four
elements, the sun, moon, days and year, and ancient histories
(853-58). The romance seems here to recall the moment at
which God (represented microcosmically by the Empress Mélior,
who has summoned Partonopeu to Chief d'Oire and hidden its

citizens from sight by her magic arts) creates humanity to pre-
side over a universe prepared for its use. In subsequent
scenes, we learn that Mélior wishes Partonopeu to live at Chief
d'Oire as in a paradise, in which she has placed him, given him
a mate (herself), and arranged for his happiness, if he will but
obey her single injunction: not to attempt to see her face be-
fore she allows him to (1443-1534).[85] Partonopeu, tempted by
an unlikely serpent-surrogate, his well-intentioned mother, dis-
obeys Mélior, and his eyes are opened, like those of his prede-
cessors in Eden, with deleterious effects: by the light of the
lantern he smuggles into the bedroom he discovers that Mélior
is a beautiful woman (not a hideous devil, as his mother has
convinced him).[86] As a result of Partonopeu's "fall," Mélior's
magic powers fail, and the lovers find themselves ejected from
the paradise of secret love those powers created, into a "post-
lapsarian" world of problems to be solved: Mélior's anger at
her lover, Partonopeu's grief-induced, self-destructive madness,
the enmity of Mélior's vassals toward any match between the
protagonists. I have elsewhere referred to Partonopeu's disobe-
dience as a *felix culpa*, because it requires the lovers to con-
front and deal with, rather than flee, the world, with the help
of Mélior's shrewd, worldly sister, Uraque.[87] But we can also
understand the two parts of Partonopeu's career, before and
after he disobeys Mélior, as fictional analogues to the work of
foundation--presided over by Mélior, the surrogate Logos-Crea-
tor, who "makes" Partonopeu's world and the rules that govern
it--and the work of restoration--presided over by Uraque, the
Christ-Redeemer, who uses her good sense, manipulative skills,
and deep compassion to save Partonopeu from madness and sui-
cide, reconcile him with Mélior, and bring both to happiness
and marriage. Both Mélior and Uraque, by the control they
exercise over different parts of the protagonist's life, refer us
outward from the poem to the poet who exercises similar control
as the ultimate creator of his characters.
 A similar, but more complex, set of references and paral-
lels to twelfth-century Creation speculation animates and organ-
izes *Li biaus descouneus*. The young knight of the title, a
recent arrival at Arthur's court, undertakes to liberate a prin-
cess who has been turned into a serpent by enchanters and can
only be freed by a kiss, the *fier baiser*. Arriving at the castle
of Sinaudon and surviving various threats and terror, the Fair
Unknown kisses the serpent (3127-3211), and immediately a mys-
terious voice declares to him his true identity: he is Guinglain,
son of Gawain (3212-48). Meanwhile, the serpent resumes the
form of Blonde Esmaree, Princess of Wales, and all her subjects,
who, terrorized by the enchanters into leaving Sinaudon, return
to celebrate. This first part of Renaut's romance links together
the self-discovery of a young knight and the self-recovery of a
princess and a city; Guinglain's fearless prowess provides the
nexus between this "work of foundation" and "work of restora-

tion." Guinglain's trials at Sinaudon include experiencing light that suddenly turns to darkness and music to mere noise (2830-3100); the shaping and disposition of the universe described and explained with such thoroughness and enthusiasm in twelfth-century hexameral texts is here reversed--order gives way to chaos. Yet out of this chaos, Guinglain is, in effect, called into being by the *raisson* (3244) of the voice that comes to him after he has endured the *fier baiser*. This *raisson*, and the *grant clarté* of daylight that greets him (3260) when he awakens from the sleep into which he has sunk after hearing the voice, serve to associate the voice with the Word of God, the creating Logos which enlightens all humanity (John 1.9). As Hugh of St. Victor says in the *Didascalicon*, thinking of the Johannine prologue, "Wisdom illuminates man so that he may recognize himself" (i.1).[88]

Only in the second part of *Li biaus descouneus* do we discover to whom the enlightening voice, creator-surrogate of both God and the poet, belongs: the mysterious Pucelle as Blances Mains, a woman, like Mélior, of great wealth, education, powers of illusion, and love for the protagonist. She has loved Guinglain for many years because of his potential as a knight (4964-69). She knows all his *destinee* on account of her *sens* (4982-83), and she has accordingly intervened massively in his chivalric career to aid him in his quest for honor. Through her prompting, Esmaree's damsel sought help from Arthur's court; she has helped Guinglain "de tot mon pooir" (4993) in the adventures he encountered on his way to Sinaudon. One of these adventures first brought Guinglain and his benefactress together, but, despite nascent love for her, he left her to keep his promise to liberate Esmaree. When he returns to her, he finds her (after an initial rebuff) in a *vergier* compared by the narrator to a *paradis* (4332); it contains every tree that God ever made (4304-06) and is surrounded by a wall into which are beautifully worked images of everything God has enclosed in the world (4293-98), making of that structure yet another microcosmic artifact and reference to the poem as artistic cosmos. The Pucelle offers hospitality to Guinglain, but warns him that, although she will leave the door of her *chambre* open, he is forbidden to enter it. Guinglain cannot resist the temptation, and is accordingly twice punished with bizarre effectiveness: each time he tries to enter his hostess' bedroom, he finds himself in the midst of a life-threatening situation--he is hanging from a plank over a cauldron of boiling water, he is supporting the whole weight of the palace on his back--that turns out to be an illusion created by the Pucelle to teach him the necessity of obeying her commands. She then summons the chastened knight to her bed, and we learn that the *chambre* is another *paradis* (4742), of which this time the floor has been ornamented with images of all the world's creatures (4762-68). Only after the lovers have consummated their mutual passion

does the protagonist--and the audience--receive a revelation of
the Pucelle's office as "creator" of Guinglain's life--and the
romance--thus far. In effect, Renaut has structured his ro-
mance to duplicate the process, frequently described in twelfth-
century hexameral commentaries, by which Moses received from
God a special prophetic knowledge of the Creator's *res gestae* in
order to write the first chapter of Genesis.[89] The result is to
make the heroine seem not only like a poet in her invention of
the romance's plot, but also like the Deity in her revelation of
it.

It is possible to discover in Guinglain's relationship with
his beloved a Timaean model of the four causes of the story
which constitutes Renaut's *Li biaus descouneus*. The Pucelle as
Blances Mains is the Demiurgos-*faber*; her *pooir* to create illu-
sions and otherwise manipulate Guinglain is the efficient cause;
her *sens*--the knowledge of Guinglain's destiny according to
which she acts to win him--the formal cause; her love for
Guinglain the final cause. Guinglain's basic aggressive poten-
tial, the raw material of martial chivalry, is the material cause
of the story; it attracts the Pucelle to him, and on it she im-
poses the plot of their love-affair according to her power, wis-
dom, and love. Of course, the Pucelle combines with her "Ti-
maean" attributes clear recollections of the Genesis Creator as
well: she admits Guinglain to her *paradis*, but he can only stay
as long as he obeys her; when he disregards her counsels not
to go to Arthur's tournament, he wakes up the next morning,
not in her bed, but in a wood, expelled from Eden (5397-5406).
Even here, however, a Platonizing interpretation suggests itself:
Guinglain rejects the form of blessedness and wholeness imposed
upon his life by the Pucelle, and regresses, like Bernard Syl-
vestris' tainted *silva*, back to the primal state of adventure-
seeking prowess upon which the mysterious beloved first exerted
her creative powers.

Altogether, *Li biaus descouneus*, by its inclusion within
itself of a master-mistress of powerful illusions and complex
plots, complete with unexpected reversals and disclosures, of-
fers perhaps the most ample testimony of any twelfth-century
courtly narrative to the self-consciousness with which a new
generation of vernacular poets pressed their task as creators
through the word.

Several twelfth-century courtly romances contain a re-
sponse to human creativity quite different from any considered
so far, and definitely worth mentioning at the conclusion of our
survey, viz., fear that fiction-making is an illicit infringement
on divine power and prerogatives. Although this worry finds
no direct parallel in twelfth-century intellectual circles, it has
many less proximate analogues and antecedents. For example,
fears that the artist's mimetic power can seduce others into idol-
atry run deep in many civilizations, finding embodiment in

Exodus 20.4-5 (a proscription of graven images of any living creature) and in the iconoclasm that marks several periods of Byzantine and Protestant Christianity. And worry about the magical powers inherent in representative images, and about the uses to which those powers will be put, is as basic in Islamic civilization; as Oleg Grabar says, "the peculiarity of the attitude of Moslem culture [toward mimetic art] is that it immediately interpreted this potential magic power of images as a deception, as an evil."[90] As recently as 1977, the *New York Times* quoted an Arab Bedouin, whose unexplainable, culturally eccentric production of representational sculptures has earned him the strong disapproval of his tribe, as confessing that his work sometimes fills him with fear that "I am going to make something that is evil, as if a devilish force is overtaking me."[91]

But if the images may be magic, their maker may be a servant of the devil. According to Grabar, in "quintessential" early Moslem texts "the main thrust of blame is directed toward the painter rather than the work of art. For it is the painter making representations who appears as a sort of competitor of God by creating something that has actual or potential life" (86).[92] Traditional stories such as the punishment of the builders of the Tower of Babel and the Fall of Icarus, who flew too near the sun on wings invented by his father Daedalus, testify to an analogous bias against the practitioners of other human fabricating arts. Indeed, even the popular comic reservation about air travel--if God had wished us to fly he would have given us wings--articulates the same strong reservation about human creativity, here technological.

Now it happens that we can document this deeply rooted fear of the artist and his power in our twelfth-century courtly texts. In Marie de France's *lai*, *Yonec*, for example, a young wife kept under guard in a tower by an old husband laments her fate, and then muses that she has heard stories in which knights and ladies found secret lovers who came to them, unseen by anyone else. She prays to God, "who has power over everything,/ that he may do my wish in this matter" (103-04). At that moment a large bird flies into her chamber and changes into a handsome knight, who says he has come to love her, in answer to her request. To calm the terror inspired in the lady by his metamorphosis, and to prove he believes in God, the knight now takes *her* form and receives communion from her chaplain. This episode offers a symbolic representation of the power of the imagination to create a world of satisfaction; Marie links the young wife's adventure to story-telling, on the one hand, and on the other to the divine power (*poeste*, 103) working through the "creative" human will (*volente*, 104). The hawk-knight's assumption of the lady's form suggests that he is, in effect, a version of her--her Logos, or creative imagination-- and also lays to rest the idea that the imagination's power is

incompatible with belief in God the Creator and Redeemer. The
hawk-knight's words to the lady can also be taken as Marie's
defense of her art to her audience: "I wouldn't want you to
feel/ guilt because of me,/ or doubt or suspicion./ I do believe
in the creator/ who freed us from grief/ that Adam, our father
led us into. . ." (146-51).

　　Partonopeu de Blois deals quite differently with fears
about the artist, here presented quite overtly as the mistaken
perception that the artist's power comes from the devil, that
great imitator of God's power for evil purposes. Mélior's art
repeatedly prompts mistrust, as when Partonopeu, before en-
countering her for the first time in bed, worries that the "bel
sanblant" of the deserted city has been made by the devil to
lead him on to perdition (1054-56). Later gifts from the em-
press--black horses, dogs, mules--evoke repetitions of this fear
of diabolic involvement.[93] And when Partonopeu returns to
France and explains the condition under which he has received
such wealth and favor--Mélior's insistence that he not see her
face--the mother becomes convinced that her son is in the grasp
of a hideous fiend who seeks to destroy him (3881-3960). Of
course, all these fears prove groundless, but *Partonopeu* raises
them in order, presumably, to defuse criticisms of its creator
similar to those directed, within the fiction, at his surrogate.

　　Perhaps the most interesting instance of a twelfth-century
poet's indictment of misdirected human creativity appears in the
third part of Gautier d'Arras' *Eracles*, a unique blend of folk-
tale, fabliau, and hagiography.[94] Gautier recounts the theft of
the Holy Cross from Jerusalem, in the year 614, by Chosdroe,
infidel King of the Persians, and its recovery in 629 by the
Byzantine emperor, Heraclius (Eracles). The early medieval
liturgical and paraliturgical sources from which Gautier formed
this part of his narrative told him that Chosdroe, having taken
the Cross to Persia, built a tower of precious metals and gems
with a ceiling painted to look like the heavens. Here he placed
the Cross and a throne for himself. He equipped the tower with
machines that create the illusion of a storm--rain, thunder,
lightning--and, placing himself on the throne, claimed to be a
god who controls the very elements. Heraclius, after defeating
Chosdroe's son in battle, went to Persia, killed the king, and
brought back the Cross to Jerusalem where, however, he was
miraculously denied entrance to the city until he humbled him-
self before God.[95]

　　Gautier's handling of this inherited mixture of the bizarre
and the miraculous highlights the danger, and the blasphemy,
of falsely directed human creativity. When Eracles meets the
son of Chosdroes in single combat on a bridge over the Danube
River, he calls on his opponent to convert to Christianity, and
the Persian replies that he believes, not in Mohammed, but in
his father alone: "I believe in him who engendered me,/ who
will protect me against you./ He makes the winds, snow, and

rain/ come as they must" (5643-46). Eracles replies derisively
to this expression of faith in Chosdroes' meteorological illusions:
"Bah! that's fantasy and *engin*!/ Nothing good comes from your
father,/ but rather all good things descend/ from him who cre-
ated everything--/ heaven and earth and whatever exists"
(5647-51). He goes on to distinguish between those who use
the Creation well, to honor the Creator, and those who abuse it
for their own purposes, coming thereby to an evil end. The
true God, and only he, deserves belief, Eracles insists, pre-
cisely because of the beauty of his Creation, and because he
became man and suffered for us on the Cross Chosdroes has
stolen (5652-80).

Eracles' analysis indicts the son of Chosdroes for failure
of perception: for being fooled by *fantosme et engien* into mis-
taking the creature (his earthly father) for the Creator (the
heavenly Father who creates through the Son). The argument
derives contemporary force by linking Chosdroes' false paradise
(Eracles calls it a *paradis* in 5680), with its artfully counter-
feited thunder and rainfall, to the marvelous machines that
captivated twelfth-century audiences in the fictitious letter of
Prester John and in courtly texts like the *Roman d'Eneas*.[96]
Since these artifacts, and the ingenuity that constructs them,
point outward from the narratives that contain them to the self-
conscious verbal artists responsible for artifact and narrative
alike, Gautier is ultimately saying through Eracles that Chos-
droes, evil king though he be, sins most in being a bad artist.
That is, Chosdroes creates a blasphemous work--a chamber of-
fensive to Christ the Redeemer because it houses the Cross that
the king has stolen--and attempts to gain credence for it by
engin--a tactic offensive to Christ the Logos-Creator because of
the usurpation and cheap trickery involved; meanwhile his son
and the rest of the Persians have been too good an audience for
this meretricious art, totally confusing divine control of the
created world with human artfulness, which can merely counter-
feit that control.

When Eracles arrives in Persia and enters Chosdroes'
tower to reclaim the Cross, he climbs up into the marvelous
"heaven" created by the Persian king to house Cross and
throne, and Gautier comments, "the effect of it is very radiant
and golden hued,/ because of the precious stones as well as the
gold;/ there isn't such a great treasure anywhere in the world./
Where could such a thing be equalled,/ if only it had been used
for God?" (5874-78). This is Gautier's last word about human
creativity: if it is not used for the glory of God (as his is in
writing *Eracles*, we may note), then it fails and deserves con-
demnation. The story of Chosdroes, seen in this light, offers an
integumentum of diabolic pride--the king, like Lucifer, wishes to
be worshipped as God--as it inspires the brilliant but self-serv-
ing and deceitful artist. By condemning Chosdroes' cynical
artistic sham, Gautier presumably intends to clear himself and

his poetry from any similar imputations of blasphemy.

We have explored two problems in this essay: how the twelfth-century understood the actuality of divine Creation, and how it assessed the possibilities of human creativity. But all the perspectives from which we have examined these difficult and controversial issues--philosophical and theological, art historical and literary--converge on a single point: the twelfth century's profound desire to respond appropriately to God's revelation of himself as the Creator--in the concept of the Trinity, in the words of the Bible and possibly the *Timaeus*, in the order and beauty of the created world, in the intellectual and imaginative capacities of humanity. The fruits of this desire constitute one of the age's most impressive legacies: a body of arguments, images, and fictions to which we can turn, and turn again, as we endeavor to take the measure of one of the richest and most complex moments in the history of European culture.[97]

NOTES

[1] See "Poetic Emblems in Medieval Narrative Texts," in Lois Ebin, ed., *Vernacular Poetics in the Middle Ages* (Kalamazoo: Medieval Institute Publications, 1983) pp. 1-32. I have also touched on matters relevant to this subject in *The Individual in Twelfth-Century Romance* (New Haven and London: Yale Univ. Press, 1977) and in "The Audience as Co-creator of the First Chivalric Romances," *Yearbook of English Studies*, 11 (1981), 1-28.

[2] See, for example, Winthrop Wetherbee, *Platonism and Poetry in the Twelfth Century* (Princeton: Princeton Univ. Press, 1972); Claude Luttrell, *The Creation of the First Arthurian Romance: A Quest* (London: Edward Arnold, 1974), esp. chaps. 1-2; T. E. Hart, "The *Quadrivium* and Chrétien's Theory of Composition: Some Conjunctures and Conjectures," *Symposium*, 35 (1981), 57-86.

[3] All references to and Latin quotations from the Bible are taken from *Biblia Sacra vulgatae editionis . . . editio emendatissima* (Rome: Marietti, 1959).

[4] I have referred to the translations of the *Timaeus* by F. M. Cornford in *Plato's Cosmology* (1938; rpt. Indianapolis: Bobbs-Merrill, 1975) and Desmond Lee (Harmondsworth: Penguin, 1965). All quotations follow Lee's translation. The quote from Cornford is from *Plato's Cosmology*, p. 31.

[5] See J. Wrobel, ed., *Platonis Timaeus interprete Chalcidio* (Leipzig: Teubner, 1876). The text and Calcidius' commentary go as far as 53C.

[6] See Augustine, *De doctina christiana*, trans. D. W. Robertson, Jr. (New York: Liberal Arts Press, 1958). For a

brief explication, see B. Smalley, *The Study of the Bible in the Middle Ages*, 2nd ed. (1952; rpt. Notre Dame, Indiana: Notre Dame Univ. Press, 1964), pp. 22-24.

[7]See, e.g., *De Gen. ad litt.* i.1.2, in *Oeuvres de saint Augustin*, XLVIII (Latin text ed. J. Zycha, French trans. P. Agaesse and A. Solignac [Paris: Desclee de Brouwer, 1972]); *Confessions* xi.10 (trans. R. S. Pine-Coffin [Harmondsworth: Penguin, 1961]); *De civitate Dei* xi.4-6 (trans. Marcus Dods [New York: Random House, 1950]).

[8]See *Confessions* xi-xii on the nature and creation of time; cf. *De Gen. ad litt.* i.15.29. For discussion, see E. Gilson, *The Christian Philosophy of St. Augustine* (New York: Random House, 1960), pp. 189-96. I am grateful to Charlotte Gross, a doctoral candidate in the Department of English and Comparative Literature, for guidance in dealing with Augustine's thought on time and Creation.

[9]On the angelic *conversio* as the key to the six days of Creation, see *De civ. Dei* xi.7, 9; *De Gen. ad litt.* iv.21.38-iv.35.56. See also Marie-Thérèse d'Alverny, "Les anges et les jours," *Cahiers archéologiques*, 9 (1957), 271-300. On *rationes seminales*, see *De Gen. ad litt.* iv.33.51, v.5.14, v.7.20, vi.6.10. See also Gilson, pp. 206-09.

[10]On *lectio divina* see Smalley, pp. 26-36; Jean Leclercq, *The Love of Learning and the Desire for God*, trans. C. Misrahi (New York: Fordham Univ. Press, 1961); J. Décarreaux, *Les moines et la civilisation en occident* (Paris: Arthaud, 1962), pp. 206-35.

[11]See Raymond Klibansky, *The Continuity of the Platonic Tradition during the Middle Ages* (London: Warburg Institute, 1950), pp. 21-29; F. Copleston, *History of Philosophy*, II (London: Burns Oates and Washbourne, 1950), chaps. 9-10, 12-13.

[12]See G. M. Paré, A. Brunet, P. Tremblay, *La renaissance du douzième siècle. Les écoles et l'enseignement* (Paris: Vrin; Ottawa: Institute d'études médiévales, 1933); R. W. Southern, *The Making of the Middle Ages* (London: Hutchinson, 1953), chap. 4, and *Medieval Humanism* (New York: Harper and Row, 1970), pp. 37f, 174-79; Colin Morris, *The Discovery of the Individual* (London: SPCK, 1972), chap. 3; A. B. Cobban, *The Medieval Universities* (London: Methuen, 1975), chaps. 1, 9; Jacques LeGoff, *Les intellectuels au moyen âge* (Paris: Editions de Seuil, 1957), pp. 3-69; James Bowen, *A History of Western Education, II: Civilization of Europe Sixth to Sixteenth Century* (London: Methuen, 1975), pp. 37-73.

[13]See Southern, *Medieval Humanism*, pp. 37-48; R. R. Bolgar, *The Classical Heritage and Its Beneficiaries* (Cambridge: Cambridge Univ. Press, 1954), pp. 130-201; Hugh of St. Victor, *Didascalicon*, trans. Jerome Taylor (New York: Columbia Univ. Press, 1961), Introduction, pp. 3-19, 28-36; Wetherbee, *Platonism and Poetry*, pp. 11-28.

Examples of twelfth-century treatises on the liberal arts in

addition to Hugh's *Didascalicon* are the *Heptateuch* of Thierry of
Chartres and the *Metalogicon* of John of Salisbury. See also the
comments on the arts in connection with philosophy in Bernard
Sylvestris' *Commentary on the First Six Books of Virgil's* Aene-
id, trans. E. G. Schreiber and T. Maresca (Lincoln: Univ. of
Nebraska Press, 1979), pp. 38-39; and on the arts as tools of
scripture study, the quotation from Hugh of St. Victor, *De
sacramentis*, below and n. 25.

[14]See, e.g., Leif Grane, *Peter Abelard: Philosophy and
Christianity in the Middle Ages*, trans. F. and C. Crowley
(London: George Allen and Unwin, 1970), chap. 1, for the
background of this phenomenon; on the neatness of organiza-
tional schemes and the premium placed on them in twelfth-cen-
tury schools, see Stephen A. Barney, "Visible Allegory: The
Distinctiones Abel of Peter the Chanter," in *Allegory, Myth,
and Symbol*, ed. Morton W. Bloomfield, Harvard English Studies,
9 (1981), esp. pp. 89-90: "the twelfth-century schools, among
their many innovations, emphasized orderliness and the de-
velopment of new techniques in curricula and tools of stud-
y. . . . Richard Rouse speaks of the rise in this period of
homo tabulator." Cf. p. 101: "the form of the *Distinctiones
Abel*, then, tends to bring order out of the vast, unwieldy cha-
os of a millenium of biblical interpretation with all its variety
of method."

[15]*Didascalicon*, pp. 44-45. Quoted with permission.

[16]See Edwin A. Quain, "The Medieval Accessus ad Auc-
tores," *Traditio*, 3 (1945), 215-64; Fausto Ghisalberti, "Mediaeval
Biographies of Ovid," *Journal of the Warburg and Courtauld In-
stitutes*, 8 (1945), 14-20.

[17]See Southern, *Medieval Humanism*, pp. 29-41; the
quotations are from pp. 32, 37, 38.

[18]See, e.g., *De diligendo Deo*, trans. Robert Walton
(Washington, D.C.: Cistercian Publications, 1974), p. 95:
"Man's nobler gifts--dignity, knowledge, and virtue--are found
in the higher part of his being, in his soul. Man's dignity is
his free will by which he is superior to the beasts and even
dominates them. His knowledge is that by which he acknow-
ledges that this dignity is in him but that it is not of his own
making. Virtue is that by which man seeks continuously and
eagerly for his Maker and when he finds him, adheres to him
with all his might. Each of these gifts has two aspects. Digni-
ty is not only a natural privilege, it is also a power of domina-
tion. . . . Knowledge is also twofold, since we understand this
and other natural qualities are in us, yet we do not create them
ourselves. Finally, virtue is seen to be twofold, for by it we
seek our maker and once we find him, we adhere to him. . . .
As a result, dignity without knowledge is unprofitable, without
virtue it can be an obstacle." Cf. M. Basil Pennington, Intro-
duction to St. Bernard, *De gradibus humilitatis et superbiae*,
trans. M. Ambrose Conway, in the same volume, p. 17: "Al-

though the 'last of the Fathers' spoke disparagingly of the philosophers of the schools, he knew the new methods and made some use of them." Pennington adds (fn. 49) that Bernard, in a sermon attacking the schoolmen, still "examines his matter through what the philosophers would call the four causes, and does it in excellent philosophical form."

[19]Bernard Sylvestris, *Commentary*, p. 5.

[20]On *integumentum* and *involucrum*, see, e.g., Wetherbee, *Platonism and Poetry*, pp. 36-48, and the bibliography in his footnotes to this section; Brian Stock, *Myth and Science in the Twelfth Century* (Princeton: Princeton Univ. Press, 1972), chap. 1. See also, on the hide-and-seek dimension of twelfth-century integuments, Jonathan Whitman, "From the *Cosmographia* to the *Divine Comedy*: An Allegorical Dilemma," in *Allegory, Myth, and Symbol*, pp. 63-86.

[21]Quoted in James A. Coulter, *The Literary Microcosm: Theories of Interpretation of the Later Neoplatonists* (Leiden: Brill, 1976), p. 102, from *Anonymous Prolegomena to Platonic Philosophy*, ed. and trans. L. G. Westerink (Amsterdam: North Holland, 1962), 15.1-7, 16.1-6.

[22]Quoted in Bernard Sylvestris, *Commentary*, Introduction, p. xii.

[23]Southern, *Medieval Humanism*, pp. 13-14.

[24]See M. D. Chenu, *Nature, Man, and Society in the Twelfth Century*, trans. Jerome Taylor and Lester K. Little (Chicago: Chicago Univ. Press, 1968), esp. chap. 8; Grane, *Peter Abelard*, esp. chaps. 5-8; D. E. Luscombe, *The School of Peter Abelard* (Cambridge: Cambridge Univ. Press, 1970); A. Victor Murray, *Abelard and St. Bernard: A Study in Twelfth Century 'Modernism'* (Manchester: Manchester Univ. Press, 1967); Bernard of Clairvaux, *Le lettere contro Pietro Abelardo*, ed. and trans. Albino Babolin (Padua: Liviana editrice, 1969).

[25]Hugh of St. Victor, *De sacramentis*, trans. Roy J. Deferrari (Cambridge, Mass.: Mediaeval Academy of America, 1951), i. prol. 5-6 (p. 5). Quoted with permission.

[26]Peter Abelard, *Expositio in Hexameron*, PL, 731D; cf. 770B. Subsequent quotes from this source will be identified by references in brackets in my text.

[27]Thierry of Chartres, *De septem diebus*, ed. Nikolaus Haring in "The Creation and Creator of the World According to Thierry of Chartres and Clarenbaldus of Arras," *Archives d'Histoire Doctrinale et Littéraire du Moyen Âge*, 30 (1955), 184; translation mine. Subsequent references to Thierry's text will be to this edition, with page and section number placed within my text in brackets.

[28]See *De Gen. ad Litt.* i.1.1 (p. 83).

[29]See Tullio Gregory, *Anima mundi: La filosofia di Guglielmo di Conches e la Scuola di Chartres* (Florence: Sansoni, 1955), and "Abelard et Platon," in *Peter Abelard: Proceedings of the International Conference, Louvain, May 10-12, 1971*, ed.

E. M. Buytaert (Louvain: Univ. Press; The Hague: Martinus Nijhoff, 1974), pp. 38-64; J. M. Parent, *La Doctrine de la création dans l'école de Chartres* (Paris: Vrin; Ottawa: Institute d'études médiévales, 1938), pp. 70-76. On Thierry's equation of the Holy Spirit and the *anima mundi* as two names for the same virtus artificis, see *De septem diebus* 193.25-27.

[30]Augustine, in his first *Tractate on the Gospel According to St. John*, trans. John Gibb (Edinburgh: T. and T. Clark, 1873), develops the parallel between a carpenter making a box in accordance with his idea of its design and God making the universe in accordance with his Wisdom (i.17). On the other hand, in *Confessions* xi.5 Augustine makes a sharp distinction between a craftsman making an object from other materials and God who creates all from nothing.

[31]See J. M. Parent, *Doctrine*, Part II, "Textes," "les Gloses de Guillaume de Conches sur le Timee," p. 143, ll. 21-27; "les gloses de Guillaume de Conches sur la Consolation de Boece," p. 130, ll. 1-12; translation mine. Subsequent references to these texts will include the page and line numbers within my text in brackets.

[32]Erwin Panofsky, *Idea: A Concept in Art Theory*, 2nd ed., trans. Joseph J. S. Peake (Columbia, S.C.: Univ. of South Carolina Press, 1968), pp. 3-43.

[33]See Abelard, *Expositio* 733C, 735A; Thierry, *De septem diebus* 192.24.

[34]Translation mine. Cf. Hugh of St. Victor, *De sacramentis* i.3.28: "the Trinity [is] proven true in its works . . . for the sign of [God's] power [is] the immensity of things; of wisdom beauty; of goodness utility."

[35]See n. 9, above, and esp. *De civ. Dei* xi.7; Abelard, *Expositio* 740C-741C. Cf. the explanation of *vespere* and *mane* in the *Tractatulus super librum Genesis* of Thierry's student, Clarembald of Arras, ed. N. Haring (Toronto: Pontifical Institute of Mediaeval Studies, 1965), p. 241, sect. 35: "when 'day' is understood in terms of the distinction among works and created things, *mane* pertains to the beginnings (*inchoativa*) of the works, *vespere* to their completion (*perfectiva*). Whence *vespere* is placed before and *mane* after; indeed, completed works are more worthy than inchoate ones" (translation mine).

[36]See *De civ. Dei* xi.2, where Augustine says that human rationality is the image of God in us, but it is so soiled by sin that it must be purified by faith in Christ before it can know that Christ created the world. Cf. *De sacramentis* i.6.2, where Hugh of St. Victor says, "Man was made to the image and likeness of God, because in the soul, which is the better part of man, or rather was man himself, was the image and likeness of God: image according to reason, likeness according to love . . . image because rational, likeness because spiritual. . . ." The history of twelfth-century interpretations of Genesis 1.27 can be found in R. Javelet, *Image et resemblance au 12e*

siècle, de saint Anselme à Alain de Lille (Paris: Letouzay et Ané, 1967); "Image de Dieu et nature au xii^e siècle," in *La filosofia della natura nel Medioevo: Atti del Terzo Congresso Internationale di Filosofia Medievale 1964* (Milan: Hoepli, 1966), pp. 286-96.

[37]By contrast, cf. *De civ. Dei* xi.4, where Augustine tells us that we learn about God's creation of the world from the Scriptures, recorded for us by holy men in whom God's inspiration was at work. For the context of the tension between *ratio* and *auctoritas*, see Grane, *Peter Abelard*, chap. 1, and the article by T. Stiefel cited in n. 38, below.

[38]Tina Stiefel, "Science, Reason, and Faith in the Twelfth Century: The Cosmologist's Attack on Tradition," *Journal of European Studies*, 6 (1976), 1-16.

[39]Stiefel, p. 7: "Thierry's commentary was the first conscious and deliberate scrutiny of the Judeo-Christian creation account to be done from a purely scientific standpoint; its historic importance has not been fully realized. There is nothing like it in scope or rigour in western medieval Europe." Cf. Stock, *Myth and Science*, pp. 240f, esp. p. 240: "Instead of following the traditional method of fitting natural philosophy into the historical framework of the Bible, [*De septem diebus*] fits the opening chapters of Genesis into the framework of natural philosophy."

[40]Cf. William of Conches, *Gloss* on the *Timaeus* 145.6-8: "Reason (*ratio*) is the force of the soul by which man distinguishes the properties of bodies and the differences among them; it takes its beginning from the imagination and the senses, for we make judgments on the basis of what we feel or imagine."

[41]Thierry, *De septem diebus* 194.30-200.47; see Haring's discussion, "Creation and Creator," pp. 157-69.

[42]See Hugh of St. Victor, *De sacramentis* i.3.19-31, esp. i.3.26, in which Hugh carefully explains that the attributes of power, wisdom, and goodness belong to all the persons of the Trinity; we merely stress the possession of different attributes by different persons in order to avoid misunderstanding--e.g., the Father is *Potestas Dei* because we might normally expect a Father, being older, to lack power, while the Son is *Sapientia Dei* lest we think that, being immature, he lacked wisdom!

[43]On the controversy, see Parent, *Doctrine*, pp. 69-81; Luscombe, *School*, pp. 115-20; Grane, *Peter Abelard*, pp. 92-101, 145-47; Murray, *Abelard and St. Bernard*, pp. 89-117; E. M. Buytaert, "Abelard's Trinitarian Doctrine," in Buytaert, ed., *Peter Abelard*, pp. 127-52.

[44]Cf. *De civ. Dei* xi.21; Augustine grants that Plato understood that the Wisdom of God is the formal cause of the Creation and the Goodness of God its final cause, but is circumspect in explaining why, not knowing "whether he read this passage [i.e., Genesis 1.3], or, perhaps, was informed of these

things by those who had read them, or, by his quick-sighted
genius, penetrated to things spiritual and invisible through the
things that are created, or was instructed regarding them by
those who had discerned them."

[45]On the significance of this definition, see Taylor's In-
troduction, pp. 7-19; R. W. Southern, "Aspects of the European
Tradition of Historical Writing: 2. Hugh of St. Victor and the
Idea of Historical Development," *Transactions of the Royal His-
torical Society*, 21 (1971), 166ff, esp. 170-72.

[46]See Wrobel, ed., *Platonis Timaeus*, Commentary xxiii, p.
88, and Hugh of St. Victor, *Didascalicon*, pp. 190-91, n. 59.

[47]See Ernst Gombrich, *In Search of Cultural History*
(Oxford: Clarendon Press, 1969), for a caveat about *Zeitgeist*
assumptions; on the particularly close links between poetry and
philosophy in the twelfth century, see the works mentioned in
n. 2, above, and Richard McKeon, "Poetry and Philosophy in
the Twelfth Century: The Renaissance of Rhetoric," *Modern
Philology*, 43 (1945-46), 217-34.

[48]See, for example, *St. Mark*, Gospel Book of Ebbo
(816-35), Epernay, Bibl. Mun. MS. 1, fol. 60V; *St. John*,
Gospel Book of St.-Médard de Soissons (early ninth century),
Paris, Bibl. nat. MS. lat. 8850, fol. 180V; *The Four Evangel-
ists*, Aachen Gospels (c.810), Aachen, Cathedral Treasury,
Evangeliar, fol. 14V. All examples illustrated in George Zar-
necki, *Art of the Medieval World* (Englewood Cliffs, N.J.:
Prentice-Hall; New York: Abrams, 1975), pp. 123, 126, 130.

[49]Cf. the more traditional image of evangelists "mounted"
on the shoulders of Old Testament prophets in the south tran-
sept windows of Chartres Cathedral; on this tradition, see
Édouard Jeauneau, "Nains et géants," in Maurice de Gandillac
and Édouard Jeauneau, eds., *Entretiens sur la renaissance du
12e siècle* (The Hague: Mouton, 1968), pp. 28-29, and the
bibliographical references in notes 31 and 32.

[50]See Denis Grivot and George Zarnecki, *Giselbertus:
Sculptor of Autun* (New York: Orion, 1961), p. 13, from which
the quotation is taken. Cf. A. Martindale, *The Rise of the Ar-
tist in the Middle Ages and Early Renaissance* (New York:
McGraw-Hill, 1972), pp. 104-05.

[51]On Thierry's Trinitarian discussion, see n. 41, above.
Cf. Adelheid Heimann, "Trinitas Creator Mundi," *Journal of the
Warburg and Courtauld Institutes*, 2 (1938-39), 42-52; the image
in question is illustrated in Johannes Zahlten, *Creatio mundi.
Darstellungen der sechs Schöpfungstage und naturwissen-
schaftliches Weltbild im Mittelalter* (Stuttgart: Klett-Cotta,
1979), fig. 376.

[52]For illustrations, see Zahlten, figs. 223, 234, 307, 337.

[53]See Adelheid Heimann, "Three Illustrations from the
Bury St. Edmunds Psalter and Their Prototypes," *Journal of the
Warburg and Courtauld Institutes*, 29 (1966), 46-56; John B.
Friedman, "The Architect's Compass in Creation Miniatures of

the Later Middle Ages," *Traditio*, 30 (1974), 419-29. The latter contains a full range of illustrations of the Creator with compass.

[54]See Friedman, "The Architect's Compass."

[55]See George Henderson, *Gothic: Style and Civilization* (Harmondsworth: Penguin, 1967), chaps. 1-2; Otto von Simson, *The Gothic Cathedral*, 2nd ed. (New York: Harper and Row, 1964), Pt. I: "Gothic Design and the Medieval Concept of Order," pp. 3-58, esp. p. 35 and n. 37 (on the Creator with compass); John Harvey, *The Master Builders: Architecture in the Middle Ages* (London: Thames and Hudson, 1971), chaps. 1-2; Erwin Panofsky, *Gothic Architecture and Scholasticism* (Latrobe, Pennsylvania: St. Vincent's Abbey, 1951).

[56]For the figures cited in this paragraph, see Zahlten, Tables 2, 3, 6 (pp. 225, 229, 238-39). On the *Clavis physicae* illustrations, see Marie-Thérèse d'Alverny, "Le cosmos symbolique du xii^e siècle," *Archives d'Histoire Doctrinale et Littéraire du Moyen-Âge*, 28 (1953), 31-81.

[57]Harry Bober, "In Principio. Creation Before Time," *De artibus opusculum XL: Studies in Honor of Erwin Panofsky*, ed. Millard Meiss (New York: New York Univ. Press, 1961), I, 13-28; quotations in this paragraph from pp. 13, 24. See Bober's figs. 1, 9, and Zahlten, figs. 67-73.

[58]See Zahlten, figs. 74-98.

[59]See Bober, "In Principio," esp. pp. 13-23.

[60]Bober, "In Principio," p. 28.

[61]Adelheid Heimann, "The Six Days of Creation in a Twelfth Century Manuscript," *Journal of the Warburg Institute*, 2 (1938-39), 269-75; the quotation is from pp. 272-73.

[62]Heimann, "Six Days," p. 273; on the Chartres parallel, see p. 271, and notes 2 and 3.

[63]Jan van der Meulen, "A Logos-Creator at Chartres and Its Copy," *Journal of the Warburg and Courtauld Institutes*, 29 (1966), 82-100. The window is numbered 138 in Yves Delaporte, *Les vitraux de la Cathédrale de Chartres* (Chartres: Houvet, 1926).

[64]"Logos-Creator," pp. 84-88. Van der Meulen supports his interpretation by summarizing the Creation theories of Thierry of Chartres and Clarembald of Arras, pp. 89-94.

[65]Jan van der Meulen, with Nancy Waterman Price, *The West Portal of Chartres Cathedral*, I: *The Iconology of Creation* (Washington, D.C.: Univ. Press of America, 1981), and "Chartres: Die Weltschöpfung in historischer Sicht," *Francia*, 5 (1977), 81-126.

[66]Van der Meulen, *West Portal*, p. 72.

[67]Bernard Sylvestris, *Cosmographia*, trans. Winthrop Wetherbee (New York: Columbia Univ. Press, 1973). On Bernard, see Wetherbee's Introduction; Peter Dronke's Introduction to his edition of the *Cosmographia* (Leiden: Brill, 1978); Wetherbee, *Platonism and Poetry*, pp. 152-86; Stock, *Myth and*

Science; George D. Economou, *The Goddess Natura in Medieval Literature* (Cambridge, Mass.: Harvard Univ. Press, 1972), pp. 53-72; Theodore Silverstein, "The Fabulous Cosmogony of Bernardus Silvestris," *Modern Philology*, 46 (1948-49), 92-116; Jonathan Whitman, "From the *Cosmographia* to the *Divine Comedy*," pp. 63-86.

[68]See Joan M. Ferrante, "'Farai un vers de dreyt nien': The Craft of the Early Troubadours," in *Vernacular Poetics*, ed. Ebin. On ties between the court at Poitiers and the school of Chartres, see L. T. Topsfield, *Troubadours and Love* (Cambridge: Cambridge Univ. Press, 1975), p. 3 and n. 6; Reto R. Bezzola, *Les origines et la formation de la littérature courtoise en occident (500-1200). Deuxième partie: La société féodale et la transformation de la littérature de cour* (Paris: Champion, 1955), II, 256-58. Text: Guglielmo IX, *Poesie*, ed. N. Pasero (Modena: Mucchi, 1973), No. 4.

[69]"Ben vueill que sapchon li pluzor," Pasero, No. 6, verse 1.

[70]Augustine, *Tractates on John* i.8-10; cf. *Confessions* xi.7.

[71]*Partonopeu de Blois*, ed. Joseph Gildea (Villanova: Villanova Univ. Press, 1967). All references are to this edition; translations are mine.

[72]*Partonopeu* 4573-4660; I discuss this passage in greater detail in "Poetic Emblems," in *Vernacular Poetics*, ed. Ebin.

[73]Chretien de Troyes, *Cligès*, ed. Alexandre Micha (Paris: Champion, 1957). References are to this edition; translations are mine. See further discussion of *Cligès*, below; I have also treated the romance in a manner relevant to this discussion in *The Individual in Twelfth-Century Romance*, pp. 114-18; "Poetic Emblems," in *Vernacular Poetics*, ed. Ebin, pp. 1-32; and "Courtly Contexts for Urban *cultus*: Responses to Ovid in Chrétien's *Cligès* and Marie's *Guigemar*," *Symposium*, 35 (1981), 34-56.

[74]*Eneas*, trans. John A. Yunck (New York: Columbia Univ. Press, 1974), 7457-8024.

[75]"Tenir la cuide, n'an tient mie,/ Mes de neant est a grant eise,/ Car neant tient, et neant beise,/ Neant tient, a neant parole,/ Neant voit, et neant acole,/ A neant tance, a neant luite./ Molt fu la poisons bien confite/ Qui si le travaille et demainne./ De neant est an si grant painne,/ Car por voir cuide, et si s'an prise,/ Qu'il ait la forteresce prise,/ Et devient lassez et recroit,/ Einsi le cuide, einsi le croit./ A une foiz vos ai tot dit,/ C'onques n'en ot autre delit" (3317-3330). ("He thinks he holds her, but doesn't at all; he's pleased for nothing, because he's holding nothing, kissing nothing, holding nothing, speaking to nothing, seeing nothing, hugging nothing, battling for nothing, striving for nothing. That potion was very well concocted which made him work so hard and so bestirred him. He goes to all that trouble for nothing, because

he thinks it's true, and goes to it with such a will that he thinks he's taken the fortress, and so becomes tired and withdraws: at least, that's what he thinks. In this one account, I've told you everything, because he never had any other pleasure.") Note the implicit contrast at the end of this passage between verbal "creation" ("vos ai tot dit") and the absence of any counterpart in experiential reality ("n'en ot autre delit").

[76]Marie de France, *Lais*, trans. Robert Hanning and Joan Ferrante (New York: E. P. Dutton, 1978; rpt. Durham, N.C.: Labyrynth Press, 1982); I have slightly altered the translation of Marie's Prologue, ll. 1-3, in order to stress my point here.

[77]*Roman de Thebes*, ed. Guy Renaud de Lage (Paris: Champion, 1966-68), 2 vols. All references are to this edition; translation mine.

[78]*Li biaus descouneus*, ed. G. Perrie Williams (Paris: Champion, 1929); all references are to this edition; translations mine.

[79]Chrétien de Troyes, *Erec et Enide*, ed. Mario Roques (Paris: Champion, 1959); all reference are to this edition; translations mine.

[80]See D. W. Robertson, "Some Medieval Literary Terminology, with Special Reference to Chrétien de Troyes," *Studies in Philology*, 48 (1951), 685, 692.

[81]See Luttrell, *The Creation of the First Arthurian Romance*, p. 68.

[82]T. E. Hart, "The Quadrivium and Chrétien's Theory of Composition," pp. 57-70; see pp. 59-60 and n. 5 on pp. 81-82 for a list of past explanations of the term *conjointure* by scholars.

[83]See *Erec et Enide*, 2572-2579, 2620-2667, 2712-2727, 2762-2771.

[84]See Hanning, *Individual*, pp. 62-79.

[85]Mélior speaks of her *covenans* with her vassals (1484), further suggesting a parallel between her and God dealing with his Creation. The main contrast between Mélior's behavior and that of God in Genesis is that the empress stresses the harm that will come to *her* if Partonopeu disobeys her (1519-24); like any human creator, she is vulnerable in her art.

[86]*Partonopeu*, 4523-30. He sees her "a descovert nue" in the light of the lantern (4528), a clear reminiscence of the discovery the fallen Adam and Eve make of their nakedness in Eden; cf. Genesis 3.7.

[87]See *Individual*, pp. 213-18, and, on the importance and function of Uraque, pp. 84-101. See further "Poetic Emblems," in *Vernacular Poetics*, ed. Ebin.

[88]See *Didascalicon*, pp. 46 and 176, n. 2.

[89]See Clarembald of Arras, *Tractatulus* 228.6-229.7, on the types of prophecy; Moses prophesies in words, "res gestas narrando" on the basis of "intelligentia" from God (229.7). The garden and chamber of the Pucelle, like the city of Chief d'Oire

in *Partonopeu*, should be seen as participants in a tradition of poetic *ekphrases* appearing in poetic texts; the aim of such descriptions is to equate the poem with the cosmos (cf. notes 21 and 22, above). Cf. the description of the chamber of Countess Adela of Blois in a poem offered to her by Baudri of Bourgueil (1046-1130): the walls are covered with tapestries depicting the Creation, Fall, and Flood from Genesis, Old Testament history, classical mythology, and the Norman conquest of England (!); the ceiling imitates the heavens, the floor is a map of the world, and the bed is decorated with statues representing the arts and sciences. The adornment of the chamber assimilates Adela to the Deity in political authority and Baudri to him in creative power. On Baudri's antecedents, see Phyllis Abrahams, *Les oeuvres poétiques de Baudri de Bourgueil* (Paris: Champion, 1926), p. 233; Abrahams also lists parallels in twelfth-century vernacular texts. For the text of the poem and thorough annotations, see pp. 196-253.

[90] Oleg Grabar, *The Formation of Islamic Art* (New Haven: Yale Univ. Press, 1973), chap. 4, "Islamic Attitudes toward the Arts," pp. 75-103; quotation is from p. 99.

[91] See William E. Farrell, "A Bedouin Sculptor Breaks a Tribal Taboo," *New York Times*, 18 March 1977, p. B1. The entire story is a fascinating instance of the persistence of extremely old and elemental fears about the artist as a blasphemous imitator of divine creativity.

[92] Cf. Northrop Frye, *Creation and Recreation* (Toronto: Univ. of Toronto Press, 1980), pp. 40-41: "If it is true that . . . the models of human creation, the city and the garden, were created by God before man existed, the human artist seems to be in a hopeless position of competing with God. This is particularly true of painters and sculptors, who have often been regarded with suspicion as potentially makers of idols, dead images set up in rivalry with the maker of living ones."

[93] See "Poetic Emblems," in *Vernacular Poetics*, ed. Ebin. Mélior herself articulates Partonopeu's fears about her possibly demonic powers (1535-56), and assures him, in language very reminiscent of the hawk-knight's in *Yonec*, that she believes in Jesus, the Creator-Redeemer. Mélior's stress on the creative activities of the Logos is sufficiently specific to recall the cosmological and hexameral analyses dealt with earlier in this essay: "He made the heaven and the sun, the earth and sea, and red fire, and the air and all creatures, and everything is of his making" (1553-56). Again, behind Mélior the poet seems to be establishing, vis-à-vis his audience, his awareness of where his power stops and God's takes over. Cf. *Partonopeu* 4615-4622, where Mélior compares her powers of illusion to those by which Mohammed performed the deed that led people to think he was God!

[94] Gautier d'Arras, *Eracles*, ed. Guy Raynaud de Lage

(Paris: Champion, 1976); all references are to this edition; translations mine.

[95] See E. Faral, "D'un 'Passionaire' latin à un roman français. Quelques sources immédiates du roman d'Eracle," *Romania*, 46 (1920), 512-36.

[96] See E. Faral, *Recherches sur les sources latines des contes et romans courtois du moyen âge* (Paris: Champion, 1913), pp. 161-67, "le roman d'Eneas et la lettre du Prêtre Jean"; pp. 307-88, "Le merveilleux et ses sources dans les descriptions des romans français du xiie siècle." See also Hanning, *Individual*, pp. 107-10, and "Poetic Emblems," in *Vernacular Poetics*, ed. Ebin. I would like to thank Dr. Sandra Pierson Prior for her kindness in reading an earlier draft of this essay, and for her astute suggestions that led to its improvement.

[97] I am grateful to the following for the illustrations which accompany this article: Bibliothèque Royale Albert Ier, Brussels; Bibliothèque Municipale de Verdun; M. L'Abbe Denis Grivot, Maitre de Chapelle de la Cathedrale, Autun; Handschriften- und Inkunabelsammlung, Osterreichische Nationalbibliothek, Vienna; The Pierpont Morgan Library, New York; the Dean and Chapter, Chartres Cathedral.

INDEX